M000209117

As Korea continues to forge ahead in the era of globalization, *100 Thimbles in a Box* provides a timely and necessary reminder of the persistence and beauty of traditional Korea. This thoroughly researched and elegantly photographed book is more than a source of knowledge—it is itself a piece of art. Debbi Kent and Joan Suwalsky have seamlessly blended culture, art, and history to offer readers an extensive overview of Korean handicraft, tradition, and identity.

Jai Ok Shim
Executive Director, Fulbright Korea

While many theorists and art historians have tried to pinpoint the beauty and essence of Korean craft, its familiarity and universality have kept it from being fully understood and properly appreciated until this book. Ideal for the general reader, *100 Thimbles in a Box* covers various themes and media in Korean art. As they explore the hidden symbolism and unique uses of Korean handicraft, the two authors trace connections between Korea's past and present. Offering abundant visual material, this book illustrates how Koreans have enjoyed art and culture in every moment of their lives.

Hyonjeong Kim Han
Associate Curator for Korean Art, Asian Art Museum of San Francisco

100 Thimbles in a Box will be treasured by everyone who loves traditional Korean culture and art. For adoptees and adoptive parents, however, it will also serve to nurture and support individual and family identity and pride. This beautiful volume will keep Korea close to all of us who love Korea, whether we are joined to it by birth, adoption, or simple admiration for its rich cultural heritage.

Margie Perscheid
President, Korean Focus

This beautiful book is a perfect introduc[tion] English-speaking audiences. Visually stunning, it places traditional art forms in the philosophical and religious contexts in which they have grown over the past 5000 years, describing how they were (and still are) made, and how they were central to the lives of the Korean people. It offers a clear explanation of the symbols that permeate handicrafts, their origins, and their functions: to bestow blessings and protect from harm. In a final chapter, the status of handicrafts in modern Korea is explored with explanations of how they are being preserved through the efforts of expert artisans and reborn in the beautiful work of modern Korean artists. This fascinating book will whet the appetite of any reader to learn more about the vibrant, engaging folk art that has colored the everyday lives of Koreans for generations.

Byung Goo Choi
Director, Korean Cultural Center in Washington, D.C.

Discovering the beauty hidden around us in our everyday lives—pausing to appreciate, for example, the humble glory of a wildflower—that brings warmth to our hearts. There are not many books that describe, as *100 Thimbles in a Box* does, the familiar grace and charm of Korean handicraft in terms of its symbolism and the various techniques involved in producing it. I believe that this book will help many individuals come not only to understand Korea, but also to love it.

Kim Yeonsoo
Former Director, Research Division of Artistic Heritage, National Research Institute of Cultural Heritage in Korea

100 Thimbles in a Box

The Spirit and Beauty of Korean Handicrafts

Debbi Kent & Joan Suwalsky

Seoul Selection

100 Thimbles in a Box

The Spirit and Beauty of Korean Handicrafts

Written and photographed by Debbi Kent & Joan Suwalsky

Published by Seoul Selection
4199 Campus Dr., Suite 550, Irvine, CA 92612, USA
Phone: 949-509-6584 Fax: 949-509-6599
Email: publisher@seoulselection.com
Website: www.seoulselection.com
Printed in the Republic of Korea

ISBN: 978-1-62412-026-8 53900
Library of Congress Control Number: 2014935543

"100 thimbles in a box" represent a wish for blessed longevity.
A Korean bride in the Joseon Dynasty created beautiful thimbles out of silk,
embroidered them with auspicious images, and gave them to the women in her new husband's family.
In this way, she conveyed her respect by wishing them long and happy lives.

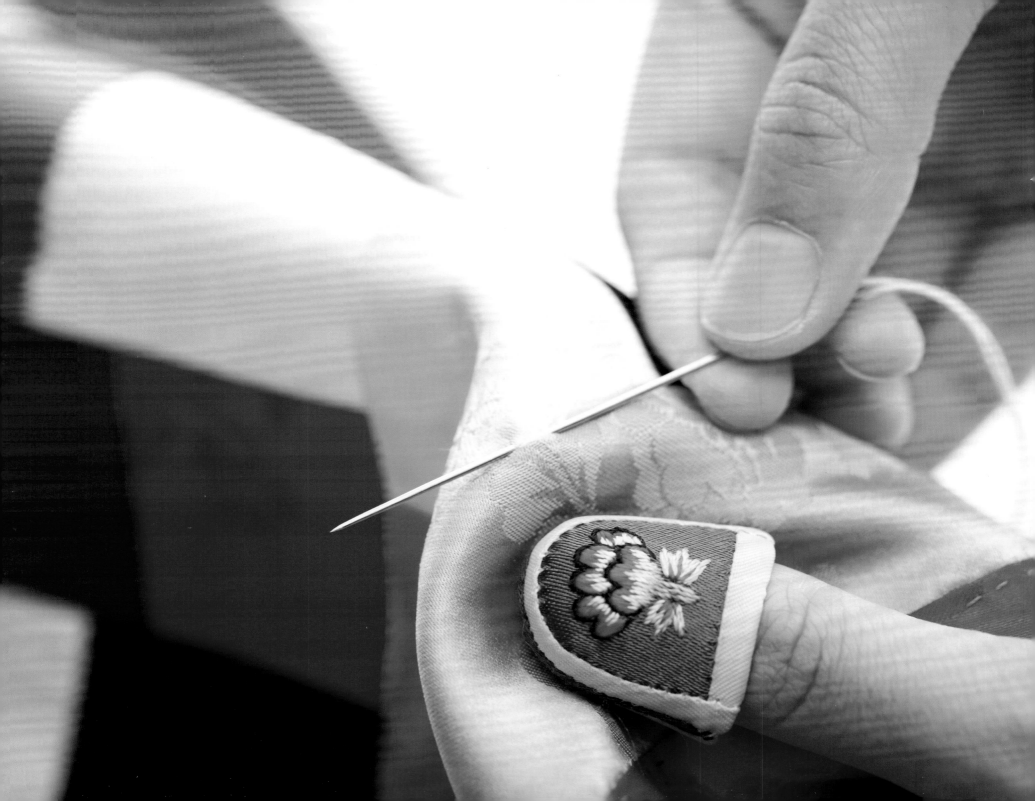

For Bill, who has believed in me from the beginning, and who, without complaining, went without dinner many a night so I could finish just one more page.

For Justin, who provided me with much-needed comic relief, as well as gentle reminders that this book was most definitely not going to write itself.

For Jess, who never failed to offer help when I needed it most.

And for Whitney and Melanie. My love affair with Korea began with the two of you, and to this mom you are, and always will be, its greatest treasures.

— Debbi

This is for April and Ted, who have graced my life beyond measure, with all my love.

It is in memory of Al, who helped make it all possible.

And it is for my first teacher and good friend, Hyeyoung Shin, who always understood why I needed to know.

— Joan

Contents

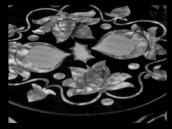

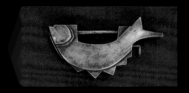
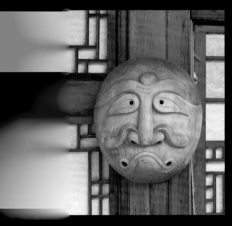

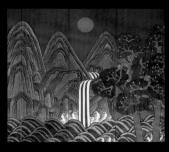
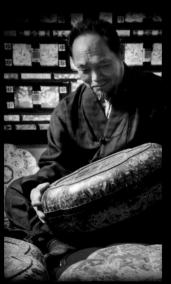

Foreword

Hands of Korea

This informative and well-researched book provides an excellent overview, with beautiful pictures, of the many unique Korean handicrafts. Co-authors Debbi Kent and Joan Suwalsky intended it to be a resource for readers outside of Korea, who have had little information on the subject. At the same time, it also provides Korean readers with a reminder of the richness of their cultural heritage in the crafts that are essential to their lives but often taken for granted.

This book describes the history and practice of seven Korean craft media and discusses the continued use of the ancient symbols that reflect a society's cultural beliefs and longings. They focus on the fields of ceramics, fiber, paper, inlay, metal, wood, and painting. Artists and artisans in each medium who are continuing traditional practices in the present time are introduced and profiled. Along with celebrating the beauty of Korean craft and its symbols, as each genre is introduced, the authors invite readers to learn more by providing an extensive bibliography for further study.

Tradition evolves over time and holds a continuum of knowledge of skill, design and style. The elegant beauty and strength of Korea's traditional crafts first arose out of necessity and daily survival—housing, utensils and vessels, walls, furniture and windows—and later extended to the love of decorating objects and surroundings. Today's craftsmen remain faithful to the long-established practices that have been carried forward from generation to generation through oral tradition and hands-on training. Looking to the past is a source of inspiration for every craftsman, and craft tradition is also an infinite resource

for contemporary artists and artisans who study the past and consciously incorporate traditional elements into their work.

For instance, in the fiber arts, the wrapping cloth, *bojagi*, was long done by women in the spirit of frugality. To make a cloth, they first had to plant hemp or ramie seeds, raise the plants, dry them, and peel away the bark to make thread from the fibers within. They then wove the cloth from which to sew their family's clothing. These diligent women carefully saved all of the leftover scraps of fabric, gathering and stitching them together to make beautiful *jogakbo*, or patched *bojagi*. Since 1999, beginning at the Rhode Island School of Design, RI, U.S.A., and spreading through workshops internationally, students from many countries and many disciplines have learned about *bojagi*-making and have brought to the genre new perspectives and design inspirations. *Bojagi* has gained an international following and now even has its own conference: in 2012 the first international Korea Bojagi Forum was held in Seoul, with another forum to be held in 2014.

Ceramics and paper, among the other crafts, have also evolved since ancient times and have drawn attention from outside Korea due to the skill of practitioners and the excellence of their products. Presently, several major biennial exhibitions honor the excellence of Korea's craft traditions. The Cheongju International Craft Biennale, the world's biggest craft festival, showcases all craft genres in Korea by inviting contemporary and traditional artists. At the Gyeonggi International Ceramic Biennale (CICB), many artists from around the world gather to exhibit and attend symposia and workshops. The ancient paper craft of *joomchi* is rapidly gaining renown as an art form in the Western world through workshops and the curation of numerous international exhibitions.

Craft in Korea has been encouraged, sustained, and continually uplifted by the Korean Traditional Craft Institute, which supports educational programs in nearly all traditional crafts and exemplifies the strong will of the Korean government to not only preserve the traditional crafts but also allow the flourishing of new interpretations of tradition in contemporary art. In another attempt to preserve the country's craft traditions, the Korean government has designated leading practitioners in each craft field as Intangible Cultural Heritages. Korean craft is becoming increasingly visible in exhibitions that travel to the Western world as well. One such exhibition in 2014 is the Korean craft exhibition in the Handmade Gallery at the Miami International Airport in conjunction with the Miami Art Basel exposition. Many contemporary artists are very involved in keeping Korea's crafts alive, gaining inspiration from tradition and transforming their visions into modern art.

Please delve into the richness of this book. You will be fascinated and delighted.

Chunghie Lee, 2014
Visual Artist/Adjunct faculty at the Rhode Island School of Design, RI, U.S.A.

Preface

100 thimbles collected in a box represent a wish for blessed longevity. A Korean bride in the Joseon Dynasty created beautiful thimbles out of silk, embroidered them with auspicious images, and gave them to the women in her new husband's family. In this way, she conveyed her respect by wishing them long and happy lives. More often than not, Korean handicrafts are embellished with symbols, bringing the desire for good fortune and the need to guard against misfortune into the daily lives of all.

This is a book about those powerful symbols and some of the beautiful handicrafts that they adorn, written by two women who have received many blessings. In August of 1983 a tiny baby girl named April arrived at National Airport in Washington, D.C. from Korea. Her adoptive parents, Joan and Al, awaited her. She was followed by Whitney, who joined her adoptive parents Debbi and Bill and brother Justin in 1986. Teddy was welcomed as Joan and Al's son and April's brother, also in 1986, and Melanie flew home to complete the Kent family in 1994. Thus began a journey for our two families that has been a remarkable gift. Not only have we had the opportunity to nurture our five children, now fine and accomplished young adults, but we have grown to love and respect the cultural tradition the four of them brought to all of us when they arrived.

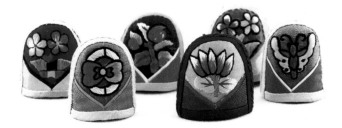

We became friends when we discovered our common interest in Korean art and handicrafts. Together we dug deeper, reading every book we could find, traveling to Korea many times, and while there, never missing an opportunity to shop for the handicrafts that we had come to love. We moved from simply buying what we liked to learning about the techniques involved in making the crafts, and tracing those crafts back in time through Korean history. We located artisans and learned from them, and then came home and taught classes about what we had learned to Korean-born children and their adoptive parents. We filled our homes with Korean artifacts, believing that it was important for our children to literally bump into their cultural heritage as they grew up, so that it would never be foreign to them. The kids became involved in all aspects of the journey, too—traveling to Korea, attending culture camps, teaching art classes, learning the Korean language, and trying to fit all the pieces together.

And now, the book. We've had a wonderful time researching and writing it, and we hope we've accomplished the goals that we set for ourselves. Korean art and handicrafts are much less well known to Western readers than are the traditions of other Asian cultures such as China and Japan, and so our aim was to write a book that would convey the fascination and delight we've experienced as we've explored and learned about them. We wanted the book to be visually dramatic, conveying the simple forms, natural materials, vibrant colors, spontaneity, and humor that characterize much of Korean folk art. We also wanted it to be verbally succinct, providing an introduction that would whet a reader's appetite for the cultural feast that Korea offers to those who come to table. Through our images and words, we also hope that we have conveyed the deep affection and respect that we feel for Korea and its people, and that you, too, will come to share our love for the ancient, yet very modern, Land of the Morning Calm.

Debbi and Joan

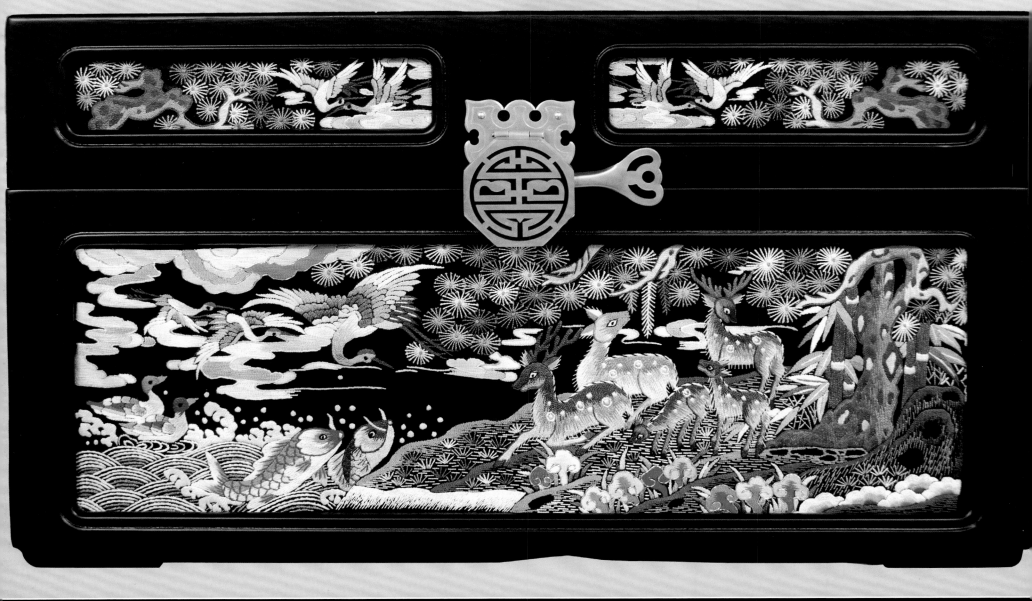

The handicraft traditions of Korea, many of them stretching back thousands of years, paint a vivid portrait of the Korean people—their ways of thinking and viewing the world, their values, their spontaneity and sense of humor, and their conception of beauty. Starting with the earliest ceramics over 10000 years ago and continuing to the present day with the exquisite work of artisans designated as holders of Important Intangible

also reflecting and embodying it. They help us understand a culture that has withstood centuries of invasion and cultural exchange only to emerge with a distinctive identity unlike any other in East Asia. Through the crafts shaped by the hands of Korean artisans over millennia, we come to know this vibrant culture that has much to teach all of us about the creation of beauty, the love and respect for nature, and harmonious living in a

Chapter I

Introduction

Handicrafts: Mirrors of the Soul

Philosophical, Spiritual, and Religious Traditions in Korea

Historical Timeline of the Korean Peninsula

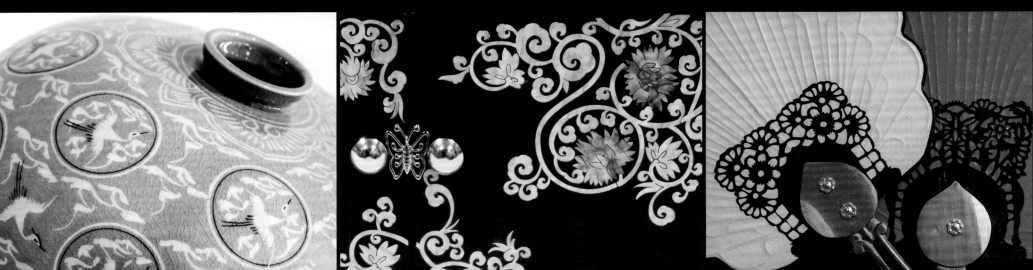

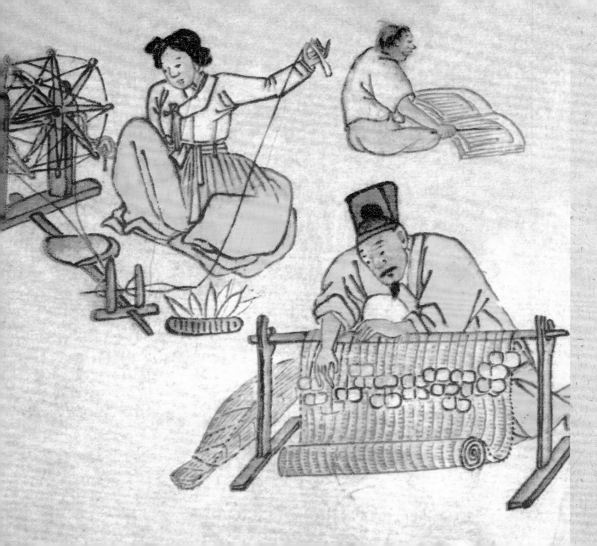

Handicrafts (*sugongye*) in any culture are a reflection of the people who create them. Working with the raw materials available to them, people make the things they need—creating shelters, making clothing, and fashioning containers and utensils with which to store, prepare, and consume food. When basic needs have been met, there is energy and incentive to improve, refine and embellish these artifacts. In times of peace and plenty, luxury items appear and craft can become art.

The creation of the materials needed for the business of living is also profoundly shaped by the beliefs, needs, and historical circumstances of the group. Thus, the buildings, bracelets, and bowls crafted by the hands, hearts, and minds of any given group are uniquely representative of that group and no other.

A small land of rugged mountains and fertile coastal areas surrounded on three sides by water, Korea has traditionally been a society of farmers and fishermen. A deep and abiding reverence for nature characterizes Korean thought and behavior and has strongly influenced their art and material culture up to the present time. Natural materials—wood, clay, stone, and fiber—figure prominently in their handicrafts. The aesthetics reflected in the handicraft traditions, sometimes referred to collectively as "endearing imperfection," and including simplicity, an unaffected spontaneity, asymmetry, and humor, also reveal the culture's affinity with nature and the desire to be in harmony with it.

Craftsmanship in Korea has always meant more than simply making objects. In the Joseon Dynasty, craftsmen were called *jangin*. Oddly, while *jangin* were considered to be of a low social status, their work was seen as extremely important. They were believed to be special people who possessed "heaven-sent talent" and who had a responsibility to use that talent to make beautiful things for people. Time, energy, materials, and dexterity were considered to be the craftsman's "four virtues" or tools. Unless the four virtues were all used, and used in harmony, the things produced by a craftsman were not truly whole. It has been said that Korean craftsmen, in addition to mastering technique, had to learn how to instill their hearts and souls into each artifact that they created.

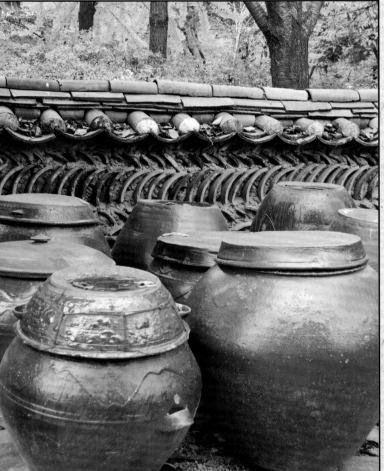

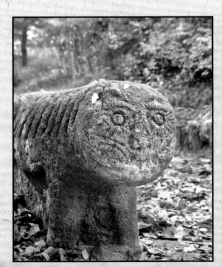

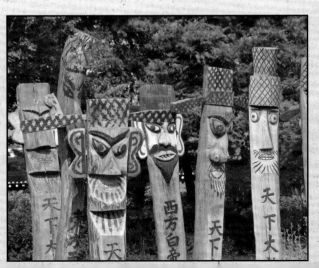

Situated between China on the west and Japan on the east, the Korean peninsula has often been subjected to foreign invasion over the course of its history. Mongol, Chinese, and Japanese armies have repeatedly invaded the peninsula, bringing cultural change with them. In times of peace, philosophical, political, religious, and artistic customs and traditions have been shared among these Asian cultures for thousands of years. However, despite their close proximity and long periods of cultural exchange, Korea, China and Japan have evolved very distinct and readily recognizable traditions of art and handicrafts. While Chinese and Japanese art are very familiar to the Western world, Korean art has been much less well known. This was a primary motivation for writing this book.

Royal seal of King Yeongjo

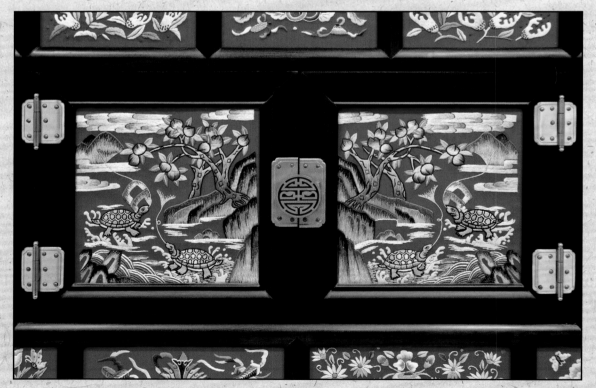

The design elements on this exquisitely embroidered chest—the rocks, water, clouds, trees, fruit, and tortoises—were not chosen simply for decorative effect. Rather, these symbols convey many of the beliefs and wishes of the Korean people.

It is difficult to think about crafts in Korea without also considering the powerful symbols with which they are decorated. These symbols, great in number, tell much about the deepest beliefs and yearnings of the Korean people. The symbols that permeate Korean handicraft traditions are explored in Chapter 2.

Korean handicrafts fall into many categories. We present a selection of them with photographs of varied examples and explanations of how they have traditionally been created. Ceramics, fiber arts, papercraft, inlay techniques, metalcraft, woodworking, and painting are presented in Chapters 3–9, with descriptions of a total of 44 different art or craft forms. We have chosen to present those that we particularly like, and although these are only a portion of the handicrafts found in Korea, they are, nonetheless, a good introduction to the larger tradition.

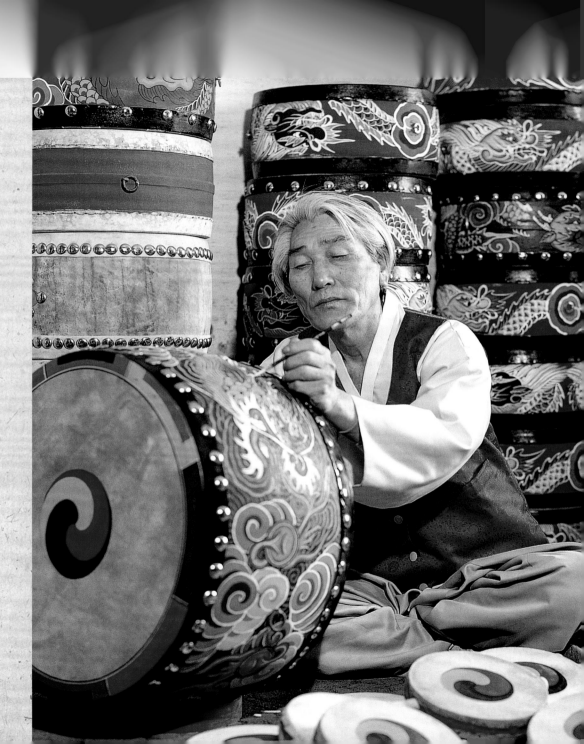

Finally, in Chapter 10 we explore the state of Korean handicraft traditions today. Handicraft traditions in any culture reflect the history of that culture, and in this role are an important part of the culture's identity. Practical by nature, crafts first and foremost are used by people to meet their everyday needs for shelter, warmth, protection, and sustenance. The particular ways in which those needs are met, however, is altered with time and circumstance, i.e., with cultural change. If handicraft traditions do not adapt to the march of time, they can become increasingly less relevant and can even disappear, taking a piece of the culture's identity with them. A very interesting issue in Korea today is the attempt to achieve a balance between preserving ancient craft traditions and adapting them to new circumstances at a time when Korea is undergoing some of the most dramatic growth and change in its long history. Fortunately, Korean art is not stagnant. Rather, today's artists are adapting traditional designs to the 21st century with stunning results.

Before we begin, it may be helpful to the reader to have a very brief overview of the key philosophical, spiritual, and religious traditions, as well as the historical events that have had a major impact on the Korean handicraft traditions that we discuss. We have attempted to provide just enough information to put the arts and crafts in this book into a meaningful context. We greatly simplify very complex ideas and a very long and multi-faceted history, and the dates that we use, while generally accepted, are not exact. After all, historical events and cultural change do not occur in a neat and tidy fashion.

Akgijang refers to the craft of making the instruments that are used in traditional Korean music, as well as those who have mastered this craft. During the Joseon Dynasty, musical instruments were made by a special government body in the palace called the Office of Musical Instrument Production. Today, *akgijang* has been designated as Important Intangible Cultural Property No. 42.

Animism

Animism posits that various aspects of the universe, including inanimate and animate objects both on earth and in the heavens, are endowed with a life force or spirit. These spirits, further, have the capacity to influence the fortunes of men for good and for ill. Hence, spirits are both worshipped and feared. In Korean history, aspects of animism permeate shamanism and Daoism, religious traditions that have influenced Korean thought and artistic creativity for millennia.

Shamanism

A mystical religious tradition that has existed in many places around the world, shamanism was brought to the Korean peninsula from Siberia and Manchuria in ancient times. Growing out of animistic thinking, shamanism holds that priests (shamans or *mudang*) are the intermediaries between the spirit world and human beings. Without either an organized clergy or liturgy, *mudangs* work individually at the village or community level to facilitate healing and problem solving for individuals. Considered to be the most basic religious creed throughout Korean history, shamanism is still an active influence in the culture today. It has also been the source of many of the animal and plant symbols in traditional folk art.

Daoism

Daoism, originating in China in the 5th century BC with the thinking of Lao Tzu, a bureaucrat who left his job to find fulfillment wandering the countryside, maintains that people, rather than simply living in society, should cultivate and maintain a deep connection to the natural world. When Daoism reached the Korean peninsula it gradually incorporated aspects of shamanism, with which it is sometimes confused. The central place that nature holds in Korean (indeed, all of East Asian) thought, culture, and art stems in part from Daoism, and landscape painting is believed to have its roots in that Daoist influence.

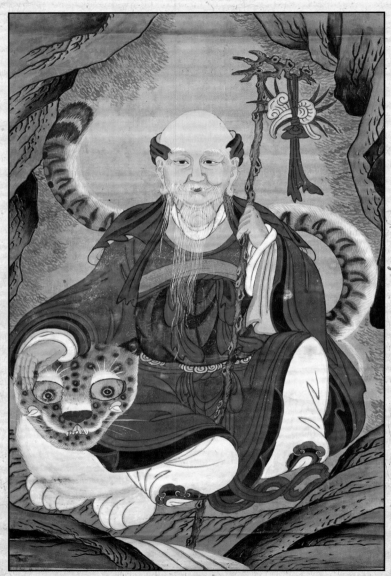

Sansin, the "mountain spirit," the highest deity in Korean Daoism. Always portrayed sitting peacefully in the forest, usually with a tiger, *sansin* is the embodiment of the Daoist philosophy of harmony between humankind and the natural world.

Buddhism

Originating in India, Buddhism was introduced to the Korean peninsula from China beginning in the 4th century AD. Focused on the here and now rather than on the afterlife, Buddhism holds that suffering in this life is caused by ignorance and desire and can only be overcome with a life of moderation, good practices, and meditation. The ultimate goal is to transcend the recurring cycles of death and rebirth and achieve a state of Nirvana. Buddhism was practiced by the ruling families and the elite, who spent enormous sums of money to commission the creation of beautiful religious paintings, ritual objects, and calligraphic manuscripts of Buddhist scripture. Still considered to be the dominant religious influence in Korea, Buddhism has permeated Korean culture for two millennia and profoundly influenced Korean character, thought, and art.

Confucianism

Based on the teachings of Confucius (551–479 BC), Confucianism originated in China and has been a philosophical background in Korea since at least the 3rd century BC. With the establishment of the Joseon Dynasty, Neo-Confucianism was adopted as the state religion, incorporating aspects of Daoism and Buddhism and adding a focus on the cultivation of the self to traditional Confucian thinking. Considered by some to be a philosophy rather than a religion, Confucianism emphasizes the establishment of harmony among people during their lifetime based on a code of conduct characterized by restraint, modesty, and respect. Rituals for worshipping ancestors are also emphasized. The art that was produced reflected these ideals, with natural forms, muted colors, and understated decoration predominating.

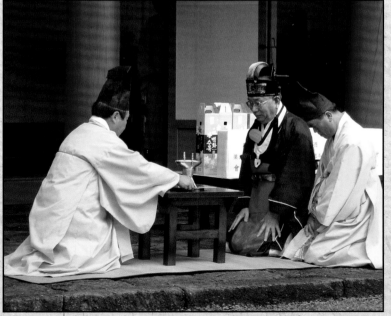

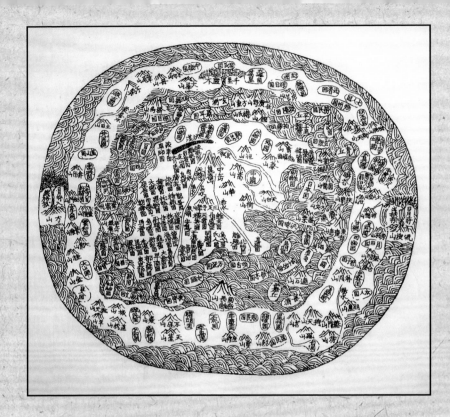

A reproduction of a *cheonhado*, or "under the sky world map," from the late 17th century. Although Korean, it presents a view of the world as imagined by Chinese and Korean scholars of the Joseon era. China is shown occupying most of the center of the world, with Korea and Japan indicated as small islands to the east. At the top is a pine tree, with the notation that "firm ground extends for 1000 miles in that direction."

Three Kingdoms (18 AD–668 AD)

Three kingdoms, Goguryeo (37 BC–668 AD) in the north, Baekje (18 BC–660 AD) in the southwest, and Silla (57 BC–676 AD) in the east, joined together in 18 AD, with Buddhism as the main religion, and developed a rich culture. The earliest examples of Korean painting are found on the walls of the royal tombs, providing important information about lifestyles. Intricately wrought gold, bronze, and iron artifacts demonstrate the superior skill of metalworkers at that time.

Unified Silla (676 AD–935 AD)

Silla eventually conquered the other two states, creating the first unified Korean government. Lasting for almost 300 years, Unified Silla was a period of peace and stability. Gyeongju, the capital, was filled with beautiful palaces and temples, and a distinctive Korean culture began to emerge. Buddhism was the official religion, and it is believed that several important temples that survive to this day were built then, in the hope of helping to ward off invasion from China and Japan.

Ancient Time (700,000 BC–18 AD)

During the Paleolithic and Neolithic periods, the Korean peninsula was inhabited by disparate groups of people that had migrated from Siberia and Manchuria, bringing shamanism with them. From 2333 to 108 BC, which included the Bronze and Iron Ages, the Korean peninsula was known as Gojoseon, which is considered to be the first "official" Korean country. The earliest pottery dates from 8000 BC. The potter's wheel was invented in the Iron Age, and pottery from that period indicates that high-firing "climbing" kilns had also been developed.

Goryeo Dynasty (918 AD–1392 AD)

In the Goryeo Dynasty an elegant, enlightened and highly creative culture emerged, with advances in government and education and some of Korea's most brilliant achievements in the arts. Celadon was perfected, assuming a distinctive character in comparison to its Chinese counterparts in terms of shapes, the color and consistency of the glazes, and the way in which it was decorated. Chinese envoys called it "first under heaven." Contact with the wider world increased, and visitors from as far away as the Middle East came to know the land as "Corea." Supported by the aristocracy, Buddhism continued as the official state religion and continued to exert a profound influence on the arts.

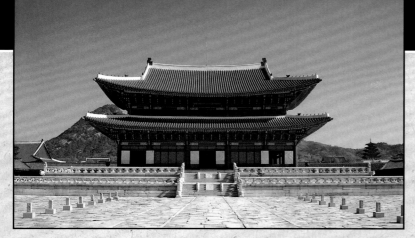

Geunjeongjeon, the main throne hall at Gyeongbokgung, the primary palace of the Joseon Dynasty, built in 1395.

Modern Time (1910 AD–Present)

Lasting for 500 years, the Joseon Dynasty ended with the annexation and occupation of Korea by Japan in 1910. Japanese rule lasted until 1945, when Japan was defeated by the Allied forces in World War II. As a result of Soviet actions following the establishment of a joint U.S.-Soviet trusteeship of the peninsula at the end of the war, Korea was divided into two countries in 1948, the Republic of Korea (South Korea) and the Democratic People's Republic of Korea (North Korea). In 1950 North Korea invaded South Korea, igniting the Korean War. Lasting until 1953, the war left the country physically and economically destitute. Since then, however, Korea has astounded the world with its recovery, referred to as the "Miracle on the Han River," and is today a vibrant modern nation. The country has carefully preserved old art forms in this period of rebuilding, and the traditional artistic heritage of Korea is largely intact today. In addition, there is a vibrant contemporary art scene that both builds on the past and propels the country boldly forward into the future.

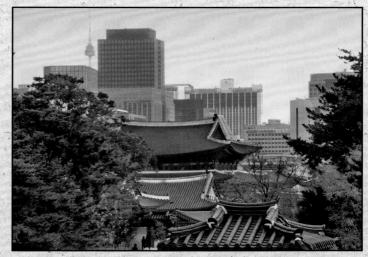

Seoul today finds ancient palaces and modern skyscrapers standing side-by-side.

Joseon Dynasty (1392 AD–1910 AD)

In 1392 the Joseon Dynasty was established, the capital was moved to Seoul, and Neo-Confucianism replaced Buddhism as the state philosophy. Thus began a very different and much more austere period of history for the Korean people, characterized by a strict code of behavior and the adoption of a simpler, more conservative lifestyle. Art forms were deeply influenced by these changes, with austere, undecorated white porcelain pottery epitomizing the change. Intellectuals began to reject Chinese influences and focus on the Korean experience, and true-view landscape (*jingyeong*) and genre painting emerged. Folk art, filled with auspicious motifs derived from shamanist and Daoist traditions, was produced by the king's Bureau of Painting (Dohwawon) as well as by itinerant painters. At the same time, some of Korea's greatest cultural achievements, such as the development of the Hangeul alphabet, occurred during this time. The Joseon era left a deep and enduring mark on Korean character and culture that persists to this day.

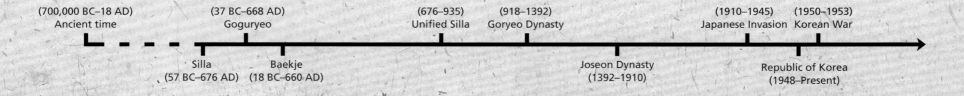

(700,000 BC–18 AD) Ancient time

(37 BC–668 AD) Goguryeo

Silla (57 BC–676 AD)

Baekje (18 BC–660 AD)

(676–935) Unified Silla

(918–1392) Goryeo Dynasty

Joseon Dynasty (1392–1910)

(1910–1945) Japanese Invasion

(1950–1953) Korean War

Republic of Korea (1948–Present)

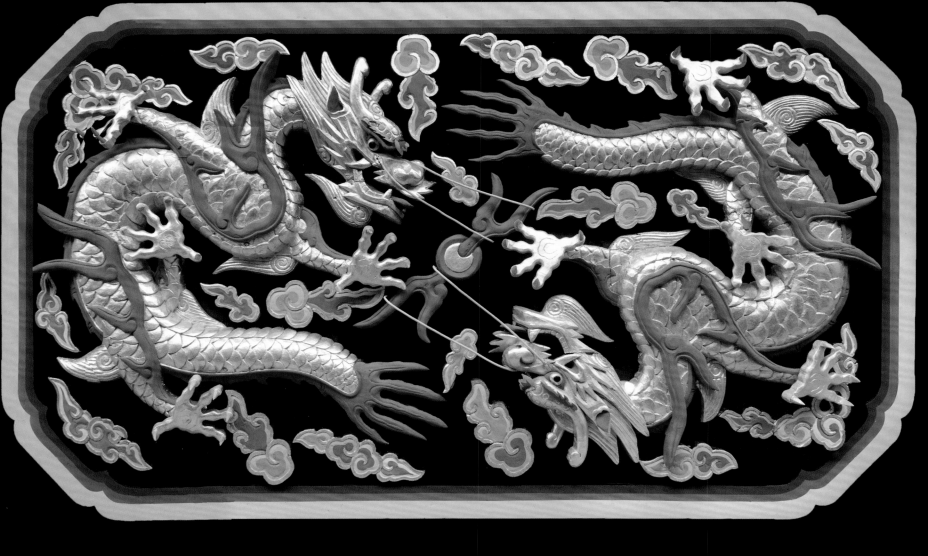

Korean handicraft traditions have always had two purposes. First, the products of the artisans' hands meet the needs of people as they go about the business of living. Second, handicrafts have long been decorated with beautiful symbols that serve very important functions—to help ward off danger and to invite blessings. Throughout Korean history, symbols have been very powerful. The role they played in the everyday lives of the people cannot be overstated, and to understand that role is to be able to better appreciate Korean culture and its people. Manual talent was considered to be heaven-sent, and fine Korean artisans have always believed that their responsibility is to put their souls into their work. The result is an enormous array of lovely handicrafts, with messages of auspicious meaning bequeathed to anyone wise enough to accept the blessings sent their way.

Symbolism in Korean Handicrafts

The Origins of Korean Symbols

Individual Symbols

Groups of Symbols

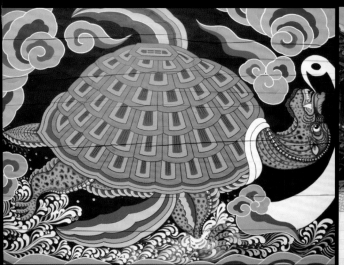
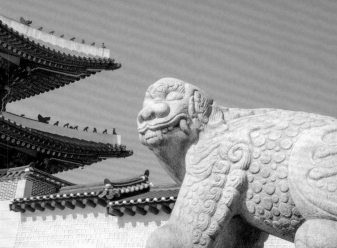
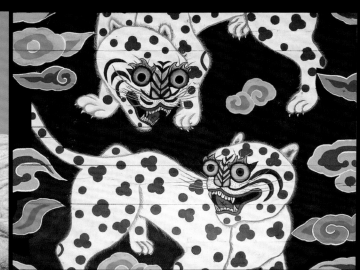

The Origins of Korean Symbols

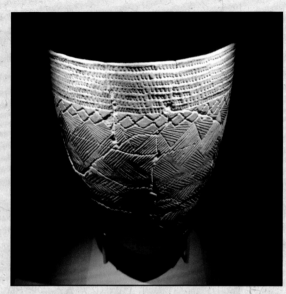

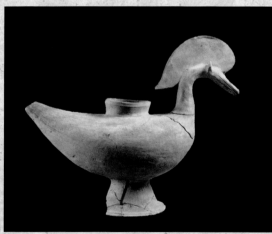

A symbol stands for or represents something else. In particular, material objects or images of them are often used to represent something that is invisible, mythical or beyond human perception. From the Neolithic Age to the 21st century, the Korean people have fashioned and decorated everyday objects, religious artifacts, and pieces of art and handicraft with symbols that reflect their deepest beliefs, hopes, and fears. The symbols have changed little over the centuries and have roots in and connections with the various spiritual and religious traditions that have been dominant in Korean history—animism, shamanism, Daoism, Buddhism, and Confucianism.

To understand the use of symbolism in Korean arts and handicrafts, one must first appreciate the deep connection that the Korean people have had with nature for many thousands of years. Man has always been seen as a part of nature, not superior to it or separate from it. The goal and highest form of a good life throughout Korean history has been defined as living in close harmony with all aspects of nature. Tied to the land and its resources for their livelihood and welfare, the earliest inhabitants of Korea were intimately connected with and directly affected by nature's beauty, bounty, cycles, and sometimes deadly effects. In awe of its power, people believed that elements in the natural world—sun and moon, rocks and mountains, rivers and lakes, trees, plants, and animals—were imbued with spirits. These spirits affected men's lives for good and for ill. Revering nature but also needing to exert some control over their own survival, early groups of people attempted to deal with the forces that surrounded them by finding ways to ward off evil spirits and attract the benevolence and protection of good ones.

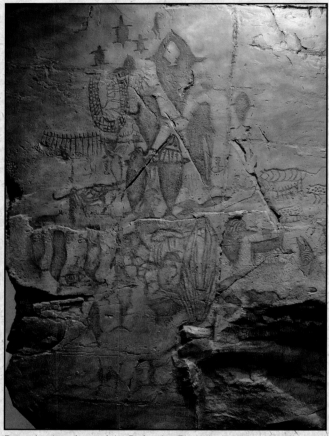

Reproduction of one of the Bangudae Petroglyphs, located in Ulsan. Depicting tigers, whales and wild boars, the petroglyphs symbolize a prehistoric people's hope for a successful hunt.

Top: The shape and design of this comb-patterned vessel are unique to the Neolithic people of the Korean peninsula, such that Korean Neolithic cuture is often referred to as the "comb-pattern pottery culture."
Bottom: A duck-shaped vessel from the Yeongnam region, dating from the 3rd century AD.

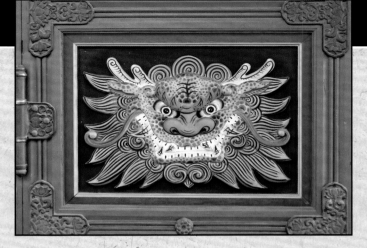

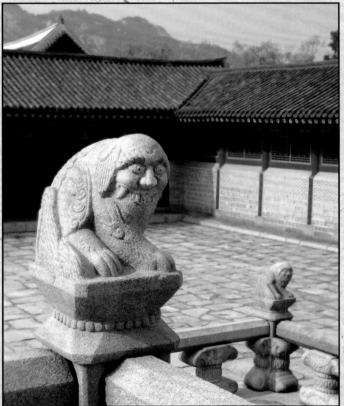

A *haetae* stands watch over Gyeongbokgung Palace in Seoul.

Symbols, whether carved on cave walls or embroidered on pillow ends, served and still serve to both placate and engage nature's spirits in man's quest to survive and prosper. The power of symbols to repel evil and bring blessings thus became an essential function of folk art and handicraft. All classes of Korean people, from the royal court to the most humble villagers, surrounded themselves with these symbols—in the palace, the government office, the temple, the scholar's studio, the artisan's shop, the village, the farmer's home. Architecture, furnishings, decorative pieces, household implements, and clothing were all decorated with symbols that gave them magical power as well as aesthetic appeal. In modern day Korea, symbols still abound and continue to touch the lives of men, women, and children every day.

In this chapter, we present many of the most important symbols, telling a bit about the origin and meaning of each one. We encourage the reader to notice that the same symbols are incorporated into many different types of handicrafts and take a variety of forms depending on the artisan or the period of history in which the artifacts were made. Having learned why symbols exist and are so prevalent, we hope the reader will better appreciate the meaning of the handicrafts pictured throughout the book. Try to imagine an object in its original context, and try to imagine the effect that it would have had on the people looking at it. Did they feel encouraged by its presence? Did they feel safer or more reassured? Did it make them hopeful for blessings to come? Did it comfort them in times of hardship and loss? Did it help them to better understand and accept their place in the natural or human scheme of things? The artifacts themselves, bearers of symbolic power, come alive in this way, sharing their spiritual messages with each of us.

Bamboo *Daenamu*

One of the most popular motifs for brush painting and for the decoration of ceramic ware for centuries, bamboo has several symbolic meanings. Evergreen and very strong, it is a Daoist longevity symbol, and because it can bend without breaking, bamboo also symbolizes the Dao (the "Way"). In the Buddhist tradition, the hollow center of a bamboo stalk represents emptiness. Because of its strength and straight form, bamboo also came to represent the qualities of the upright Confucian gentleman scholar. Indeed, it is included as one of the Four Gentlemen Plants or Four Gracious Plants (Sagunja).

Bat *Pyeonbok*

A Daoist symbol for good luck and good fortune that developed because the words for bat (蝠) and good fortune (福) sounded similar, the bat is often featured in the hardware on Korean chests, in mother-of-pearl inlay, and in embroidered pieces. Five bats symbolize the five fortunes: longevity, health, wealth, virtue, and a natural death. Also believed to drive away evil spirits, the bat was used on chests with valuable contents such as grain or money.

Butterfly *Nabi*

A symbol with both Daoist and Confucian roots, butterflies, especially when pictured in pairs, came to represent a long, happy marriage because the words for butterfly (蝶) and "eighty-year-old-man" (耋) sound alike in Chinese. More broadly, the butterfly also symbolizes love, joy, and prosperity. Colorful, graceful butterflies are often seen in Korean *hwajodo* (paintings of birds and flowers), and are a favorite motif for embroidery. Butterfly brasses also adorn many headside chests made for the women's quarters.

Carp *Ing-eo* & Other Fish

Carp and other types of fish have a number of different symbolic meanings reflecting shamanist, Daoist, and Confucian traditions. Originating in a Chinese legend of carp swimming upstream against the current to leap a large waterfall called the Dragon Gate, carp came to symbolize courage, perseverance, and success. Carp that surmounted the waterfall were believed to be transformed into dragons, and this, in turn, came to stand for successfully passing the all-important government civil service exam. In the Joseon Dynasty, paintings of leaping carp were placed in boys' bedrooms to inspire them, and they were given to young men about to take the exam. Two carp pictured under a lotus symbolized successful passage of both sections of the exam.

Fish also came to symbolize vigilance because they do not close their eyes, even when they sleep. Drawer handles and locks for chests with valuable contents, such as money or rice, were often shaped like fish, and paintings of fish were hung on storeroom doors as guards. And finally, a pair of fish connotes a happy marriage and fertility, based on the fact that fish lay many eggs.

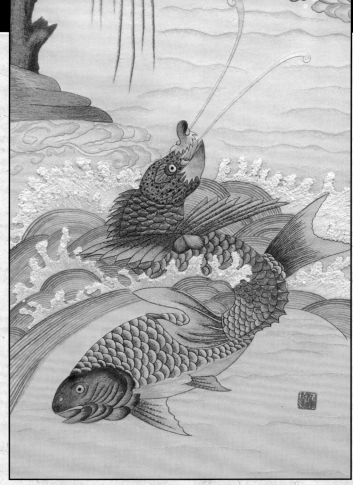

Embroidery by Choi Yu-hyun

Chrysanthemum *Gukhwa*

One of the Four Gentlemen Plants (Sagunja), the chrysanthemum stands for the ability of the Confucian scholar to make contributions late in life (i.e., the ability to bloom even in the cold weather of autumn). A second meaning, seclusion, grew from the story of a Joseon era poet who wrote about wanting to withdraw from society following an argument with a superior. Having penned his thoughts, he picked up a chrysanthemum as he gazed at Mt. Namsan.

Clouds *Gureum*

In Daoist cosmology *qi* is the eternal breath of life and constitutes everything that exists. Plants, animals, and geological features are *qi* in a condensed form, while the atmosphere is *qi* in a diluted form, representing the infinite potential for life. Clouds, a part of the atmosphere, represent the potential for life in a form that can be seen. Because clouds and mist surround the peaks of the mountains in the Daoist Land of the Immortals, clouds came to stand for eternal life and are one of the Ten Symbols of Longevity (Sipjangsaeng).

Crane *Hak*

Considered to be supreme among birds, the crane is revered and beloved in Korean art and folklore. One of the Ten Symbols of Longevity, the crane is thought to be the companion and messenger for the Daoist immortals, carrying them on their backs to and from the Islands of the Immortals in the Eastern Sea of China. Images depicting this have been found on tomb murals from the fifth and sixth centuries AD. Astonishingly, 9000-year-old ceremonial flutes made from the wing bones of red-crowned cranes have been found in China, suggesting a much older tradition of cranes as meaningful in East Asian religious rites. Naturally long-lived, cranes were believed to become immortal once they had lived for 2000 years.

Cranes were also admired for nobility of character and came to symbolize the traits of a Confucian gentleman scholar who lives a life of integrity. Because female cranes are known to be very caring of their young, the crane also came to represent a happy marriage and the virtues of a good parent.

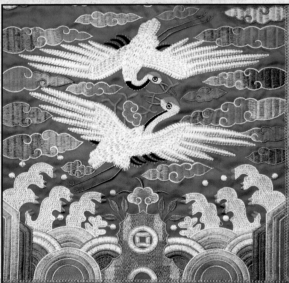

The crane was embroidered on rank badges worn by civil officials on the front and back of their robes in the Joseon court.

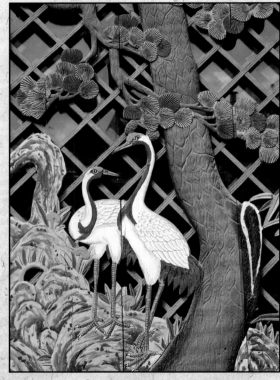

Door detail from Jogyesa Temple in Seoul

Deer *Saseum*

The deer has been a favored animal in Korean folklore, perhaps most famously as one of the Ten Symbols of Longevity. Some sources say that the association with longevity derives from the belief that deer can smell and find the mushroom of immortality (*yeongji*), while others attribute it to the deer's ability to shed its horns in the fall and grow new ones in the spring. Traditionally, Koreans used ground deer horn in medicines to confer long life and carried pieces of deer antler as a protection against misfortune and disease. Deer are also considered to be friends of man, bringing luck and always repaying favors. Usually pictured in groups, many deer together connote many forms of luck, while a pair of deer symbolizes happiness in marriage.

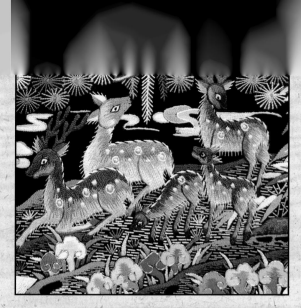

Dog *Gae*

Of shamanist and Daoist origin, the dog is a guardian that protects against theft. One of the four animals whose function was to protect the household against evil, pictures of the dog were placed on storehouse doors or on chests containing things of value. Typically the dog is pictured in a very exaggerated form, sometimes with four eyes and four ears, heightening its attributes of strength and fearlessness and emphasizing its ability to detect thieves even in darkness and bad weather.

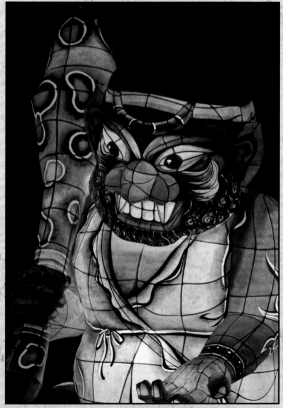

Dokkaebi

Dokkaebi, mythical creatures with menacing faces and sometimes horns and a magic club, have appeared in Korean folk legends since the Three Kingdoms Period. They materialize out of familiar items such as trees or brooms, appear only at night, and are very fond of mischief, such as moving a farm animal to the roof of the farmer's house. Although they have powers beyond human ability, they are frequently rather stupid and can be duped. They also have some very likeable characteristics. They are trustworthy and always pay their debts on time, and being a "god of means" (a god that creates effects), if they are in the mood, the *dokkaebi* may grant the wishes of ordinary people.

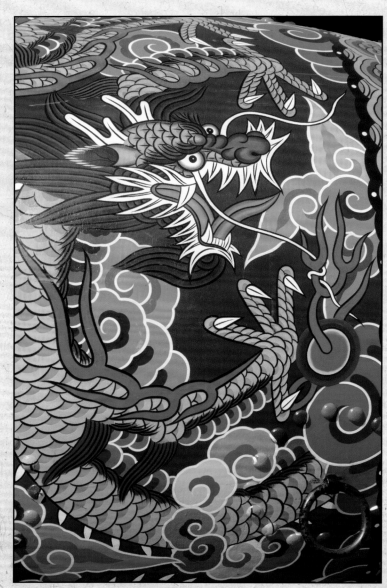

The *yonggo*, or dragon drum, is used in military wind-and-percussion music (*daechita*).

Dragon *Yong*

Introduced from China, the dragon was originally a Daoist symbol but later came to be associated with all of Korea's religions. Unlike in the West, dragons in Asian cultures are not feared, but are admired and revered. With the head of a camel, the antlers of a deer, the eyes of a rabbit, the ears of an ox, the body of a snake, the belly of a frog, the scales of a carp, the claws of a hawk, and the paws of a tiger, the dragon was believed to be both male and female and to have the ability to lay eggs and change its size at will. Strongly associated with water, the dragon was believed to live in both the Dragon Palace at the bottom of the sea and the clouds in the sky. Rain was believed to be a dragon ascending to the sky, and one of the earliest and most important of shamanist rituals was invoking dragons to bring rain in times of drought.

The dragon is included in two different sets of Korean symbolic figures. In Obangsinjang (the Daoist Spirit-Generals of the Five Directions), a blue dragon represents the east. The directional spirits traditionally played a critical role when choosing auspicious sites for buildings and graves, assuring that they would be in harmony with the forces of nature. The dragon is also one of the Four Animals of Good Luck (Saryeong), and was frequently portrayed in folk art in the Joseon era.

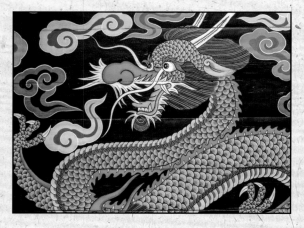

Symbolizing creative mystical power and virtue, the dragon also came to stand for the king. The king's face was referred to as *yongan*, his clothes were called *yongpo*, and the throne was called *yongsang*. Magnificent dragons were embroidered in gold on his robes. Because of the association between the dragon and the king, there were strict regulations about how dragons could be pictured. Those drawn with five claws could only be used in the palace or in Buddhist services. Commoners were permitted to have dragon pictures, but only if they had four claws.

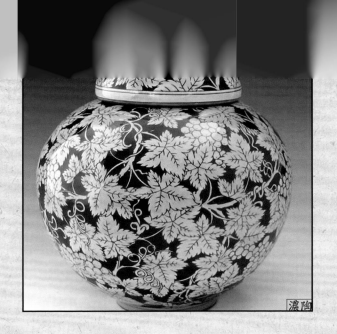

Grapes *Podo* & Grapevines *Podonamu*

Grapes on the vine stand for an endless line of descendents, one of the most important Confucian goals. Often painted on eight-paneled screens, the vines denoted the continuation of the family line, while the grapes promised the birth of sons. These screens were often placed in the room of newlyweds. One famous Joseon era artist actually mixed grape juice with his paint to further enhance the power of the grapevines that he painted.

Haetae

One of the four animals that protect the household from evil, *haetae* are auspicious creatures believed to live deep in mountainous terrain where they eat the food of the mountain gods. Extremely powerful, they have two functions. First, they protect against fire. Throughout much of Korean history, homes had straw roofs and were illuminated with candles or oil lamps. Even the royal palaces, as well as homes of the wealthy, were made of wood, and fire was a constant concern. Second, since they attack only when faced with injustice, *haetae* are considered to be guardians of fairness. Placed on the ends of the eaves of the palace roof, they symbolize the people's wish for just and objective rule by the king. Pairs of stone *haetae* placed outside palaces and government buildings cleanse the hearts and minds of those entering and exiting the buildings, assuring that those officials will (to this day) serve the nation well.

A *haetae* has a face like a horse, green scales and colorful spots on its body, and a horn on its head. Quite charming in appearance (and often pictured with a hint of a smile) despite their great power and serious functions, *haetae* appear frequently in lacquer ware, embroidery, and as painted designs on porcelain.

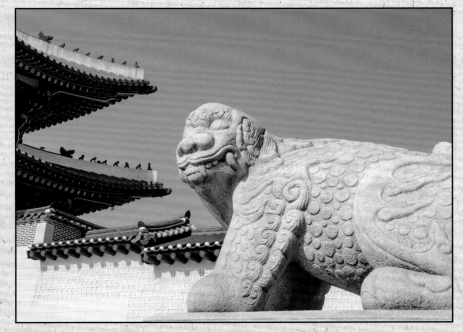

A stone *haetae* stands ready to protect against fire in front of Gwnaghwamun Gate at the entrance to Gyeongbokgung Palace.

Girin

One of the Four Animals of Good Luck (*Saryeong*), the *girin* is a mythical beast with the head of a dragon, body of a deer, tail of an ox, scales, and a horn in the center of its forehead. Often painted in bright colors with flames coming from its mouth, the *girin* is, perhaps contrary to its appearance, a symbol of peace, prosperity, and a happy marriage.

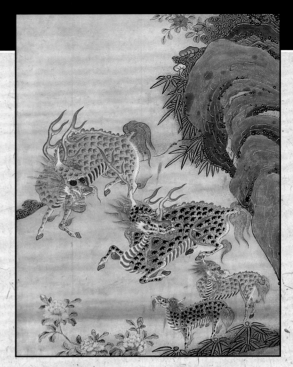

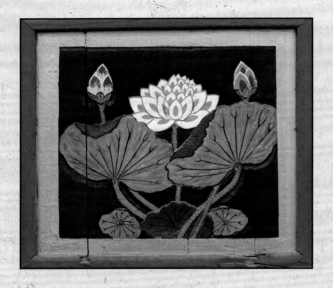

Lotus *Yeonkkot*

With associations in all of the Korean religious traditions, the lotus symbolizes one of the Daoist eight immortals with mystical powers, Buddhist purity and transcendence, and the Confucian ideal of an upright man of honor. All of these meanings reflect the enigmatic and seemingly miraculous way in which a lovely pristine flower slowly appears in the sunlight from black mud at the bottom of a pond. The prominent seeds of the lotus also symbolize fertility and the birth of many sons.

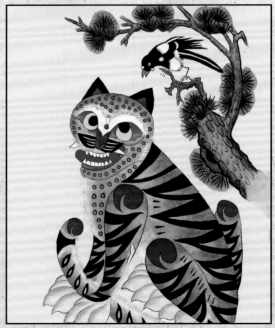

Magpie *Kkachi*

A very sociable bird that chooses to live in the company of human beings, the magpie is considered to be the messenger of the Daoist village spirit and the bearer of good tidings. This meaning is probably taken from the Chinese practice of picturing a magpie with a leopard. The word for leopard (豹) sounds like the word "to inform" in Chinese. Thus, the magpie became the messenger of joyous news. When pictured with a tiger (perhaps a Korean version of the original Chinese leopard) and a pine tree (the symbol for the first month of the lunar calendar), the magpie indicates that one will receive good news or have good fortune in the New Year. In the Joseon Dynasty, a political spin was placed on the popular tiger and magpie paintings, with the magpie representing the common people complaining mightily to a government official (the tiger) about the many injustices in their lives.

Mandarin Ducks *Wonang* & Wild Geese *Gireogi*

Both Mandarin ducks and wild geese have been used as symbols of faithfulness and love for one's husband or wife because of the fact that these birds tend to mate for life. In traditional Korean weddings, the groom presents a wooden duck or goose to his prospective mother-in-law the day before his wedding, promising his loyalty in marriage. In more affluent households, the wedding ducks or geese tended to be finely carved and beautifully painted with bright colors, while poorer families often used more primitive, unpainted ones. Interestingly, the plain wooden ducks develop a lovely patina with age and have become sought-after antiques. In another type of symbolism, paintings of geese and reeds suggest a peaceful life in old age.

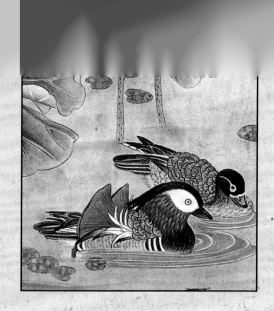

Mountains *San*

In earliest times, when animism shaped Korean thought, mountains were worshipped, especially if they had unique geological formations. Imbued with *yang* and believed to last forever, mountains became one of the most important of the Daoist longevity symbols. Five peaks ringing the Korean peninsula took on special significance: Geumgangsan in the east, Myohyangsan in the west, Jirisan in the south, Baekdusan in the north, and Samgaksan in the center. These are the five mountains represented in the Irworobongdo, a screen of sun, moon, and five peaks, which always stood behind the throne of the king in the Joseon Dynasty. Of these, Geumgangsan, the Diamond Mountain, along the east coast of Korea was believed to be the home of immortals, heavenly maidens, magical deer, the mushroom of immortality, and other ingredients needed to make the elixirs used in Daoism to achieve immortality. Also believed to be the home of the Buddha, the Diamond Mountain is still filled with temples and shrines built on the highest peaks.

Mushroom (Fungus) of Immortality *Yeongji*

An ancient Daoist symbol, the mythical mushroom signifies eternal youth and longevity. Believed to grow in the Land of the Immortals, the mushroom bestows immortality on anyone who eats it. Interestingly, *yeongji* and clouds are often painted or embroidered with the same swirling shape, indicating the essence of the primordial breath of life, *qi*.

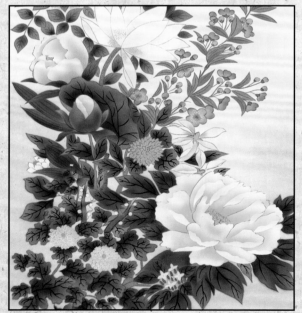

Orchid *Nan*

One of the Four Gentlemen Plants (Sagunja), the orchid was admired for its delicate fragrance and grace. As such, it came to symbolize the refined thinking of a Confucian scholar.

Peach & Peach of Immortality *Seondo*

An ancient symbol of longevity, the mythical peach of immortality (*seondo*) confers long life free from illness. Grown in the orchard at the palace of the Daoist Queen Mother of the West in the Kunlun Mountains of central Asia, the divine peach is usually shown as blue in color. The tree on which it grows takes 3000 years to bloom and another 3000 years to bear fruit. The fruit takes yet another 3000 years to ripen. When the peaches are ready to eat, the Queen holds a great banquet for the hungry immortals.

Ordinary peaches, which are peach colored rather than blue, connote many descendents, and a woman who dreams of one will give birth to a son.

Peony *Moran*

Considered by Koreans to be the queen of flowers, the peony symbolizes wealth, happiness, purity, love, and feminine beauty. One of the most frequently depicted flowers in paintings and embroidered pieces for all social classes, peonies on a screen are always used as the backdrop for the traditional wedding ceremony. Usually shown fully open and at very close range, several beautiful peony blooms surrounded by leaves are believed to be a harbinger of good fortune. In the Joseon Dynasty, the peony also came to symbolize the king and the bestowal of honors.

Persimmon *Gam*

Persimmons, commonly grown in Korea, retain a uniform color whether ripe or unripe, and so are considered a symbol of faithfulness. For that reason they were often selected as gifts to be given to superiors by loyal subordinates. The persimmon tree conveys the wish that all will be well.

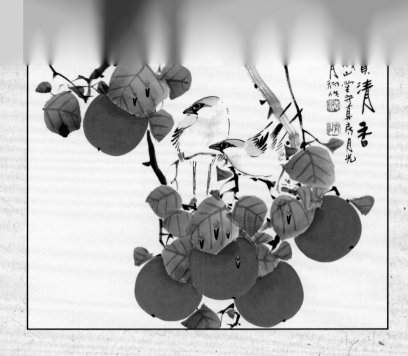

Phoenix *Bonghwang*

One of the mythical Daoist Spirit-Generals of the Five Directions (Obangsinjang), as well as one of the Four Animals of Good Luck (Saryeong), the phoenix appears only in peaceful, prosperous times and only when a virtuous ruler ascends the throne. Though the texts agree that the phoenix is large and elegant with five beautiful colors, they differ in other aspects of the creature's description. The phoenix is generally said to be a combination of various animals, with a chicken's head, a swallow's beak, a snake's neck, a dragon's scales, and a fish's tail. Like the animals from which it is created, it represents their qualities of loyalty, virtue, wisdom, abundance, military power, innocence, and longevity as well as their abilities to dispel darkness and bring the dawn, prevent disaster, and predict the future. It roosts only in the paulownia tree in the mystical Land of Immortality, and eats only bamboo shoots. Originally associated exclusively with royalty, the phoenix was embroidered in gold on the queen's garments. Today, it is still incorporated into the Korean Presidential Seal.

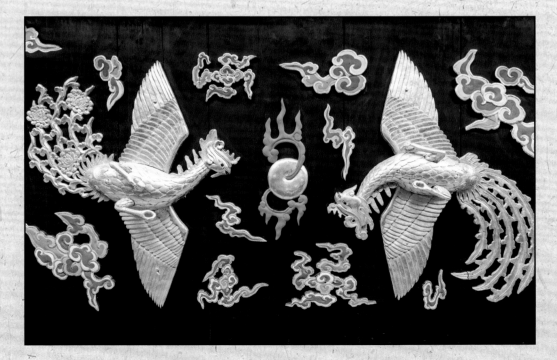

Pine Tree *Sonamu*

Like many Korean symbols, the pine tree has a long history and multiple meanings. In ancient times it was thought that the sun rose from a mulberry tree in the east and set on a pine tree in the west. A Daoist symbol of longevity, the pine was often depicted with immortals. Stories about the immortals had them climbing enormous pines to reach the sky, as well as eating pinecones and drinking the resin of 1000-year-old pine trees to achieve immortality. In Confucian thinking the gnarly appearance of the pine tree represented old age and, by extension, virtue. The evergreen pine's long life and ability to withstand wind and weather also symbolized the sound principles and fidelity of gentleman scholars. Because the pine tree also represents the first month in the lunar calendar, it was often depicted in talisman paintings pasted to the front doors and gates of Korean homes to ward off evil in the New Year.

Plum & Plum Blossom *Maehwa*

Representing fidelity, the plum is a symbol of appointment to or promotion within the civil service. The plum blossom (*maehwa*) is one of the Four Gentlemen Plants and has been much loved by Korean artists for centuries. Blooming at the end of winter, it is a symbol of the noble spirit overcoming all hardships.

Pomegranate *Seongnyu*

A favored subject for painters in Confucian times, the pomegranate tree was called the "tree of 100 sons" because the fruit produced many dozens of seeds. The seeds were also referred to as "countless gold coins in a bag," based on the shape of the fruit when it burst open to release the seeds. Often depicted in Confucian *chaekgado* screens (paintings of the scholar's study), pomegranates symbolized wealth, honor, and many sons. A painting of pomegranates was frequently placed so that a newly married woman would see it, thereby hastening the birth of a boy.

Rabbit *Tokki*

There are numerous instances of the rabbit's role as a protagonist in both Korean folklore and Buddhist tales. They are most often portrayed as being smart, quick-witted and clever, although sometimes rather frail. Since rabbits give birth to many offspring at one time, they are also a symbol of abundance and new beginnings. In the West, it is said there is a man in the moon. However, in most of Asia, including Korea, the moon's dark spots are said to resemble a rabbit pounding in a pestle. The moon rabbit, *daltokki*, uses this mortar and pestle to grind the Elixir of Immortality, and in the case of Korean children's tales, rice cakes as well.

Rocks *Bawi*

Rocks, a very popular image in Korean paintings, represent and carry the same symbolism as mountains and are one of the Ten Symbols of Longevity. When painted or included in an embroidered piece, they were often depicted in quasi-human or animal form, tiger rocks being especially common. In the longstanding East Asian tradition of viewing stones, a rock with an interesting shape is polished and placed on a wooden stand carved to fit its contours. Placed in the scholar's study or the garden, the stone becomes an object of contemplation and inspiration.

Rooster *Dak*

One of the four Daoist animals that protected the household, the crowing rooster at dawn was believed to drive away spirits that wandered about during the night. Pictures of the rooster were pasted to the gates and doors of the house to repel evil. The cock's crow also came to stand for the announcement of a bright future, a distinguished career, and, by extension, fame. Two roosters facing each other symbolized the hope of obtaining a government position. A rooster among chickens signified dignity, while a cock with a hen and chicks (or hen and chicks pictured alone) symbolized a happy family life.

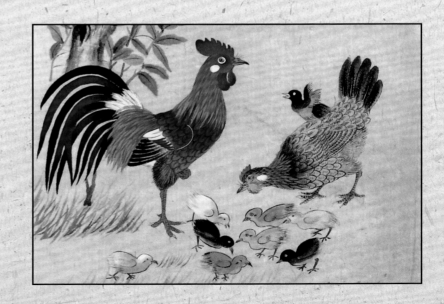

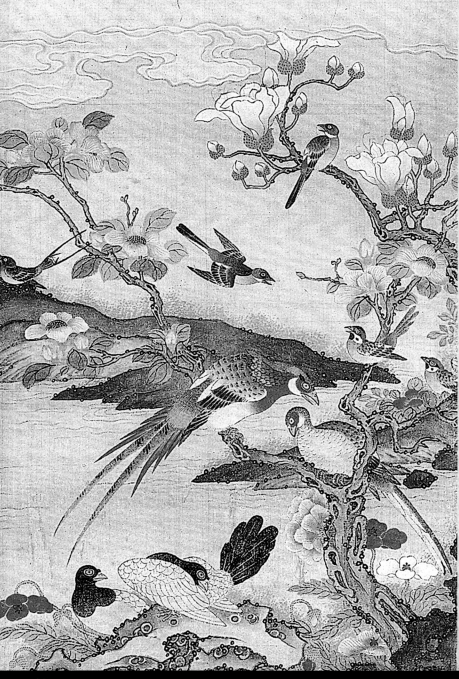

Sparrow *Chamsae*

Common in Korea, sparrows signify pleasure and delight and are believed to bring happiness. Usually shown in groups, sparrows are charming additions to *hwajodo* (paintings of birds and flowers), the most common type of Korean folk painting.

Sun *Hae*

Originating in ancient animistic thinking, the sun was worshipped as life giving and all powerful. In Daoist philosophy, the sun is *yang*, symbolizing generative power and, by extension, longevity. It is one of the most important of the Ten Symbols of Longevity. It also came to stand for the king, and perhaps the most spectacular example of this symbolism is seen in the Irworobongdo, a screen of sun, moon, and five peaks, which stood behind the king's throne in the Joseon Dynasty.

Swallow *Jebi*

A graceful bird that prefers to nest close to people's homes, the swallow is a Daoist symbol for delight and pleasure, as well as an omen of success and prosperity. Often seen in embroidery, swallows with their distinctive long forked tails are also the inspiration for the V-shaped metal fittings on Korean chests.

Three-Headed Hawk

A mythical creature commonly used in talisman paintings attached to the main doorway of the house, a three-headed hawk has the power to protect from wind, fire and flood (the three disasters). The hawk is also able to bring three years' worth of good fortune.

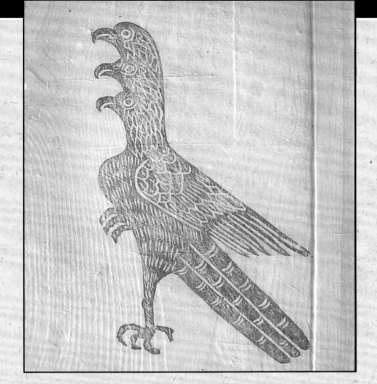

Three-Legged Crow *Samjogo*

A very old Daoist symbol, the black, three-legged crow is often pictured against a red circle and represents the sun. Its origins can be traced back to the East Asian tradition of sun worship, and it can be found in many mythologies from that region, as well as those from Asia Minor and North Africa.

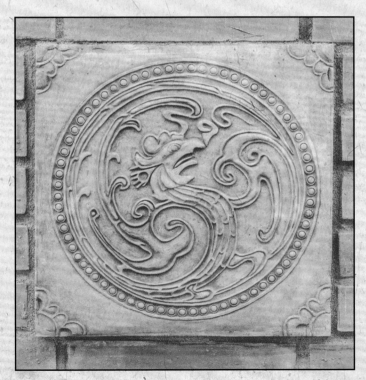

During the Goguryeo Dynasty, *Samjogo* was considered a symbol of great power, thought to be even more powerful than both the dragon and the phoenix. It remains a symbol of the Goguryeo Dynasty and was one of several emblems considered as a replacement for the phoenix when the Korean seal of state was revised in 2008. However, although *Samjogo* appears today in Korean historical television dramas, it is seldom pictured in folk art and handicrafts.

Tiger *Horangi*

The tiger has held a central spot in the hearts and minds of the Korean people for centuries. Powerful and beloved symbolic protectors, the tiger has been portrayed in a number of different ways in Korean folk art and handicrafts. With the ability to protect from the three disasters (fire, flood and wind) as well as the three agonies (war, pestilence and famine), the tiger is among the most important of the Korean guardian figures. Its picture was traditionally hung on the main door of the house on the first day of the New Year to bring good luck and banish evil spirits. The tiger was also believed to be the messenger of *sansin*, the mountain spirit. When pictured with a magpie, the pair symbolizes the arrival of good news.

Loved as a folk figure and appearing in many traditional stories, the tiger was portrayed as a somewhat comical and bumbling animal, with a goofy, smiling face. In the stories, people sometimes share their daily lives with tigers as with other ordinary human neighbors, and they talk with tigers as they would talk to their friends or relatives. Korean children grow up listening to these funny stories, often told by their grandparents, and so they learn to love *horangi*.

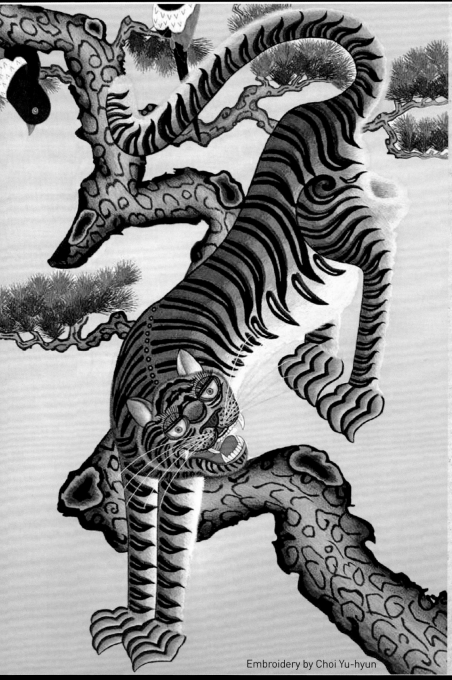

Embroidery by Choi Yu-hyun

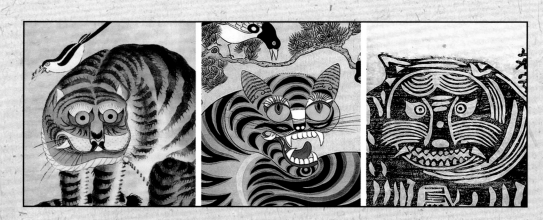

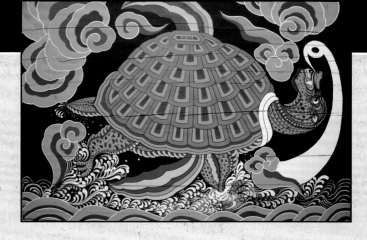

Tortoise *Geobuk*

Naturally long-lived, the tortoise is one of the oldest and most revered Korean symbols. One of The Spirit-Generals of the Five Directions (Obangsinjang), as well as one of the Ten Symbols of Longevity (Sipjangsaeng), the mythical black tortoise of the north lived for 1000 years. Also included as one of the Four Animals of Good Luck (Saryeong), the tortoise is a favorite symbol appearing in folk painting and handicrafts.

Taegeuk

Originating in Daoist philosophy, one of the most important principles in Eastern thought is the notion of *yin* and *yang*, called *eumyang* in Korean. Daoism conceives of a basic unity underlying the elements, functions, and values of the universe. *Yin* and *yang* are the dual form in which *qi*, the force responsible for creation, expresses itself. Opposite yet interdependent forces, *yin* and *yang* operate together eternally in a circular fashion to create perfect balance and harmony and propel the course of natural and human affairs. *Yang* is positive, male, light, heaven, sun, left. *Yin* is negative, female, dark, earth, moon, right. Neither is more important than the other; together they create wholeness.

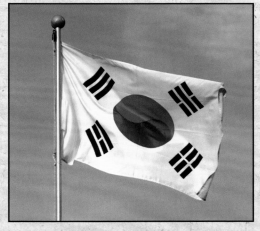

The concept of *yin* and *yang* is depicted by a circle called *taegeuk*. It is comprised of two nesting comma shapes, the topmost one red (*yang*) and the bottom one blue (*yin*). Dating back to the 7th century, this design was used as a symbol to drive away evil spirits in the Goguryeo and Silla kingdoms. Today, the *taegeuk* symbol forms the center design of the South Korean flag (Taegeukgi), prompting the frequently heard comment that Koreans may have the most philosophical flag of any nation on earth. Placed on a white field and surrounded by sets of black trigrams in each corner, the *taegeuk* symbolizes the ultimate reality. The white field represents the peace-loving spirit of the Korean nation, while the trigrams, taken from the Chinese *Book of Changes* (*I Ching*), indicate the balance of opposite forces and represent peace, unity, creativity, and light.

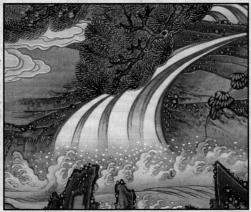

Water *Mul*

Another ancient Daoist symbol, water in the form of rivers, waterfalls, and waves is one of the Ten Symbols of Longevity and represents eternal life. Often used to beautiful compositional effect in paintings and embroidered pieces, waves and falling water lend a lyrical grace to these works of art.

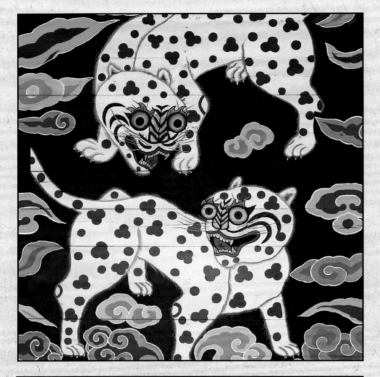

Some Korean symbols belong to well-known groupings. Although these symbols also appear in handicrafts singly, it is helpful to know the symbolic meaning of the larger groups when they are encountered.

The Spirit-Generals of the Five Directions Obangsinjang

In Asian cosmology, there are five directions—east, west, south, north, and center—that are also represented by different colors and are linked to the seasons of the year. Among the most powerful of the protector spirits, the Spirit-Generals of the Five Directions (Obangsinjang) defend against evil coming from all directions throughout the year. The Blue Dragon of the East, General Cheongje, is associated with spring and "beginnings." The White Tiger of the West, General Baekje, represents autumn and the harvest. The Red Bird (phoenix or *bonghwang*) of the South, General Jeokje, connotes summer and agriculture, and the Black Tortoise of the North, General Hyeonje, usually shown entwined with a serpent, is linked to winter or darkness. General Hwangje, depicted as a Yellow Dragon, is the protector of the Center (earth), the direction that

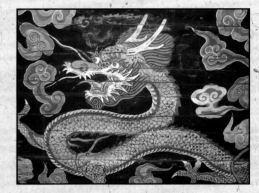

anchors the other cardinal directions. Derived from very ancient Chinese Daoist guardian spirits, these mythical generals are also modeled after constellations of stars in the sky. Traditionally they have figured importantly in the art of geomancy in Korea, the process of choosing auspicious sites for homes, other buildings, and gravesites that are in harmony with the forces of nature.

The Four Animals of Good Luck Saryeong

Saryeong includes four animals that bring good fortune: the dragon, the phoenix, the tortoise (not entwined with a serpent), and the *girin*. With three animals common to Saryeong and Obangsinjang, it is easy to confuse them. However, the functions of the sets are different and, while the guardians of Obangsinjang were seldom pictured in Korean art and handicrafts, the good luck symbols of Saryeong were very popular motifs during the Joseon Dynasty.

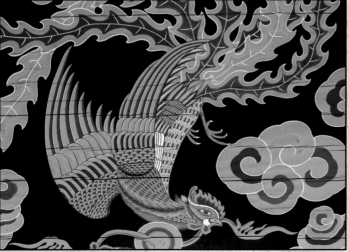

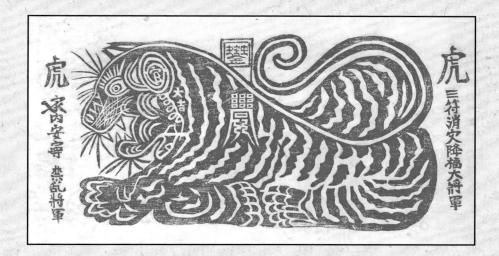

The Four Animals & Talisman Pictures

A third set of four symbolic animals consists of the tiger, the rooster, the dog, and the *haetae*. These four traditionally had the very specific job of protecting the home against evil spirits. They were most commonly painted or block printed on paper in red ink, preferably made from cinnabar, an expensive ingredient that had to be purchased from Buddhist monks, shamanist *mudang* (shamans) or fortune tellers.

These talismans were mounted on various parts of the house to provide protection. At the New Year a tiger was attached to the main gate, a dog was attached to the storeroom door, a rooster adorned the middle gate, and the *haetae* was mounted in the kitchen (for he also protected against fire). Other pictures were displayed on chests containing valuables, on the ceiling, and on posts of the house. Sometimes family members also carried them in their pockets. Symbols other than the four animals were also used as talismans. The dragon and the three-headed hawk repelled evil, while the sun, moon, stars, pomegranates, dragon, phoenix, tortoise, rabbit, and *girin* invited good fortune into the home.

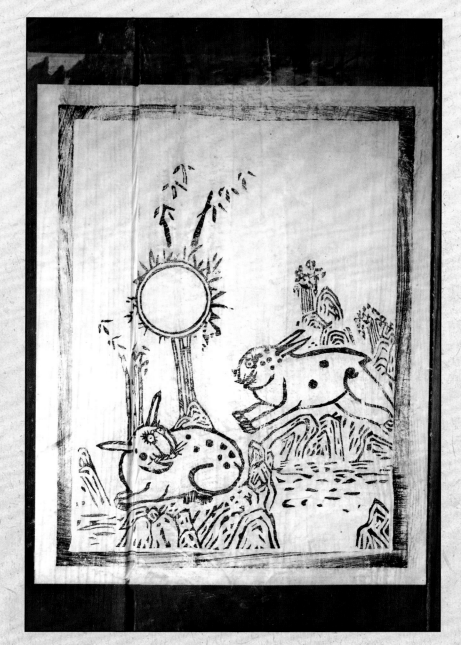

The Four Gentlemen Plants *Sagunja*

A *gunja* is a learned man of noble character, the ideal of Confucian philosophy in the Goryeo and Joseon Dynasties. In their quest to become superior Confucian men, upper class *yangban* (wealthy, landed gentlemen) devoted themselves to the learned arts, including reading, writing poetry, playing musical instruments, and painting. Their "literati" paintings, modeled after a similar Chinese tradition, consisted of monochrome brush paintings on *hanji* (traditional Korean handmade paper) of natural themes such as landscapes, plants, and flowers.

Favored subjects for literati paintings were the Four Gentlemen Plants, also called the Four Gracious Plants: chrysanthemum, plum blossom, grass orchid, and bamboo. These plants represented the attributes to which those who painted them aspired. The chrysanthemum and plum, able to bloom very early and very late in the season, provided models of the wisdom that scholars could contribute at various times of life. The graceful, softly fragrant orchid stood for refined thinking, while the straight, evergreen bamboo symbolized integrity and principle.

The Four Gentlemen Plants, clockwise from top left: chrysanthemum, plum blossom, grass orchid, and bamboo.

The Ten Symbols of Longevity *Sipjangsaeng*

Daoist in origin, the ten most important Korean symbols of longevity are mountains, rocks, water, clouds, pine trees, the mushroom of immortality, tortoise, deer, cranes, and the sun. All represent the wish for a long life, free from disease, spent in perfect harmony with nature. When pictured together on glorious screens, the ten symbols are called Sipjangsaeng. Bamboo and the peach of immortality sometimes also appear in Sipjangsaeng screens, bringing the total number of symbols to twelve.

In Chinese art, the mystical Land of Immortality is usually pictured with human figures, the immortals. However, in the Korean tradition, Sipjangsaeng portray a land without human figures, where plant, animal, geological, and celestial symbols combine to symbolize not the afterlife, but the wish to live a long and healthy life in close and wise harmony with and in the natural world.

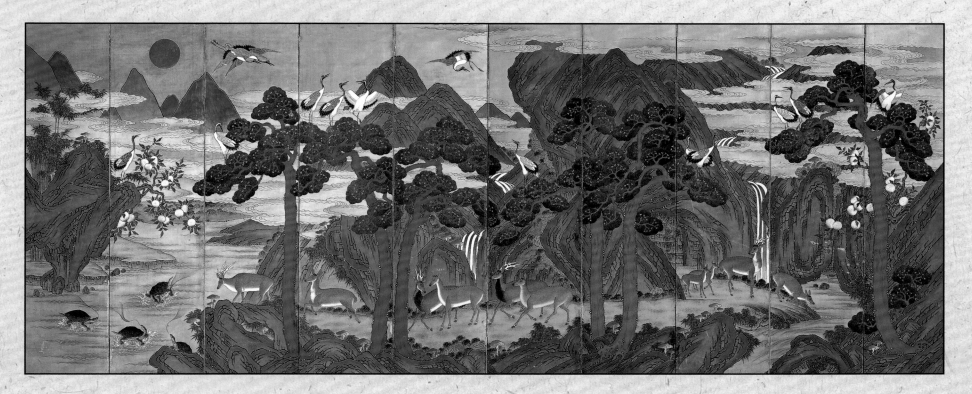

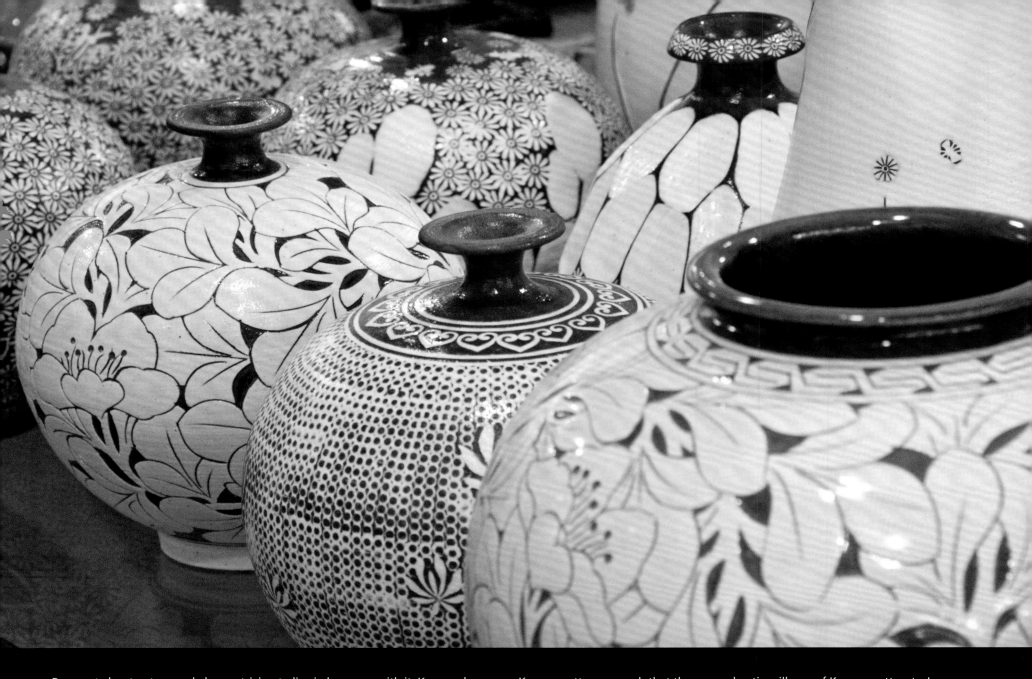

Reverent about nature and always striving to live in harmony with it, Koreans have used earth as a building material to fashion walls, tiles, and vessels. Korean pottery, known to have existed since at least 8000 BC, is universally considered to be some of the finest in the world. *Cheongja,* or celadon, was perfected there in the 12th century AD, and was considered by the Chinese to be one of the "twelve best things in the

Korean pottery so much that they moved entire villages of Korean potters to Japan to work for the Emperor, thereby profoundly influencing Japanese ceramics to this day. Today, Korea remains a world leader in the ceramic arts, with contemporary potters continuing to both produce traditional pottery and to create new forms that expand upon their distinguished heritage.

Chapter 3

Ceramics & Clay

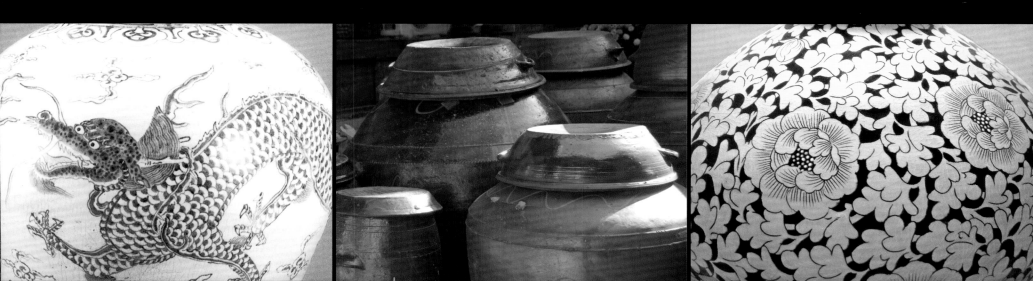

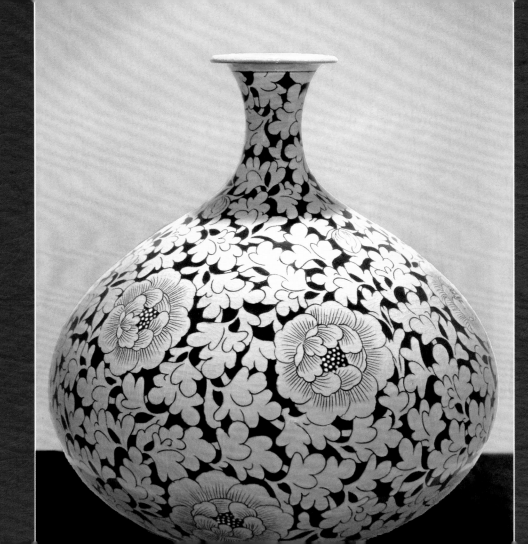

cheongja is the well known Korean porcelain pottery known as celadon. Originally brought to Korea from China during the Unified Silla period, celadon was refined by Korean potters over several hundred years, especially in kilns in the southern and eastern parts of the country, reaching its zenith in the mid-12th century in the Goryeo Dynasty. During this time, innovations in technique, pattern, and form resulted in a distinctively Korean art form that is considered by many to be Korea's greatest artistic achievement.

Unlike Chinese celadon glazes, which were thick and created a heavy, majestic effect, Korean potters developed unique glazes which were thin and translucent, faintly revealing the clay surface of the pot and resembling "the blue of the sky after the rain." Visiting envoys from China, who considered Korean celadon "first under heaven" and one of the "twelve best things in the world," carried many of these treasures home with them. There was much for these envoys to choose from since, during its height of popularity in the Goryeo Dynasty, celadon was used for tableware (bowls, cups, small dishes, wine pots, and bottles), as well as items for the writer's desk (brush holders, water droppers, and flower vases). Other celadon pieces included incense burners and water sprinklers (*yeonjeok*) used in Buddhist ceremonies, tiles used on roofs and floors, cosmetic boxes, oil

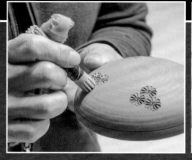
A pattern is stamped into the clay.

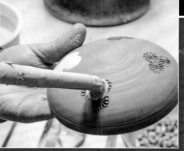
Slip in a contrasting color is applied to the stamped pattern.

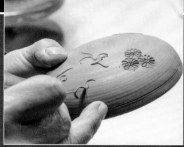
After drying, the slip is scraped away so it remains only in the pattern.

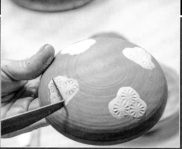
A design may also be carved by hand into the clay and filled with slip.

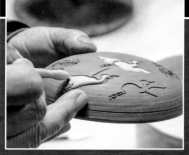
Or the slip may be applied on top of the design for a raised effect.

In its early phases, Korean celadon was decorated with subdued incising of patterns, by stamping and by molding. Later, potters developed a unique decorative technique known as *sanggam* that consisted of carving patterns on the surface of the unfired clay vessel. These patterns were filled with white or reddish slip (clay dissolved in water) before the vessel was fired for the first time. Following the first firing, the piece was glazed with celadon glaze and fired again in a very hot kiln. The result was a lovely inlaid pattern under the glaze that often included multiple colors on a single piece. Flowers, animals, and geometric patterns were most commonly used to decorate these pieces.

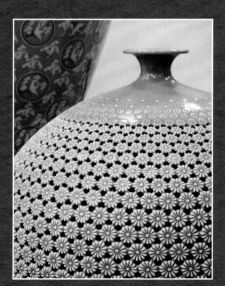

Flying cranes, clouds, and peonies were very popular themes. This technique died out, however, with the coming of the Joseon Dynasty and its austere Confucian philosophy. Today, however, the *sanggam* technique has been revived by Korea's highly skilled contemporary ceramic artists who are creating celadon pieces in myriad forms and in varying shades, from very pale to very dark green. Celadon is readily found in shops and markets throughout Korea, with pieces signed by the most famous potters commanding prices of many thousands of dollars.

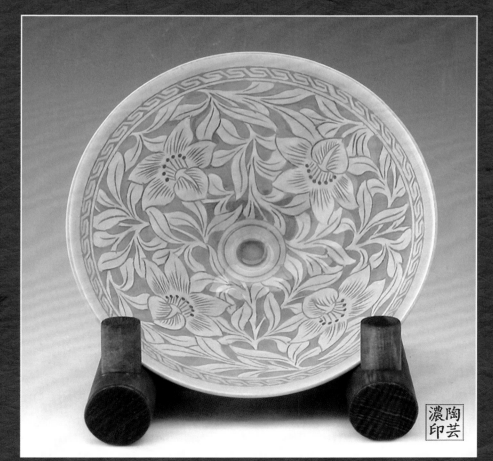

Stoneware *Buncheongsagi* 분청사기

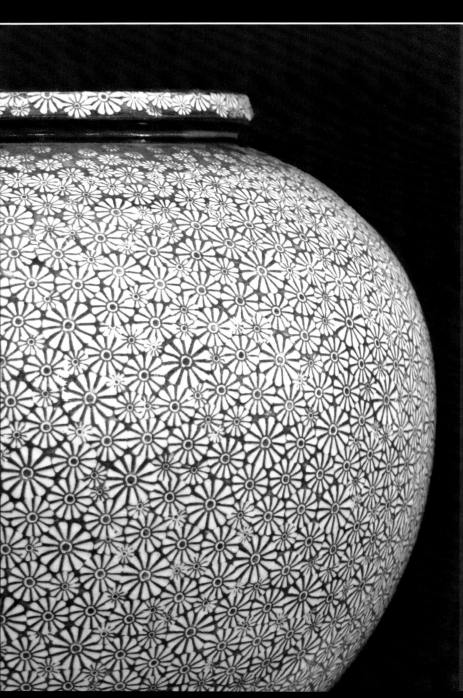

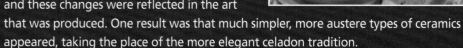

When the Joseon Dynasty was established in Korea in 1392 AD, Confucianism, an ethical system that promoted personal integrity and social harmony, was introduced by the new regime. This profoundly shaped and altered the behavior and aesthetics of the Korean people, and these changes were reflected in the art that was produced. One result was that much simpler, more austere types of ceramics appeared, taking the place of the more elegant celadon tradition.

Serving as the link between celadon and the forms that followed, *buncheong* is a type of stoneware pottery decorated with a white layer of painted slip (liquid clay). It was the most common type of pottery produced during the 15th century. Made for everyday use and for the common people, *buncheongsagi* pieces were robust and unpretentious but had a lively and sometimes humorous spontaneity about them.

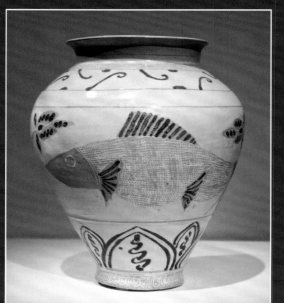

Surfaces were often incised or stamped with imaginative designs and images and then painted with white slip. When the slip was wiped off, the recessed decoration was highlighted. Or the surface could be painted with an iron oxide underglaze. This type of pottery was widely admired by the Japanese because of its unaffected simplicity and its motifs taken from nature.

Left: Contemporary *buncheong* jar decorated with stamping and slip technique
Right: 15th c. *buncheong* jar, inlaid, stamped, and painted with an iron oxide underglaze

White Porcelain *Baekja* 백자

In the 16th and 17th centuries, yet another form of Korean pottery developed. Taking its name from its white color, *baekja* was porcelain pottery made in strictly regulated government kilns near the city of Kwangu for the royal family and the aristocracy. Also reflecting the Confucian values of the Joseon Dynasty, *baekja* embodied the dignity, simplicity, self-restraint, and pride of Confucian gentleman scholars. Sometimes left undecorated, white porcelain vessels were simply shaped and unpretentious, with graceful proportions and curves. Imperfections were tolerated and even valued as proof of the vessel's "pure" nature. The glazes that were used ranged in color from pale bluish-white to yellowish-white to pure white. White porcelain was seldom carved but was often painted with underglaze designs in cobalt blue or dark ferrous brown. The simple motifs included flowers, compositions from nature, and calligraphic brushstrokes. Korean white porcelain was especially appreciated by the Japanese nobility and influenced the way in which tea bowls came to be made by Japanese potters. Many of these bowls were so valuable and highly prized that they were given individual names.

Korea is a land rich in many types of clay and minerals, helping to explain its centuries-long tradition of ceramic excellence. Korean potters are still known

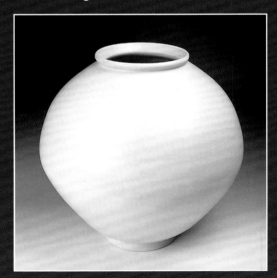

today as among the finest in the world, continuing all three traditions of Korean pottery —*cheongja, buncheongsagi,* and *baekja* —as well as creating new forms. The kilns of the country are alive and well, and shops and markets are full of beautiful ceramics for all to use, collect, and enjoy.

One of the most striking examples of *baekja* is the "Full Moon Jar," completely unadorned and as round and beautiful as its namesake.

18th c. Joseon Dynasty jar with dragon and cloud cobalt underpainting

Earthenware Pots *Onggi* 옹기

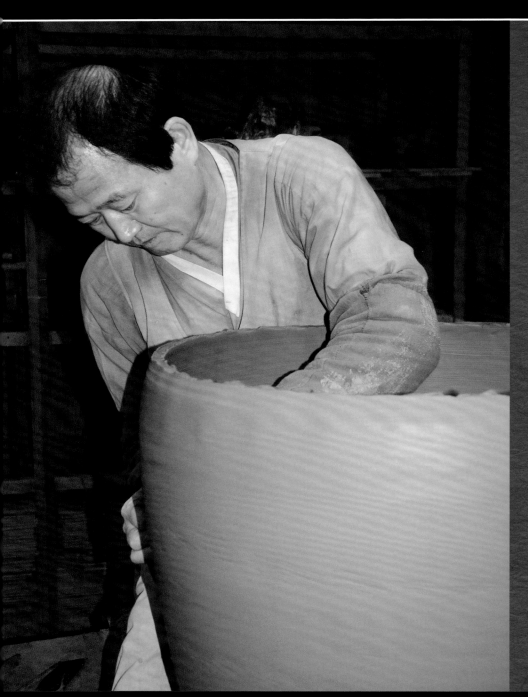

What would Korea be without soy sauce and kimchi? And how would these essential foods be made without the most basic of Korean pottery—*onggi*, also called *dok*? These very utilitarian earthenware pots, which vary in size from soup bowls to enormous cisterns, have been used by Korean families for thousands of years. The substantial dark brown or black pots were traditionally used to both prepare and store many types of foods, including water, soy sauce, soy bean paste, salted fish, rice, grain, wine, and *kimchi*. The shape, size, and specific names of *onggi* varied depending on the region in which they were made and the purpose they served.

Made of local clay, the pots were traditionally formed on a potter's wheel by combining lengths of rolled clay or coils and then smoothing them until the pot was of the desired size and shape, after which it was thoroughly dried in the shade. The pots were either left unglazed or covered with a natural glaze of gray loam and ash, which gave them a glossy, hard finish. They were often decorated with simple designs traced by the potter's fingers in the glaze before it dried.

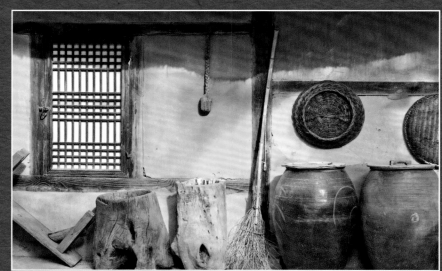

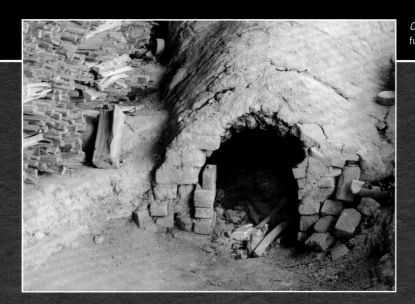

Onggi were fired in a wood-burning kiln, stoked until it was as hot as a smelting furnace. This firing process took almost a week from start to finish.

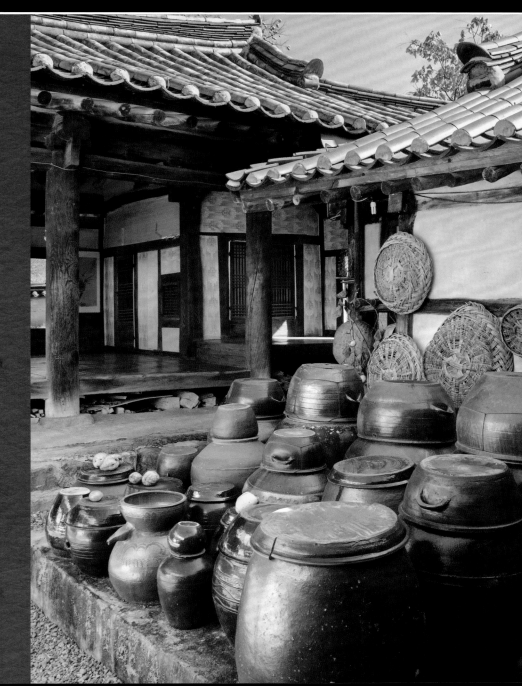

Because of the way they were made, *onggi* "breathed," allowing air through the pores, facilitating the fermentation of the important condiments inside. Housewives fine-tuned this fermentation by carefully monitoring the pots, removing and replacing the lids depending on the weather. To help control temperature, the pots were placed in a sunny, protected area behind the house near the kitchen, sometimes on a specially constructed "sauce jar" terrace called a *jangdokdae*. In wintertime, they were often buried in the ground or placed under a straw-covered A-frame called a *kimchigak* or kimchi shed.

Although collections of *onggi* can still be seen in Korea, even on apartment building roofs in Seoul, they have been replaced in many homes today by plastic, glass, and metal containers. Entire villages long devoted to making *onggi* have disappeared, and only a few artisans remain who continue crafting these very special pots. Koreans, however, are very sentimental about *onggi*, even if they no longer use them as commonly as before. The traditional condiment bay near the kitchen, with its collection of sturdy jars slowly brewing the basic ingredients for the family's sustenance, was an intimate, peaceful, and comforting place—the essence of home.

Ceramic roof tiles (*giwa*) were introduced into Korea from China in the first century BC. During the next 1000 years, in the Silla and Unified Silla periods, roof tiles developed into a magnificent art form. Used to cover the roofs of palaces, houses of the wealthy, and other important religious and public buildings, tiles protected the wooden buildings themselves and those living and working in them from the wear and tear of wind, rain and temperature. But they did more than that. They enhanced the sense of dignity and elegance of traditional Korean architecture. According to ancient beliefs, the foundation of the house represented earth and the roof represented heaven. On the roof, selected tiles were made in the form of auspicious symbols that were believed to ward off evil spirits and protect the buildings from harm, especially from fire.

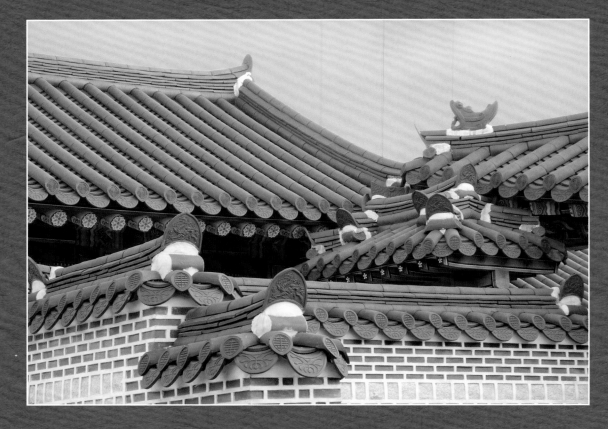

Traditionally, roof tiles were crafted by hand and were so well made that they were impervious to weather and seldom cracked. The perfect clay for tile making came from rice paddies. Collected and stored in the fall, the clay was brought out in the spring and thoroughly kneaded to eliminate all air and impurities, a laborious and time-consuming process. Shaped in wooden molds, the tiles were dried in the sun and then fired in a kiln so that all traces of moisture were removed. Although most tiles were not glazed, some of the most elegant were actually made of porcelain clay with beautiful celadon glazes. Two types of tiles were made to cover the roof corresponding to the principles of *yin* and *yang* —convex (male) and concave (female). Tiles were made in various sizes; some found from the Unified Silla period measured over two feet in length and weighed almost 42 pounds each.

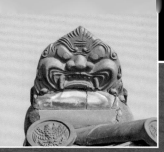

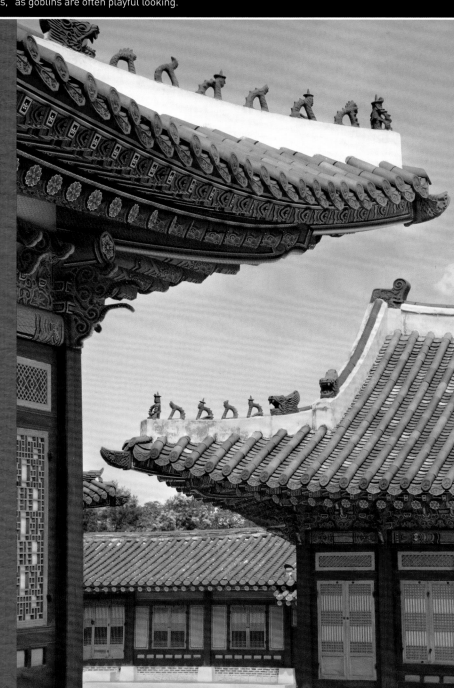

Decorative tiles were of several types. Rectangular tiles depicting dragon or monster (*dokkaebi*) faces were placed facing in each of the four cardinal directions (north, east, south, and west) on top of the roof. Roof-end tiles covered the eaves and protected the exposed wood from the weather. The most popular designs for these tiles were lotus flowers in full bloom, arabesque designs, clouds, goblin faces, and even some human faces.

The most important tile-roofed buildings also had other guardian figures placed on the roof to ward off evil spirits. The main roof ridge of a palace often ended with a replica of a dragon's head (*yongdu*), an eagle's head (*chwidu*) and an owl's tail (*chimi*). An odd-numbered set of decorative figures, usually ranging from 3 to 11, called *japsang* were lined up along the hips and vertical ridges of the roof. The lead figure was usually a Daoist immortal, sometimes on a horse, followed by various animals, such as a dragon, lion, phoenix, flying horse, monkey, giraffe, or even sea horse. As with roof tiles, *japsang* were believed to protect the building by warding off evil spirits. Taken from Chinese architecture, *japsang* in Korea took on their own unique forms and charm, embellishing royal palaces and the homes of the aristocracy with their whimsical, but reassuringly protective, presence.

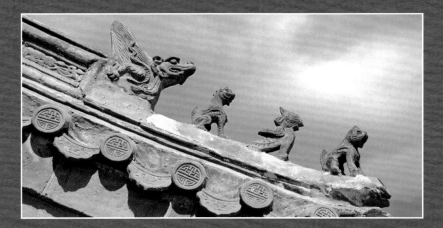

Walls and Chimneys Dam 담 & Guldduk 굴뚝

Korean homes, palaces, and even cities have traditionally been surrounded by walls. Some walls, like the one built to encircle the new capital (present day Seoul) when the Joseon Dynasty was established in 1392, were meant to protect. That wall had four massive primary gates, one facing in each of the four directions, and four secondary gates. Although much of the wall was torn down by the Japanese during their occupation of Korea in the 20th century, small segments of it, as well as three of the gates, still stand today.

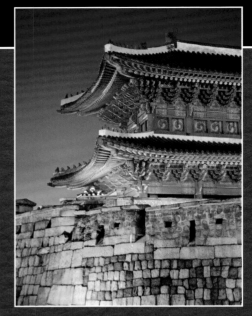

Dongdaemun, or "East Gate," is one of three of the original eight gates that were part of the Seoul Fortress Wall that survive today.

Other walls, especially those surrounding homes, helped to create and express the sense of family that is so deeply rooted in the Korean heart and mind. The Korean word *uri*, meaning "we" or "us," is believed to come from the word for the wall around a house, *ultari*. These walls have been characterized as friendly, as they have no locked gates and welcome family, neighbors, and friends to gather together within.

In country villages and on farms, walls were typically made of stacked stones, logs, or planks. Clay walls, consisting of a mixture of clay, straw, lime, and pebbles, were also common. Occasionally roof tiles were imbedded in the clay mixture to strengthen the wall and create patterns. Shrubs were also commonly planted around the house to provide a living wall or screen. Frequently, country walls were topped with thatched and braided straw to protect them from the weather, giving the impression that they were wearing hats.

Brick and square stones were used for walls surrounding middle- and upper-class homes and palaces. These walls were designed to include lovely decorative patterns and many auspicious symbols, often incorporating elaborate motifs of flowers, plants, and animals set into plaster. Topped with roof tiles, they had an elegant, finished look that was in harmony with the buildings they surrounded.

The beautiful wall surrounding Jagyeongjeon, the king's mother's residence, at Gyeongbokgung Palace in Seoul

A chimney incorporated into Amisan Garden of Gyeongbokgung Palace

Brick chimneys were built on the ground to carry cooking and heating smoke away from the house. Often quite large, they too were decorated and turned into works of art.

The symbols commonly used to decorate both walls and chimneys conveyed wishes for longevity, good fortune, wealth, happiness, and fertility. Brickwork in geometric designs, including lightning, tortoiseshell patterns, zigzags, octagons, and the Buddhist swastika—some of the oldest symbols in Korean art—was often combined with other symbols to create walls and chimneys of breathtaking beauty. With such a multitude of symbolic elements to choose from, no two walls or chimneys were alike. Together they constitute one of the most charming aspects of traditional Korean architecture, instilling buildings and their grounds with an elegant, lively, and very personal appeal.

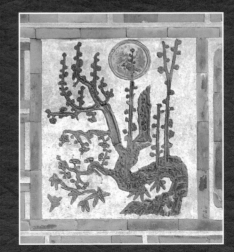

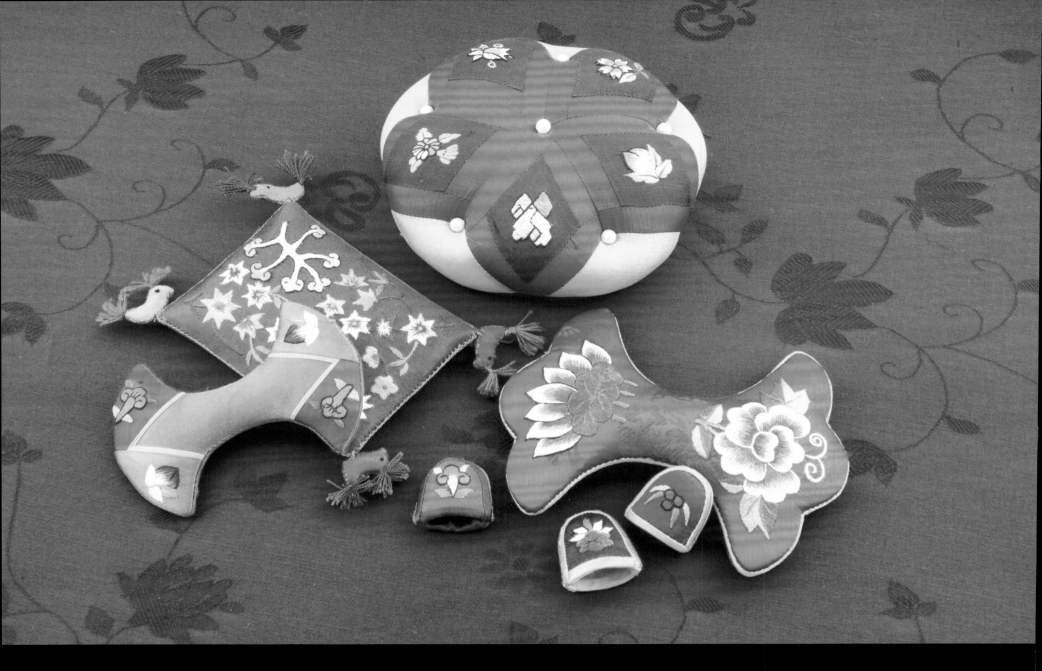

Bone needles dating from 3000 BC indicate that the needlework tradition in Korea is a very long and ancient one. Almost exclusively the work of women, the provision of clothing for all seasons and all occasions, the weaving and embellishing of linens and other household necessities, the construction of wrapping cloths, and the intricate knotting and embroidering of personal ornaments have consumed much of the time of Korean women throughout history. At the same time, these necessary labors have given rise to some of the most beautiful and unique of Korean craft traditions. The quality of workmanship, the creativity, the infusion of auspicious symbolism, and the joyful use of color that characterize Korean needlework are some of the great treasures of Korean culture.

Chapter 1

Fiber Arts

Thimbles *Golmu* 골무

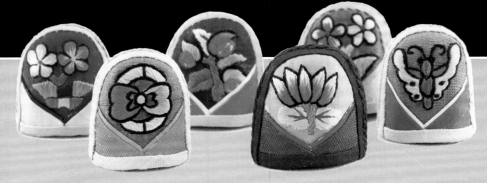

One hundred thimbles in a box will bring blessed longevity. So promises an old Korean saying, reflecting the significance and power of this tiny item in a woman's sewing box (*banjitgori*). Self-made and tailored to the woman's own finger, the thimble (*golmu*) was shaped from two small pieces of cloth or leather cut to the proper size and shape. Padded with layers of cotton or paper to make them stiff and impenetrable, the pieces were covered with brightly colored and often embroidered silk before being sewn together.

No two alike, thimbles were charming examples of Korean traditional handicraft that came to be a favorite of collectors.

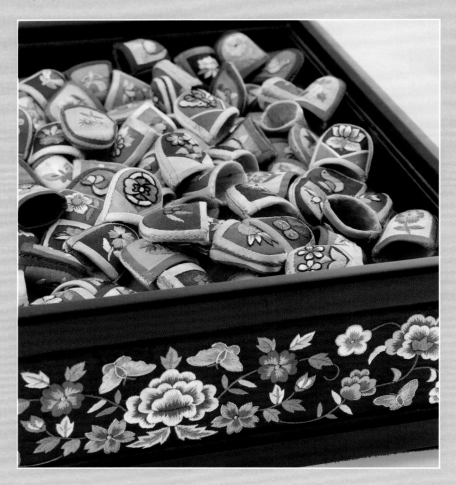

Korean women have a long and distinguished tradition of needlecraft that includes embroidery, quilting, and the making of clothing, linens, and wrapping cloths for the family. In the Joseon Dynasty, women were confined to the women's quarters when they weren't working in the fields, and they spent much of their time with needle, thread, and thimble, piecing and embellishing fabric. The *banjitgori* was a treasured possession, acquired before marriage and used to make the gifts that would be given to the future groom's family. After marriage, it accompanied the young woman to her in-laws' home, where she spent the rest of her life in its company.

In ancient times, the sewing box was woven of humble bark strips or paper cords but later was made of layered paper. Lids were added, and the boxes were often decorated with colorful patchwork designs. Some wealthy women had boxes made of inlaid mother-of-pearl or embroidered silk, incorporating symbols of longevity and fertility. Regardless of the box's elegance, its contents and purpose were the same.

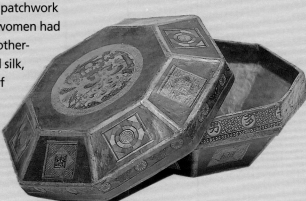

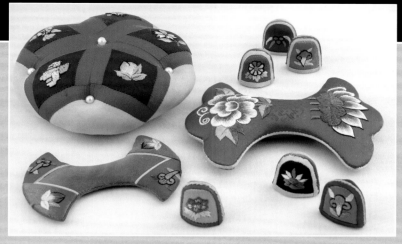

Today's sewing tools are often made of colorfully embroidered silk.

Today sewing boxes have been made nearly obsolete by ready-made clothing that is often discarded when it is outgrown or becomes worn. Sadly, *golmu* and her friends no longer live a long and useful life together in a beautiful box as they did for much of Korean history. But, collected and admired for their beauty and creative potential, one hundred thimbles will surely still bring blessed longevity.

Along with thimbles, needles were an essential tool in the sewing box. Shorter and weaker than modern needles, they were kept in a needle bag for protection. Filled with human hair that was believed to absorb moisture and keep the needles from rusting, the bags varied in size but, like thimbles, were often embroidered. Travelers of both sexes carried a needle bag and thread with them in case they needed to make repairs to clothing en route. Thread was wrapped on rectangular or round spools made of wood or paper and often carved or decorated. Itself a symbol of longevity, thread was never wasted and was reused whenever possible. Sewing scissors were large and long and made of iron. A ruler, made of two bamboo strips that were hinged together and notched to indicate standard intervals of approximately one inch, was also included in the *banjitgori*, as were two long-handled irons, a round one to smooth the fabric and a small pointed one for reaching into the tightest of places.

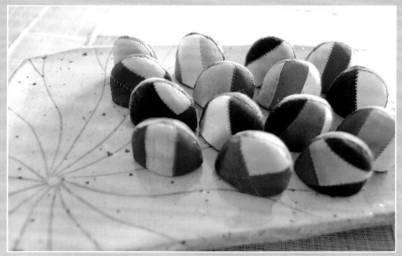

Beautiful contemporary thimbles by Youngmin Lee

Jasu, or embroidery, is a highly valued art form in Korea with an ancient history. It is believed that it was practiced as long as 8000 years ago, with the use of stone and bone needles. Although real examples of embroidery from ancient times have not survived, its early existence is inferred from old wall paintings and historical texts. According to one account from the Three Kingdoms Period, "On an auspicious day in early May, officials held their morning meeting. They wore purple clothes with wide sleeves over blue pants. Their hats were decorated with flowers and birds embroidered in gold."

As embroidery continued to be practiced throughout Korean history, it changed to adapt to the times. For example, themes of nature were widely used early on. But later, when Buddhism became the official state religion, Buddhist symbols were also incorporated into designs, and pieces such as surplices and altar covers were made by Buddhist monks for their temples.

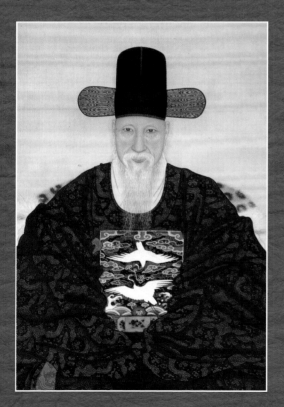

As the wealth of the upper class increased during subsequent historical periods, embroidery also became a way of signifying rank and status. During the Goryeo Dynasty aristocrats became so infatuated with their increasingly lavish lifestyle that the royal court was forced to repeatedly prohibit them from wearing embroidered dragon or phoenix designs (symbolizing the king and queen) or gold leaf on their clothing. In 1454, King Danjong of the Joseon Dynasty established a formal dress code that required officials to wear embroidered insignia on the front and back of their clothing. The royal family wore round insignia embroidered with mythical beasts believed to have divine powers. Civil officials wore depictions of birds, while those in the military wore images of beasts. Finally, the crane was adopted as the single official emblem of civil servants, while the tiger became the emblem for military officers.

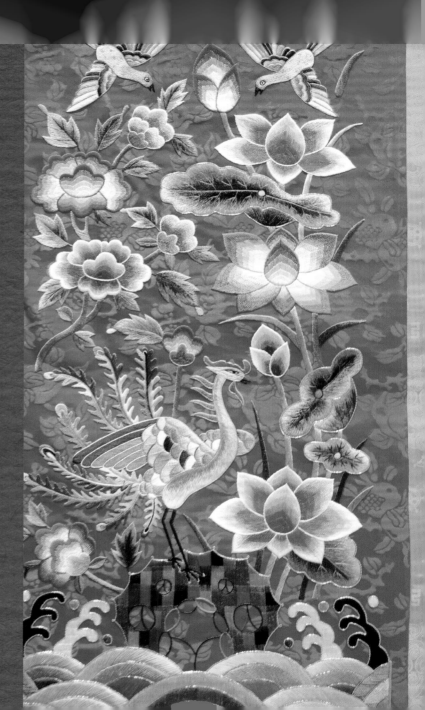

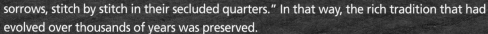

Han Sang-soo, called "a living treasure for the craft of embroidery," and named Intangible Cultural Asset No. 80, with two magnificent examples of her work.

With the imposition of austere Confucian principles in the Joseon Dynasty, embroidery assumed a new role. Women were drastically restricted in their activities and thus spent most of their time at home in the women's chambers. Embroidery became the one creative outlet remaining to them, and has been described as "the way that Korean women relieved their feelings of oppression and their sorrows, stitch by stitch in their secluded quarters." In that way, the rich tradition that had evolved over thousands of years was preserved.

Interestingly, although most Korean traditional crafts have been done by both sexes, embroidery has always been practiced only by women. Throughout most of history, embroidery involved not only stitching designs, but also creating the materials to be used. A woman had to start by picking mulberry leaves to feed her silkworms. She spun, wound, and dyed the thread from the cocoons, and designed what she planned to make. Only then could she concentrate on embroidering a piece of cloth.

Although embroidery undoubtedly originated as a way of decorating garments, the Koreans have traditionally used it to embellish many personal, household, and public objects, and this is still true today. One can easily find examples of embroidered chests, pillows, wrapping cloths, *norigae*, jewelry, wall hangings, screens, and paintings, just to name a few. The amazing artistry and technical skill that characterize Korean embroidery are thankfully alive and well. In an effort to preserve this art form, the Korean government has named it an Intangible Cultural Heritage—*jasujang*—promoting support for master artisans and the training of apprentices.

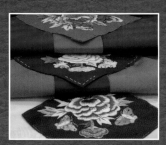

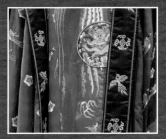

Ornamental Knotwork *Maedeup* 매듭 & *Norigae* 노리개

Maedeup is the Korean word for knot. Different from the Western tradition of macrame, *maedeup* uses one fiber instead of two, and both sides of the finished piece are identical. Ancient wall paintings suggest that knotted ropes were made as early as the Three Kingdoms Period and were probably used for everyday purposes such as counting and tying. But by the Joseon Dynasty, knotting had evolved into a fine art that was regulated by the government and widely used by Koreans in every walk of life. Special artisans were tasked with making *maedeup* for the royal court, and entire villages became devoted to creating them.

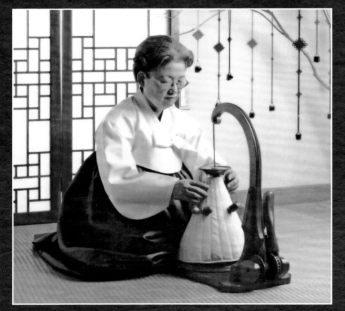

Kim Hee-jin, a master of *maedeup*, has been designated a holder of Important Intangible Cultural Heritage No. 22. She invented a cord frame that allows a varying number of silk threads to be twisted together to form a base cord of different widths.

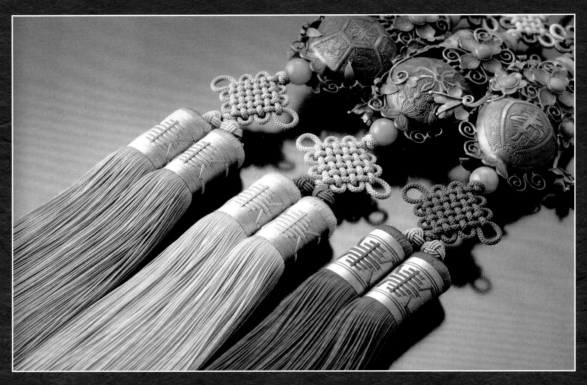

Women of the court wore heavily ornamented *norigae* such as these. In spring, summer and autumn, ornaments made with beads or jade were preferred, while agate and amber were worn in the winter.

The most well-known type of *maedeup* is the *norigae*—a beautiful knotted piece with a tassel, meant to be worn hanging from the tie of a woman's *hanbok*. A *norigae* consists of three parts: the knotwork, which is always vertically repetitive and symmetrical; the tassle, which can be made from cord of varying thicknesses; and the ornament, which is made from precious metals and stones such as gold, silver, bronze, jade, amber, coral, pearl, or malachite.

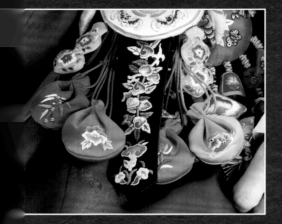

The size, shape, materials, and colors of *norigae* reflected the status and importance of the women who wore them, and varied by the particular occasion for which they were being worn. For example, queens, royal concubines, and princesses wore *norigae* at all times, while other court ladies wore them only for official ceremonies. Ordinary women routinely wore *norigae*, too, and since they could only afford those made with simpler, less expensive materials, they often embellished them with embroidery.

Like many traditional Korean art forms, *maedeup* incorporated themes of nature that were familiar and meaningful to people. The names of the various knots—lotus bud, butterfly, bee, dragonfly—clearly reflect this, as do the names of the tassles that are often attached to the knotwork—strawberry, octopus, abalone. The most popular designs for *norigae* ornaments are animals (bat, tortoise), insects (butterfly), plants (pepper, grape, peony), and household objects (gourds, drums, locks, bells). The shapes of these ornaments carried meaning for the women wearing them. A pepper or an eggplant symbolized the wish for a loving relationship and many children, while a peach meant that the wearer hoped for a long and healthy life. Ornaments in the shape of gourds and tiger claws were worn to repel evil spirits.

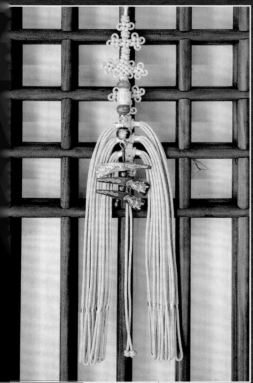

Norigae are still widely worn, especially attached to the *hanbok* jacket. But *maedeup* can be seen elsewhere as well. From tiny ones dangling from key rings to the grand examples that tie back floor-to-ceiling draperies at the Korean Ambassador's residence in Washington, D.C., it is clear that *maedeup* is an ancient art form that is still relevant in the modern world.

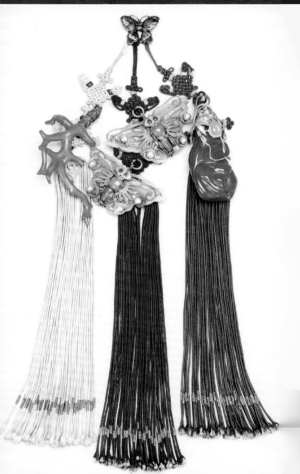

A triple *norigae*—one having three ornaments—was worn at court ceremonies or very special family events, while a single *norigae* was appropriate for everyday use.

Gold Leaf Imprinting *Geumbak* 금박

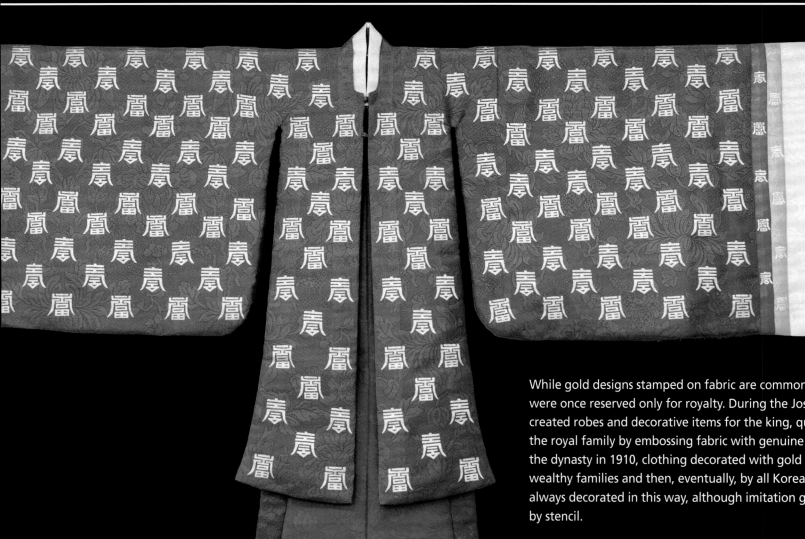

While gold designs stamped on fabric are commonly seen in Korea today, they were once reserved only for royalty. During the Joseon Dynasty, skilled artisans created robes and decorative items for the king, queen, and other members of the royal family by embossing fabric with genuine gold leaf. After the fall of the dynasty in 1910, clothing decorated with gold gradually came to be worn by wealthy families and then, eventually, by all Koreans. Today, *hanbok* are almost always decorated in this way, although imitation gold is usually used and applied by stencil.

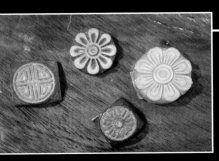

Stamps are hand-carved from fine-grained hardwoods such as pear, ginkgo, and birchwood. More than 20 different knives are used to create over 700 traditional designs.

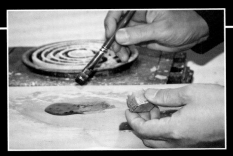

The glue is made from various natural ingredients to suit the fabric to be printed. It must be kept at exactly the right temperature before and during use.

Pure gold leaf is pounded on an anvil into small, almost transparent wafers.

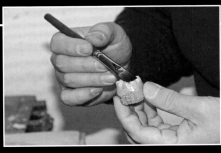

The glue is carefully brushed onto the wooden stamp.

The stamp is then quickly, but precisely, pressed into place.

The gold leaf is gently tapped onto the stamped area where it adheres to the glue.

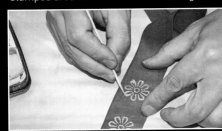

Enormous skill is needed to cover each area of the sticky pattern evenly without wasting any precious gold dust.

Traditional stamping with gold leaf is a labor-intensive process that requires great skill and years of training and practice to perfect. The artisan must create the stamps and make both the glue and the wafer-thin leaves of gold before he can finally create the fabric design. The gold leaf is prepared by pounding pieces of pure gold on an anvil for several days, then cutting the resulting sheets into very small square pieces and wrapping them in *hanji* paper that is then lacquered. Each piece is pounded again for several days until nearly transparent wafers are achieved. The glue is also handmade. Different natural ingredients (for example, fish bladders) are used depending on the fabric that will be printed. The glue is carefully brushed onto the wooden stamp, which is then quickly but meticulously pressed onto the fabric. Then, one wafer at a time, the gold is tapped onto the glue with the fingers. The results are breathtakingly beautiful.

Clothing made with genuine gold is heavy and extremely costly. Using this traditional method, six ounces of gold are needed to stamp a single hair ribbon worn in a wedding ceremony. For that reason, artificial gold is substituted for most projects today.

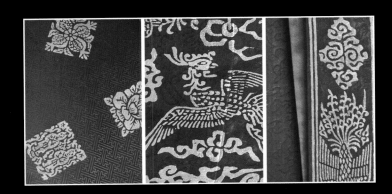

Wrapping Cloths *Bojagi* 보자기

Bo is a Korean word meaning to cover and protect. There is a long Korean tradition of using square pieces of cloth called *bojagi* to cover, contain and carry household objects, ritual objects, and special gifts. Commonly used during the Joseon Dynasty, their use was bound up with the belief that good luck or happiness (*bok*) could be "wrapped up" in the cloth. Thus,

A scene from the MBC TV series *Jewel in the Palace*

a beautifully wrapped object was believed to confer respect and honor to both the object and its recipient, and to bring luck and good fortune.

Bojagi fell into two general categories: *gungbo*, wrapping cloths used in the royal household and court, and *minbo*, those used by the common people. Large numbers of *gungbo* in all sizes were made to order by seamstresses in the palace every year and were used to wrap gifts given by members of the royal family, including everything from personal ornaments or spoons to bedding and furniture. Royal *bojagi* were usually double-sided and made of silk, with red and pink being the preferred colors.

Always the job of women, making *minbo* became an outlet for their creativity. Much less formal than the *bojagi* used by royalty, *minbo* were of several different types. If made by piecing together small bits of cloth

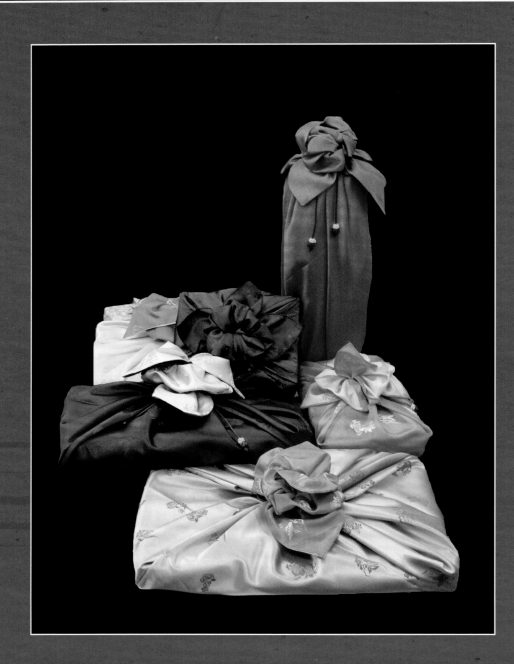

left over from making clothing, it was a *jogakbo*. If embroidered, it was a *subo*. Like craft traditions in many cultures, making *bojagi* became a way for women to meet their families' needs while at the same time expressing their love and artistic nature.

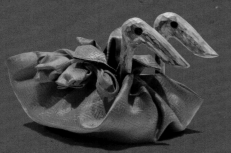

Minbo were used for many purposes, and the name of the cloth reflected its use. A *gyeongjeonbo*, for example, was used to protect the Buddhist scriptures. A beautiful blue and red *gireogibo* was used to wrap the wooden goose or duck used in a traditional wedding ceremony. In the home, *bojagi* were used to wrap clothing and bedding (*ibulbo*), to cover tables (*sangbo*) and food (*sikjibo*), and to carry anything and everything. Gifts of money were traditionally presented in *donbo*, the forerunner of the money envelope.

Bojagi were traditionally made from cotton, *mosi* (Korean ramie), linen, and silk. With the exception of brocade, which is widely used, Korean *bojagi* tend to be made with solid color fabrics. Sometimes they are made with two layers of cloth, a different color on each side creating a striking effect when the cloth is knotted. The beautiful embroidery found on *subo* is traditionally done in the five principal colors (blue, red, yellow, white, and black). Elements such as trees, flowers, butterflies, birds, and insects are common, reflecting the Korean affinity for nature and belief in its power to bestow happiness and good fortune. In addition to cloths that are pieced and embroidered, *bojagi* are also sometimes stamped with traditional patterns in gold (*geumbakbo*).

The use of *bojagi* was on the wane as a younger generation of Koreans adopted disposable wrapping paper and plastic. However, perhaps due to environmental concerns, a realization of their practicality, or an appreciation of their beauty, today *bojagi* are once again commonly seen in shops and markets throughout Korea. And, in fact, important documents are still delivered to the National Assembly wrapped in beautiful *bojagi*.

Minbo are often used to cover windows and doors.

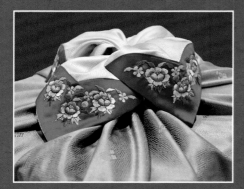

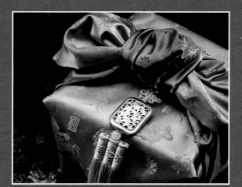
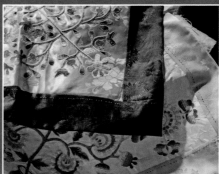

Korean Patchwork *Jogakbo* 조각보

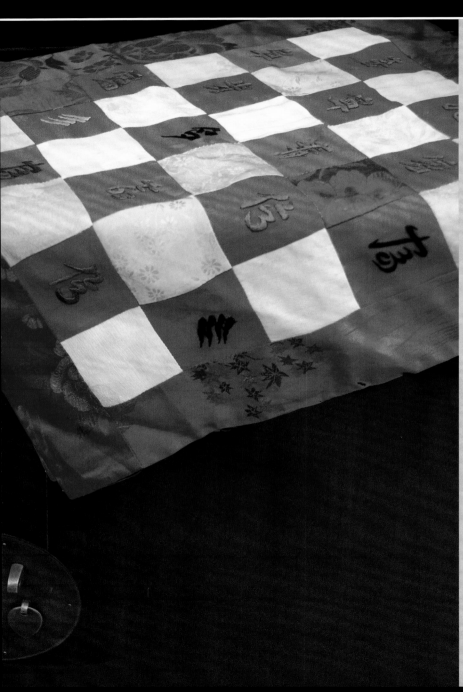

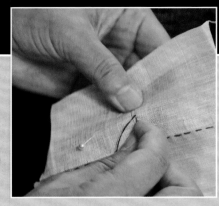

As explained, Korean *bojagi,* or wrapping cloths, can be grouped into two major types: *gungbo* and *minbo*. By far the most common and popular type of *minbo* was the *jogakbo*, a cloth pieced together from small bits of fabric left over from making clothes.

In the past, fabric was very valuable in Korea, so even the smallest pieces were not thrown away. Instead, women saved every scrap, combining them to create original, one-of-a-kind wrapping cloths. The making of *jogakbo* not only gave the women an outlet to express their sense of beauty and creativity, but each piece added to a *jogakbo* was believed to bring additional blessings and happiness to the person who eventually used or received the cloth.

During the Joseon period, mothers began making *jogakbo* as soon as a daughter was born, and these *jogakbo* were later given to her as a wedding gift. Many *jogakbo* that survive today appear to have never been used, a sign that these daughters and even granddaughters treasured them, undoubtedly recognizing the great care that went into making them.

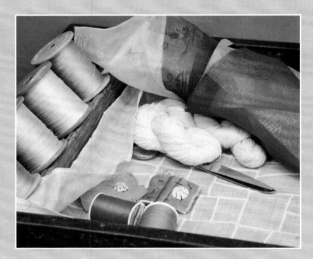

Mothers also taught their daughters the art of *jogakbo,* as Koreans felt it was important for children to learn that everything in the world has a purpose, and that with hard work and dedication, even something considered worthless, such as a scrap of fabric, could be turned into a thing of value.

A stunning example of contemporary *jogakbo* is this *durumagi* (overcoat) by Chunghie Lee.

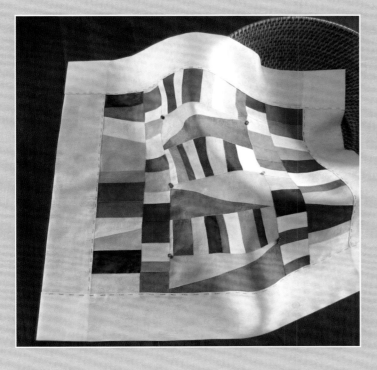

Jogakbo bears an undeniable resemblance to American quilt art —in both cases, the artist combines various colors and shapes in perfect harmony. But unlike American quilts, the meticulous stitching of the *jogakbo* is often visible on the surface of the piece, usually in a contrasting color. In addition, small knots shaped like bats were common on *jogakbo*. They were believed to bring good luck, since the Chinese character for bat sounds like the Korean word for good fortune (*bok*).

Today one can see the influence of *jogakbo* in many Korean handicrafts—in linens, lamps, wall hangings, and clothing. The favored fabric is *mosi,* or ramie, cut and stitched into stunning patterns. Considered to be a quintessentially Korean art form, *jogakbo* reflects the creativity, passion, and hopes of countless generations of unnamed women creating beautiful cloths with which to wrap up good luck and happiness for those whom they loved.

Traditional Costume *Hanbok* 한복

The *hanbok*, the traditional Korean costume, is said to reflect the Korean artistic aesthetic—flowing lines and curves that lead the eye, large expanses of open surface area that invite the imagination, and the bold use of color, often with symbolic meaning. Thousands of years ago, men and women both wore short tight pants and waist length jackets. Later, women wore long skirt-pants and wide-sleeved jackets that hung to the hip and were belted. The less complicated, more comfortable style that is still worn today evolved in the Joseon Dynasty with the conversion to simpler Confucian values. Today *hanbok* are worn largely for special occasions and anniversaries, although contemporary designers are also creating adaptations for everyday wear.

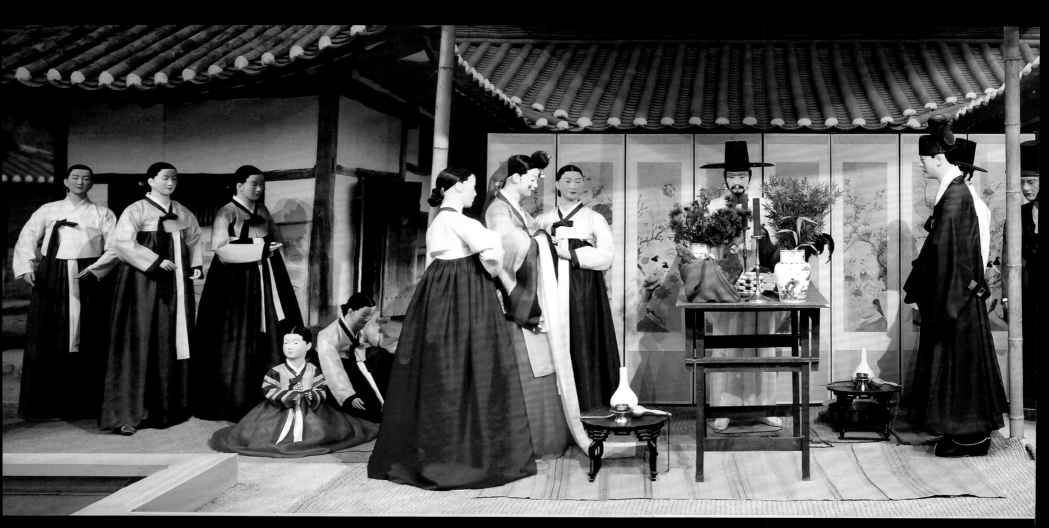

The child's *hanbok* is identical to the adult's but tends to be especially colorful. A special version is worn for the first birthday, considered to be the most important day in a child's life. On that occasion, boys typically wear a long blue vest (*gwaeja*) over pants, and a black hat or hood that has a long tail. Girls are dressed in a red skirt, a jacket that often has striped sleeves, and a hat or ribbon on the head.

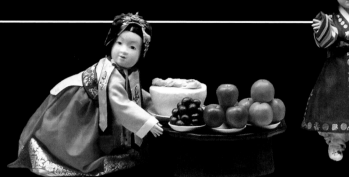

For men, the *hanbok* consists of a vest (*jokki*), a broad, hip-length jacket (*jeogori*), and roomy pants (*baji*) that are belted at the waist and tied at the ankles with long strips of cloth. An outer jacket (*magoja*) is closed with one or two drop-shaped buttons made of amber, gold, or silver. Pants and jacket are made of the same or contrasting colors, which are more muted than those used for women. An outer coat completes the ensemble.

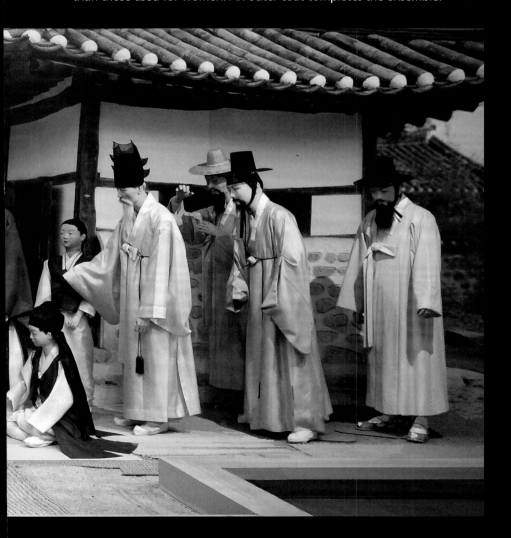

For women, the *hanbok* consists of a floor length wrap-around skirt (*chima*) that reaches to just under the arms and is secured with a sash. Being tied high on the body makes it easier for women to sit on the floor, and the flowing skirt retains body heat. A short fitted jacket with long, gracefully curved sleeves (*jeogori*) is tied in a beautiful special knot (*goreum*). The skirt and the jacket are usually different, often complementary, colors, creating endless, beautiful and dramatic combinations.

Traditionally, the colors were symbolic. For example, single women could wear a red skirt with a yellow jacket, while a dark blue skirt and jade green jacket indicated a married woman. A purple tie on the jacket signified that the woman was not a widow, while dark blue cuffs advertised that she had one or more sons.

Hanbok for royalty and the wealthy were traditionally made from ramie in the summer and from silk the rest of the year, while cotton was used by the lower classes. Although the upper classes wore color, commoners strongly preferred to wear white, symbolizing purity. Indeed, early visitors to Korea referred to Koreans as the "people in white."

For a traditional wedding ceremony, the bride wears a green bridal robe (*nokwonsam*) over a red skirt and yellow jacket, a special headdress, and a long white silk cloth (*hansam*) over her hands. For men, the traditional wedding costume includes a formal dark robe and girdle (*gwandae*) and a special black hat with side flaps made of stiffened silk gauze (*samo*).

Accessories for Hanbok

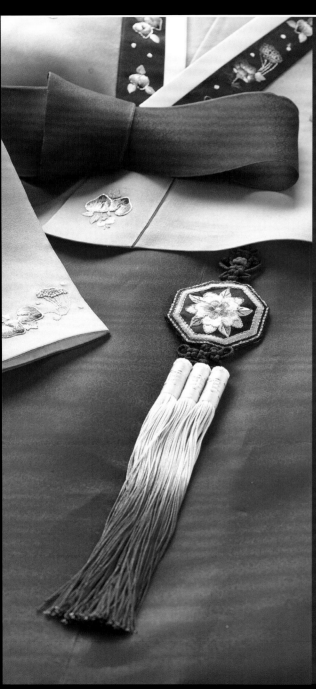

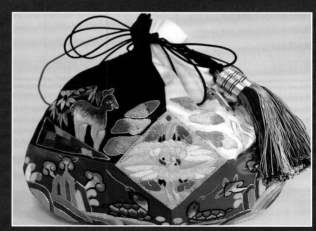

The Korean *hanbok* has extremely simple lines and is not usually made from patterned fabric. Touches of elegance are provided by various accessories that have traditionally been worn with it.

For women, a *norigae,* a colorful piece of knotwork with attached decorations and tassels, is often hung at the center front of the jacket. A long hairpin, or *binyeo,* is used to secure the hair in a bun at the nape of the neck. They can be very simple or highly ornate, depending on the occasion. In the past, men also used a small *binyeo* to fix their topknots in place.

Because *hanbok* have no pockets, both men and women carry fabric pouches, or *jumeoni,* that are often lavishly decorated with embroidery, tassels, and pendants. The names of the pouches vary depending on their design and purpose. *Obangnang* are made with the five colors representing the five directions, while *sipjangsaeng jumchi* are embroidered with the symbols of longevity. Ear-shaped pouches called *gwijumeoni* are frequently embroidered with the characters for long life and good fortune or with images of waves, rocks, clouds, and herbs.

An ear-shaped pouch called a *gwijumeoni*

The colors of the five directions on an *obangnang jumeoni*

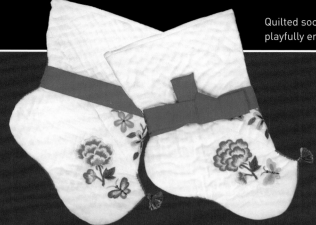

Quilted socks (*beoseon*) made for children are often playfully embroidered and have ties that secure them.

When indoors, feet are clad in special white cotton socks with upturned toes called *beoseon* that are quilted, sometimes padded for warmth in the winter, and often decorated with a tassel or a bit of embroidery. Unlike Western socks, *beoseon* fit the foot exactly and retain their shape when taken off.

The traditional shoes worn with *hanbok* are of a distinctive shape, not seen anywhere else in Asia. Shaped like a canoe, with an upturned toe, they can be worn on either foot. Those worn by upper-class women and girls, called *danghye,* were made of silk and decorated with floral embroidery. *Yangban* men wore leather or silk shoes called *taesahye*. Commoners, however, wore sandals woven out of coarse straw in dry weather, while wooden shoes in an upturned-toe shape protected their feet in the rain and mud.

One of the most charming *hanbok* accessories, however, must certainly be the *dolddi,* the wide belt worn by children on their first birthday. The belt, embroidered with auspicious symbols or the Ten Symbols of Longevity, in red for girls and dark blue for boys, was attached to the back of the baby's jacket and then wrapped twice around the waist to ensure a long and successful life.

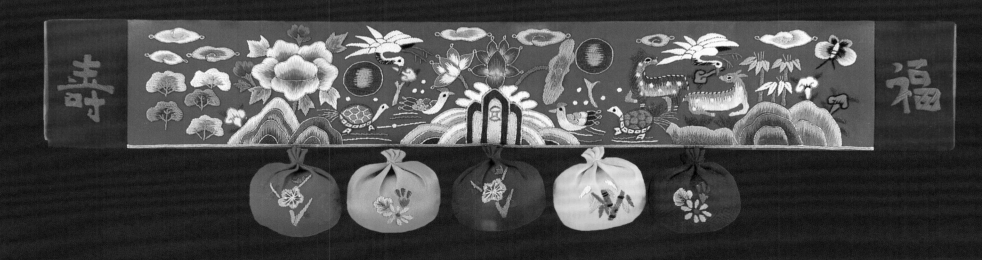

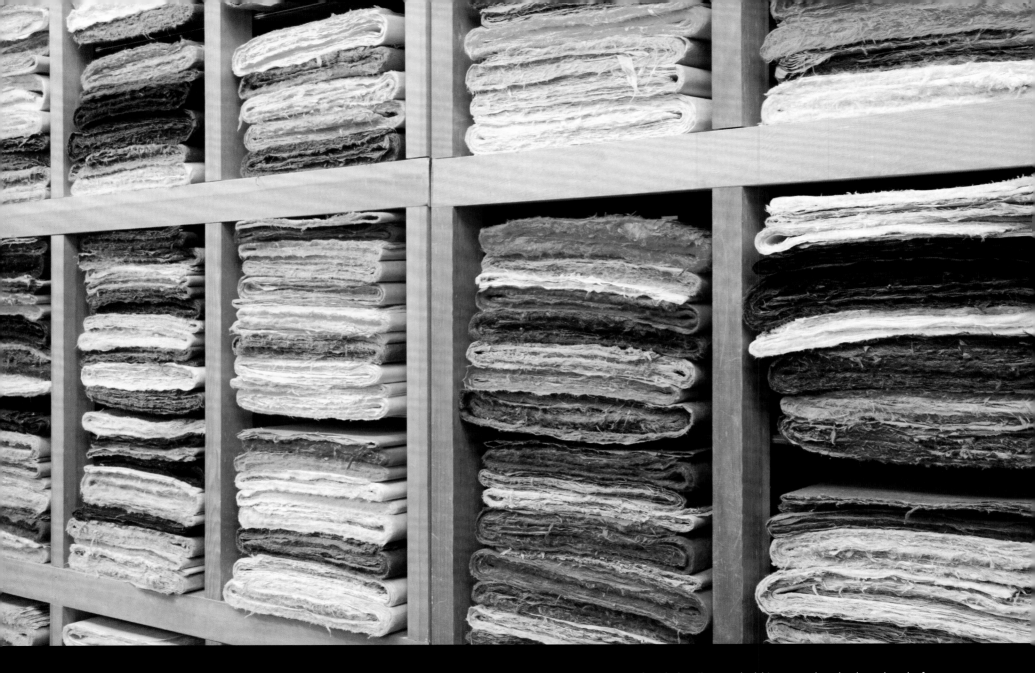

Paper made from the inner bark of paper mulberry trees, *hanji*, is one of Korea's finest inventions. First developed between the 4th and 7th centuries AD, it was admired throughout Asia for its beauty and durability. Koreans have used it for centuries in their homes and daily lives, as well as in their literary and artistic endeavors. The heated *ondol* floors of Korean homes as well as lattice windows and doors were covered with *hanji*. Household items such as baskets, bowls, fans, lanterns, kites, shoes, and even clothing have been fashioned from paper. There is a long and beautiful Korean tradition of making chests and other types of boxes from layers of paper that are then lacquered to preserve them. *Hanji*, both in its production and many applications, epitomizes Korean ingenuity and creativity.

Paper

Handmade Paper

Fans

Kites

Lanterns

Handmade Paper *Hanji* 한지

Made of the inner bark of the young paper mulberry tree, traditional Korean handmade paper (*hanji*) is some of the finest in the world. Developed sometime between the 4th and 7th centuries AD, *hanji* was acclaimed by Chinese and Japanese statesmen and scholars. *Hanji* does not deteriorate, and its use in the creation of important religious and government documents for a millennium has contributed greatly to their survival. The oldest surviving piece of *hanji* is a Buddhist scroll called *Mugujeonggwang Daedaranigyeong* (National Treasure No. 126) which is estimated to be at least 1300 years old. A natural and highly renewable resource, *hanji* came to be used in Korean culture for an astonishing variety of purposes, far beyond its role as the material for scholarly pursuits, such as books, scrolls, and calligraphy paper.

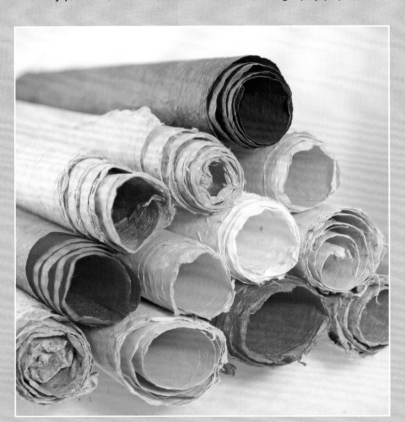

Mixed with water into a liquid clay, *hanji* was used to fashion containers of all types, including bowls, water basins, and chamber pots, which were then lacquered to make them watertight. Rolled into tight cords, it was also used to weave objects, including baskets, lanterns, clothing, and shoes.

Sheets of paper were used in an extraordinary number of ways. In the home, windows and doors were lined with *hanji* and it was used to create the multilayered *ondol* floors that were heated from below. Pasted onto a frame, *hanji* was used to create kites, fans, lanterns, sewing boxes, and furniture. Oiled paper was made into hats, covers for food, umbrellas, and even armor for soldiers.

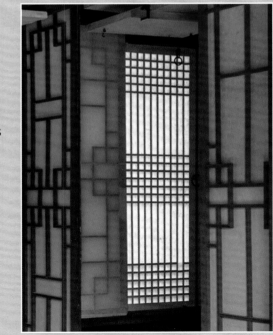

Hanji is a combination of two words—*han*, which means "Korea," and *ji*, which means "paper." The name came about in the early 20th century as a way to distinguish traditional handmade paper from *yangji*, or Western, machine-made paper.

Hanji was also called baekji, meaning "one hundred paper," because its manufacture required 99 steps, with the 100th step being the human hand that picked up the finished sheet.

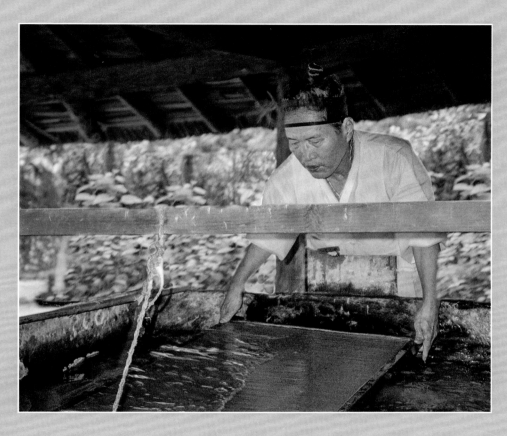

Making *hanji* is a labor-intensive process that is no longer widely practiced in Korea. Branches of young paper mulberry trees (*daknamu*) were traditionally cut in the fall. Steamed or boiled, they were stripped of their bark. The white inner bark, the primary ingredient in *hanji,* was removed and boiled with bleach and lye. After being rinsed in a running stream and being cleaned of impurities by hand, the bark was placed on a stone surface and beaten with a wooden bat to reduce it to a pulp. Mixed with *dakpul,* a substance obtained from the hibiscus family that acts as a glue and strengthener, and colored with natural dyes, the pulp was formed into sheets by means of a screen dipped into the mixture. Gently shaking the screen from side to side after removing it from the liquid caused the fibers to knit together. The sheets were then removed from the frame and dried in the sun or on a heated *ondol* floor.

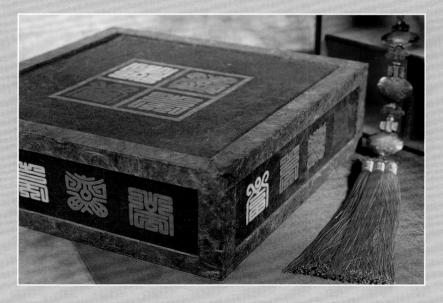

In the 20th century, the production and use of traditional paper in Korea waned as other forms of less expensive paper became available and as modern materials replaced *hanji* in the manufacture of most products. However, in the last forty years interest in traditional crafts in Korea has been promoted by the government. Slowly, the use of *hanji* by traditional craftsmen and its incorporation into more modern art forms have heralded a renaissance for this beautiful, strong, and natural material. Today, it is easy to find many lovely products made of traditional handmade paper in Korean markets and shops, recapturing and echoing an older, simpler time.

Fans *Buchae* 부채

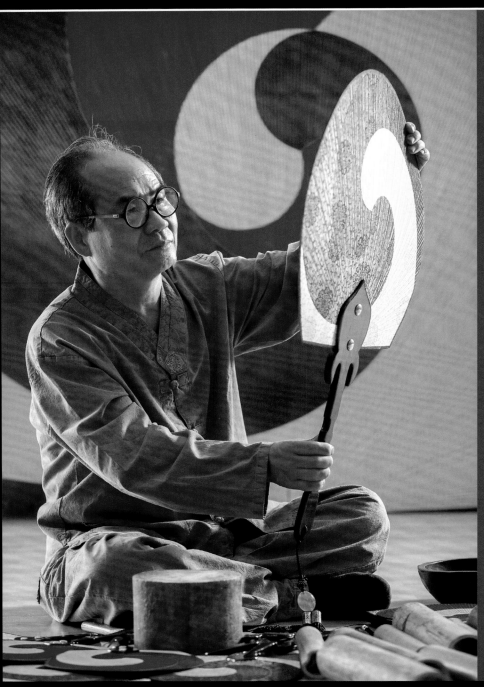

There are two types of Korean fans: *danseon*, which is rounded, flat, and rigid, and *jeopseon*, a folding fan. A more refined version of *jeopseon* is called *hapjukseon*, which was believed to have been invented in Korea by a Buddhist monk in the Goryeo Dynasty. Legend has it that he loved a woman whom he could not pursue, so he made a fan in her shape to carry with him and remind him of her. The folding fan was admired by Chinese envoys to Korea and was carried back home with them, subsequently gaining popularity across Asia.

Both types of Korean fans were traditionally made of thin bamboo ribs covered with *hanji* or silk. The selection of the bamboo was of utmost importance. If not grown or harvested properly, the color and quality of the wood were not considered fine enough for beautiful fans. *Jeopseon* were made of bamboo ribs, overlapped and hinged together at the base. *Danseon* were made with a skeleton of very thin bamboo strips either flared straight out from a wooden handle or bent into lovely designs such as leaves, birds, and fishtails. Paper or fabric was carefully glued onto the bamboo framework, pulled tight to reveal the bamboo frame, and then finished along the edges. Fans were frequently painted or decorated with cutout *hanji* patterns, often incorporating symbols of good fortune. The handle was shaped, carved or decorated, and a *maedeup* loop was attached.

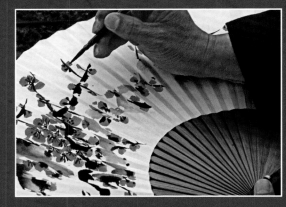

Jo Chung-ik, a master of traditional fans, created the original drawing technique for the tricolor *samtaegeuk* symbol that appears on many of the *danseon* fans seen in Korea today.

In the Goryeo and Joseon dynasties, *danseon* were usually carried by women and *hapjukseon* by men. During the summer heat, fans were used to cool, to brush away insects, and to shade the face from bright sunlight. It became a custom for the king to present fans to his officials on Dano Day, the fifth day of the fifth lunar month, the beginning of summer. The custom was adopted by commoners, who also began to exchange fans on this day.

But fans have also served many functions other than purely utilitarian ones. A gentleman or lady was not properly dressed until they had their fan, whether in summer or winter. *Yangban* used fans to gesture dramatically while reciting poetry. Fans were given as gifts (sometimes containing secret messages) and served as tokens of agreement in pledges. In the traditional wedding ceremony, both bride and groom hid their faces with fans. And at funerals, mourners used them to shield their faces as a sign of respect.

Shamans have used fans in many of their ceremonial dances as one means of enticing the spirt being addressed to grant the prayers being sought. In the 20th century, one

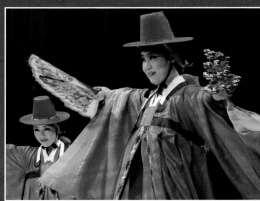

of those dances was the basis for the development of the well-known Korean fan dance, the *buchaechum*. Originally created for a single dancer, the *buchaechum* is now performed by a large group of identically dressed dancers using feathered folding fans painted with peonies to create beautiful visual effects as they move in synchronized waves of motion to represent a large, fluttering flower.

The *mudangchum*, or shaman dance

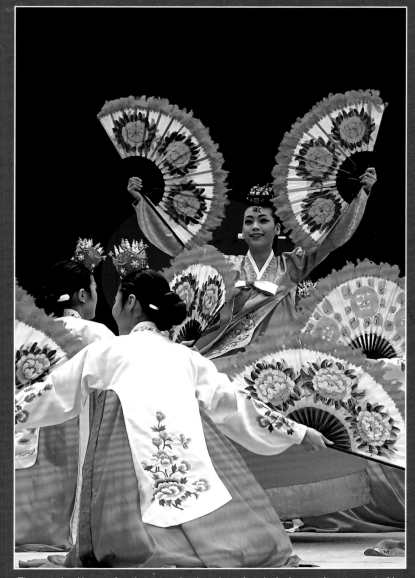

The popular Korean fan dance, or *buchaechum*, is relatively new. It was created in the 20th century and has its origins in the shaman dance.

Kites *Yeon* 연

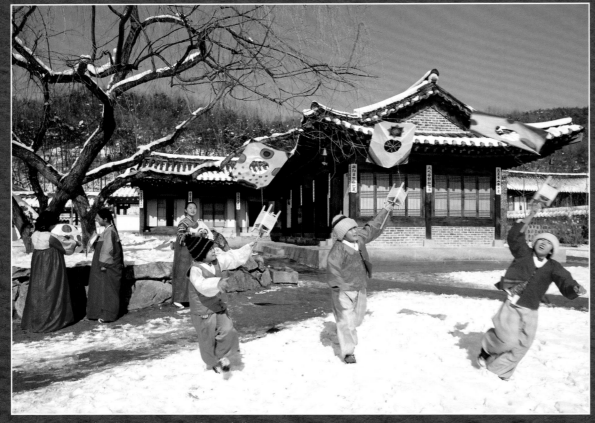

Yeon were most often flown by men and boys of all ages.

Unlike kites of any other culture, the Korean kite (*yeon*) is made with a hole in the middle of its rectangular field. Contrary to intuition, this hole makes the kite very easy to fly, needing only gentle tugs on its line. Made of *hanji* and bamboo, traditional kites (*bangpaeyeon*) were painted in the traditional colors of black, white, red, blue, and yellow, with bold designs that gave rise to many colorful names to identify them. The frame, always in 2 x 3 proportions, was constructed of five lengths of bamboo. Four of the pieces intersected at a point where the center hole, with a diameter half the width of the sail, would be placed, and the fifth piece formed the stiff top edge. The *hanji* sail was securely glued to the frame, optional tails attached (or not), and a single nonelastic thin silk string was strung from the sail to a handheld spoke reel.

Light as a feather and sturdy as an ox, the *yeon* is beloved by Koreans and is traditionally flown in midwinter during the New Year season. Kite flying (*yeonnalligi*) begins on the first day of the lunar calendar and continues until the first full moon of the year. On the last day of kite-flying season, a person's name and date of birth were traditionally written on the kite, together with the Chinese character meaning "bad luck." The kite was allowed to rise to the end of its string, the string was severed, and the kite was released, carrying the bad luck away and promising good fortune during the New Year.

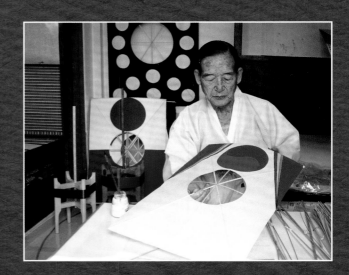

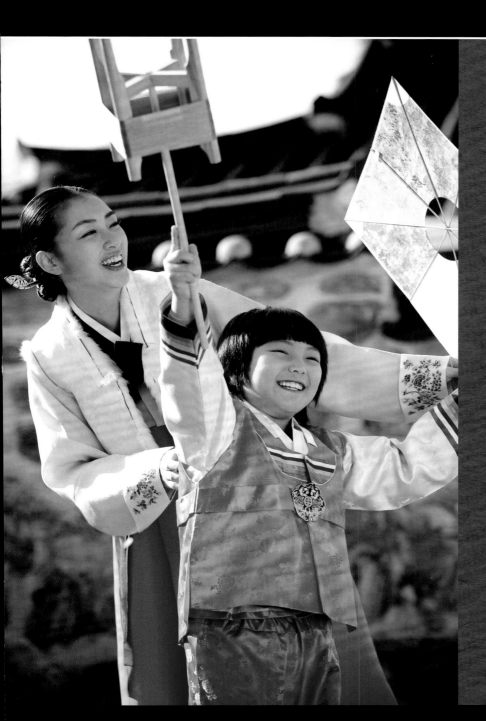

The origins of kites in Korea are not known with certainty, but there is a history of kites being used for military purposes. In 647 AD, General Kim Yu-sin of the Silla Kingdom was trying to quell a revolt. A falling star, considered to be a bad omen, had incited people to rise up against Queen Jindeok. The general sent up a kite with a burning ball attached that gave the illusion that the star had reascended to heaven, meaning good fortune would come to Gyeongju under the Queen's rule. As a result, peace was restored. In the 14th century, kites were reportedly used to shoot fire toward the enemy, and during battles with Japanese invaders in the 16th century, the various designs of signal kites were used to convey orders to the waiting army.

Kite-fighting has long been a favorite sport in Korea, continuing to this day. The objective is to outmaneuver the opponent with dramatic swoops and dives, ultimately severing the string of the opponent's kite with one's own. Perhaps in tribute to this long sporting tradition, the stadium that was built to host the 2002 World Cup soccer games in Seoul was shaped like a kite, with a large hole in the center of the roof. At night when the lights were on in the stadium, the fiberglass roof resembled *hanji* paper. Perhaps this had something to do with the South Korean team unexpectedly sailing to a fourth place finish out of 32 teams from around the globe!

Lanterns Deung 등

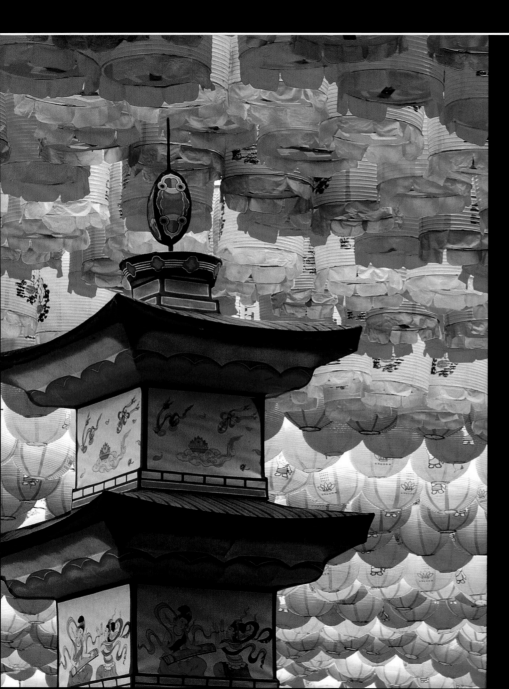

Probably the best-known lantern in Korea is the paper lotus lantern, which is used every year by the tens of thousands to celebrate the birth of Prince Siddhartha Gautama (Gautama Buddha), founder of Buddhism, on the eighth day of the fourth lunar month. To make a lantern and hang or carry it is to make a symbolic wish that light, compassion, and wisdom touch all of mankind. The most extravagant display occurs during Seoul's Lotus Lantern Festival, which extends over a period of several days. Starting with exhibits of beautiful reproductions of traditional lanterns at major temples in the city, the festival continues with activities designed to teach people about Buddhism and culminates in a spectacular parade of lanterns by the thousands winding through the city streets.

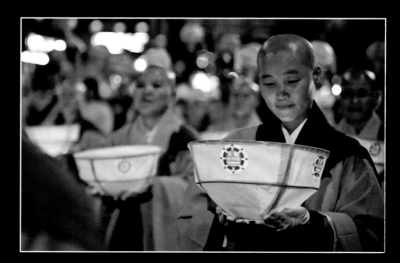

Modern lanterns are still made in the traditional manner of covering a bamboo frame with *hanji*, which is then painted or covered with a second layer of tinted paper. Holes at the top and/or bottom allow heat and smoke to escape.

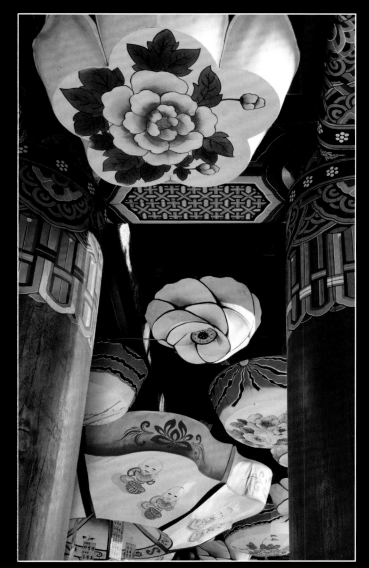

Traditional painted *hanji* lanterns hang from the gate of Jogyesa Temple in Seoul.

Ancient records indicate that lantern lighting was practiced in Korea even before Buddhism was introduced to the country from China, with people gathering to enjoy the lights of tin lanterns. With the arrival of Buddhism in the 4th century, lotus-shaped lanterns became popular. King Taejo (918–943 AD) of the Goryeo Dynasty established a lantern festival that has endured over 1000 years and continues to the present day. On the first night of the festival, called Lantern Evening, families throughout Korea placed poles in front of their homes and hung a lantern for each family member. Wealthier households decorated the poles with the tail of a ringed pheasant and colorful silk flags, while others used evergreen boughs. These lanterns remained lit for nine days, with brighter ones considered to be luckier. People believed that lighting a lantern led to enlightenment and was a way for their wishes to be granted, and throughout the village, people competed to erect the tallest lantern pole with the brightest light. It was a very festive time, with everyone walking about at night eating rice cakes and admiring the luminous spectacle.

The lanterns that were used in these village festivals were created in many shapes in addition to the Buddhist lotus, and all had symbolic meaning. Carp, cranes, dragons, kites, melons, and turtles were fashioned by attaching paper or red and blue cloth to frames made of bamboo.

Two other types of lanterns were traditionally found in Korea. Before electricity, handheld candle-burning lanterns (*chorong*) made with a wooden frame and covered by red or green silk or colored paper produced a soft illumination in the home when needed during the hours of darkness. Stone lanterns graced the gardens of royalty and the wealthy, symbolizing light rather than actually providing it.

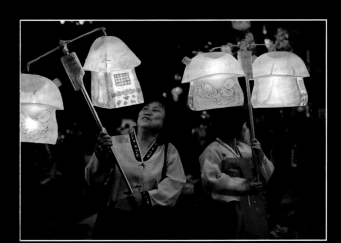

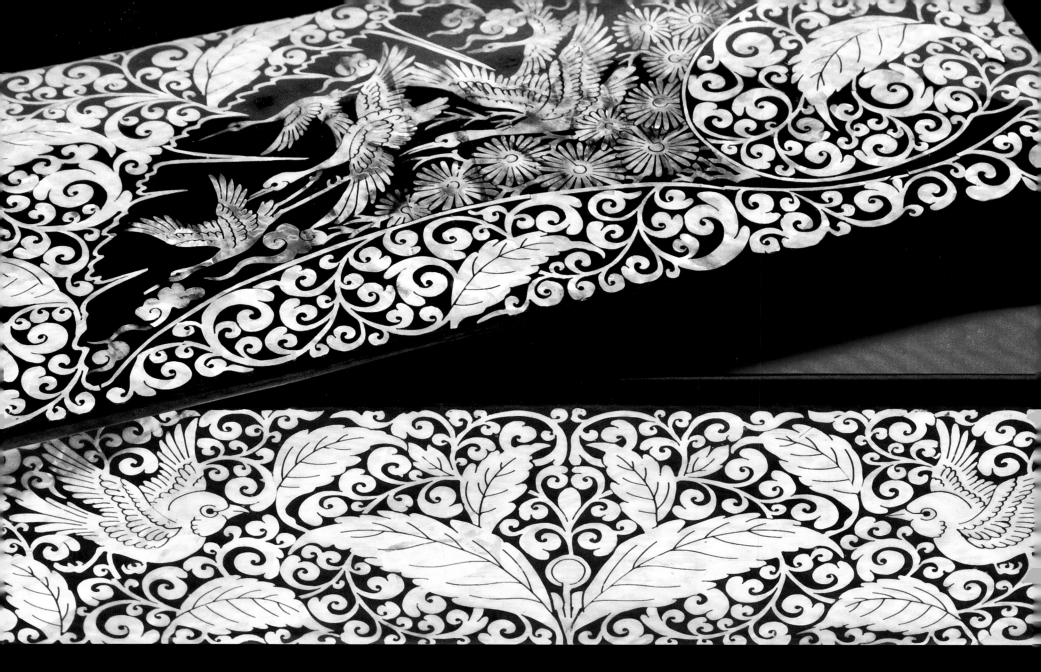

Korean craftsmen have mastered several forms of fusing contrasting materials together as a way of beautifully embellishing furniture, ceramics, and other household and personal items. Inlaying metal, shell, ox horn, and clay onto wood, metal, ceramic, or paper surfaces creates designs of breathtaking beauty. Several of these techniques are uniquely Korean and epitomize the highest levels of artistic creativity and workmanship. Not surprisingly, these traditional crafts make extensive use of symbolism in their execution, weaving meaning and artisanship in the effort, always to assure good things for the Korean people.

Chapter 6

Inlay

Metal Inlay

Mother-of-Pearl Inlay

Ox Horn Decoration

Metal Inlay *Jogak* 조각 & *Ipsa* 입사

Existing since the early part of the Bronze Age, metalwork has been an important handicraft in Korea. Reaching its height as an art form in the Goryeo Dynasty, metalwork included the production as well as decoration of both religious and secular objects. Inlaying metal into and onto metal became a highly developed art form that is believed to have derived from the art of inlaying lacquerware (*najeonchilgi*) and to have been strongly influenced by the practice of inlaying clay designs into celadon (*sanggamcheongja*). Two different but related metal inlay traditions have been designated as Important Intangible Cultural Heritages—*jogakjang* (No. 35) and *ipsajang* (No. 78).

A variety of *jogak* techniques were developed, all of which involved labor-intensive, highly skilled handiwork, including wire inlay, fretwork, intaglio, relief and inverse inlay, and incising on both the inside and outside of the metal object. Several of these techniques were often combined on an individual object, creating extraordinary effects. The objects themselves were made of various materials including silver, gold, zinc, bronze, and even stone. During the Goryeo period, bronze was the most popular, often inlaid with silver and gold. Very fine lines were hammered into the surface of the vessel (intaglio), parts of designs were chiseled away (fretwork), entire backgrounds were filled with wire (reverse inlay), or metal sheets were hammered onto the surface (*gogak*). Elaborate geometric, floral, and traditional patterns were all popular.

Kim Cheol-ju followed in the footsteps of his father Kim Jeong-seop—the first designated holder of Intangible Cultural Heritage for *jogakjang*—who taught him the skill of engraving.

Contemporary perfume container inlaid with gold, silver and jade

Wire inlay (*ipsa*) was one of the most widely practiced traditional techniques. In one method, the artisan draws a pattern on paper and traces that pattern onto the polished surface of the item to be decorated using a sharp object. Threads of gold and/or silver are prepared by beating the precious metal into thin sheets and cutting these sheets into fine threads. The threads are twisted and then hammered into the etched lines on the object and rubbed with a piece of antler to tightly imbed and polish them. Another method involves coating the surface of the object to be decorated with a substance that will protect it during the carving process. Lines of varying widths are chiseled into the hardened surface using a burin and then inlaid with precious metal. The artistry that is achieved with these exceedingly difficult inlay techniques is extraordinary, and because of the detail and precision that are attained, inlaid objects are best examined up close. Fortunately, because they are metal, many beautiful examples have survived and can be seen and appreciated in museums today.

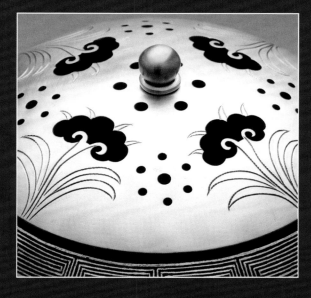

With the advent of the Joseon Dynasty and its austere philosophy, the elaborate and elegant wares made using inlay techniques in the Goryeo period began to disappear. Today, however, those techniques have been revived as Korea has focused on preserving traditional handicrafts. Master artisans continue to create lovely metal on metal objects that are truly treasures of Korean art.

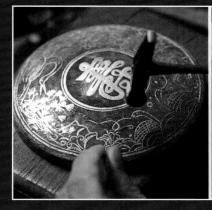
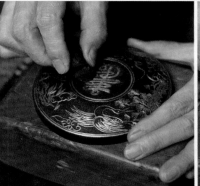
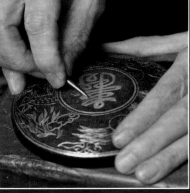

Metal threads are hammered into the etched pattern. The entire surface is rubbed with charcoal, which is then removed from the design to enhance the pattern.

Mother-of-Pearl Inlay *Najeonchilgi* 나전칠기

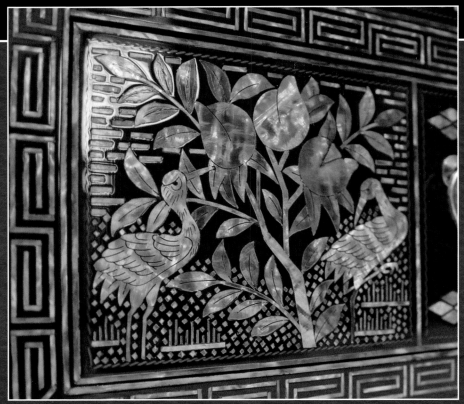

The technique of mother-of-pearl inlay originated in China and reached the Korean peninsula around the 8th century AD. Since then, the art of creating beautiful designs with mother-of-pearl inlaid into or applied onto the surfaces of religious artifacts, household objects and furniture has been a favored Korean art form. During the Goryeo Dynasty *najeonchilgi* artisans became masters of the craft, creating designs of great beauty and complexity that were much sought after throughout the Far East. The intricate patterns were primarily small, symmetrical floral themes, chrysanthemums and peonies being particularly popular. Some artists completely covered their pieces with these intricate designs to reflect wealth and status, which were very important in Goryeo society. Some used tiny mother-of-pearl strips rather than larger shapes, inlaying them one at a time to form the design. Later, in the Joseon era, designs became larger and covered an even greater area of the piece being decorated. Plants and animals, geometric patterns, and Chinese characters were all pictured.

What is commonly known as mother-of-pearl is the nacre, or inner shell layer of various mollusks such as abalone and oyster. Harvested from the mollusk by removing the outer layer of shell (by grinding or with acid), the nacre is polished and made into a flat sheet. Design elements are cut, sawn, or chiseled from the sheet and then applied to the surface of the item being decorated. Pieces of nacre are either placed directly on the flat surface or inlaid into it. The decorated surfaces are smoothed before being covered with many coats of clear lacquer.

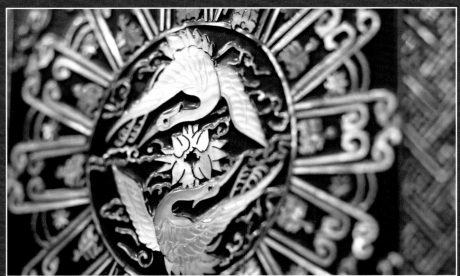

The lacquer can be applied to many different types of surfaces including pottery, leather, paper-maché, and wood. In Korea, wood was and is most commonly used. Because of the many layers involved and the long drying time required for each layer, it can take months or even years to complete a single piece. And while the lacquer cannot withstand heat, it is otherwise durable enough to last for over 1000 years.

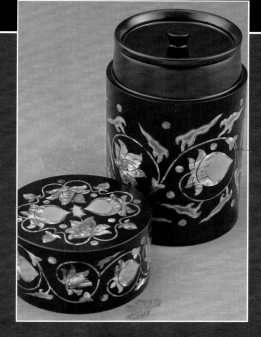

The beauty of *najeonchilgi* comes from the combination of lovely designs and the subtle, iridescent colors of the shell. Largely pastel, these range from ivory to pinks, blues, greens, lavenders, yellows, and golds and vary depending on the type of mollusk. Originally made for royalty and the upper classes, mother-of-pearl furniture and household objects graced palaces and aristocratic homes, reflecting the dignity and sophistication of Korean culture.

During the Joseon Dynasty with its Confucian mind-set, many art forms in Korea became simpler and less elegant or died out altogether. The popularity of *najeonchilgi*, however, did not wane, and in fact became even more elaborate than it had been in the earlier Goryeo period.

The Korean love of mother-of-pearl decoration continues to this day, and beautiful examples are widely available in shops and markets. Korean inlay is considered some of the world's finest, as Korean artisans are masters at cutting the shell lining into paper-thin strips and using its brilliant iridescence to create exquisite designs. These master craftsmen continue to train apprentices in the intricacies of the craft, producing elegant pieces of art in the process. *Najeonchilgi* endures as a beautiful expression of Korea's superb tradition of craftsmanship and aesthetics.

Ox Horn Decoration *Hwagak* 화각

Known only in Korea, *hwagak* is the art of decorating small wooden pieces of furniture or accessories with ox horn that has been flattened and painted on the reverse side with bright, auspicious designs. Possibly crafted as early as the Three Kingdoms Period, *hwagak* is believed to have first been made of tortoiseshell, a rare material that became increasingly difficult to find. More plentiful and easier to obtain, ox horn was substituted during the Goryeo period. Regardless of the material, the process of making these transparent decorative sheets was extraordinarily difficult.

Clean, white horns from young bulls were boiled for hours until soft. The horns were then hollowed out and flattened over a charcoal fire. After being ironed under a press for several more hours, the horn was polished to make a thin, transparent sheet 0.5 mm or less in thickness. When the sheets were ready, they were trimmed and painted on the reverse side with designs executed in the traditional colors of red, blue, green, yellow, and white. Glued to wooden surfaces and smoothed with an ivory stick, charcoal, or soy sauce, the sheets protected the painted undersurfaces for extremely long periods of time. As a result, numerous ox horn artifacts from the Joseon Dynasty have been found in pristine condition.

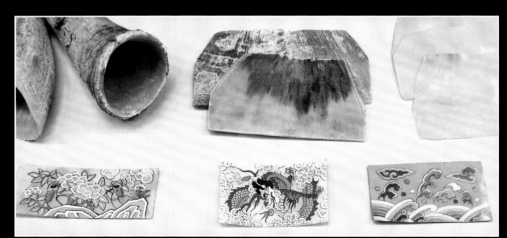

The steps required to transform the raw bull's horn into a delicately painted, transparent sheet are many and arduous.

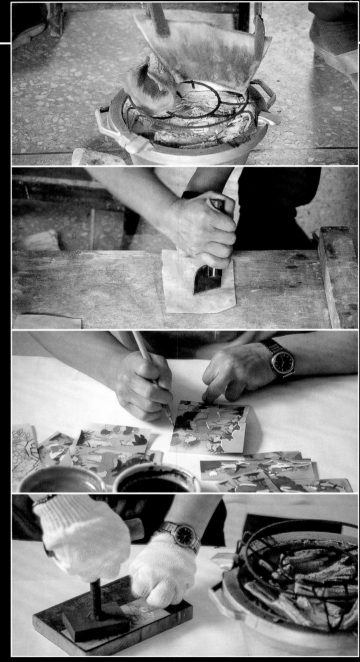

Various stages in the *hwagak*-making process, featuring the work of Lee Jae-man, a master of the craft

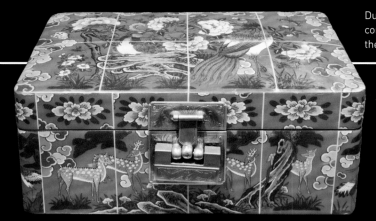

During the Joseon Dynasty, colorful ox horn pieces were most often created for women and included jewelry boxes, combs, spools, measures for the sewing box, and small chests. The painting depicted favorite themes, including the Ten Symbols of Longevity, flowers, birds, the Four Gentlemen Plants, and light-hearted scenes of everyday life.

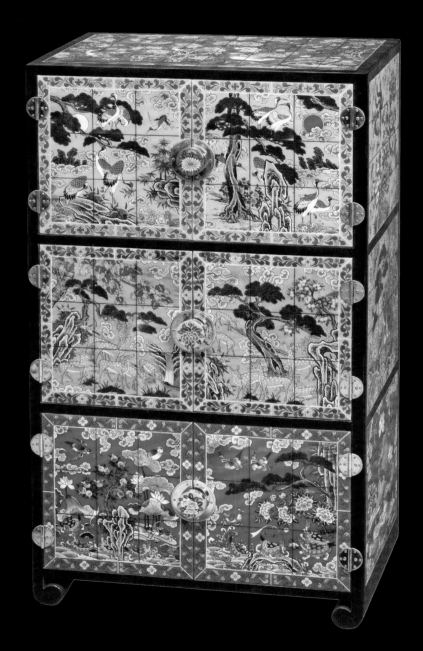

It was during the early Joseon Dynasty that this art form reached its peak. Because of the labor and expensive materials involved, it was produced solely for royalty and the upper classes. The ruling class continued its exclusive use of *hwagak* until the 17th century, when two wars brought about by the invasions of foreign forces caused the decline of the dynasty and thus a relaxation of some of its restrictions. As a result, *hwagak* began being produced for commoners, and the industry grew and thrived for the next 200 years. However, it suffered a serious blow in the early 1900s when a devastating flood in Seoul destroyed the many *hwagak* workshops located near the Hangang River, from which the industry never quite recovered. As a result, painted ox horn began to be replaced by celluloid imitations.

Fortunately, there are still several master craftsmen who continue to practice *hwagak* today, creating beautiful antiques of tomorrow. Because of the extreme skill and amount of time required to create one of these pieces, they are very expensive and are usually available only in museum shops and showrooms featuring the work of National Treasures.

A beautiful example of *hwagak*, which means "brilliant horn."

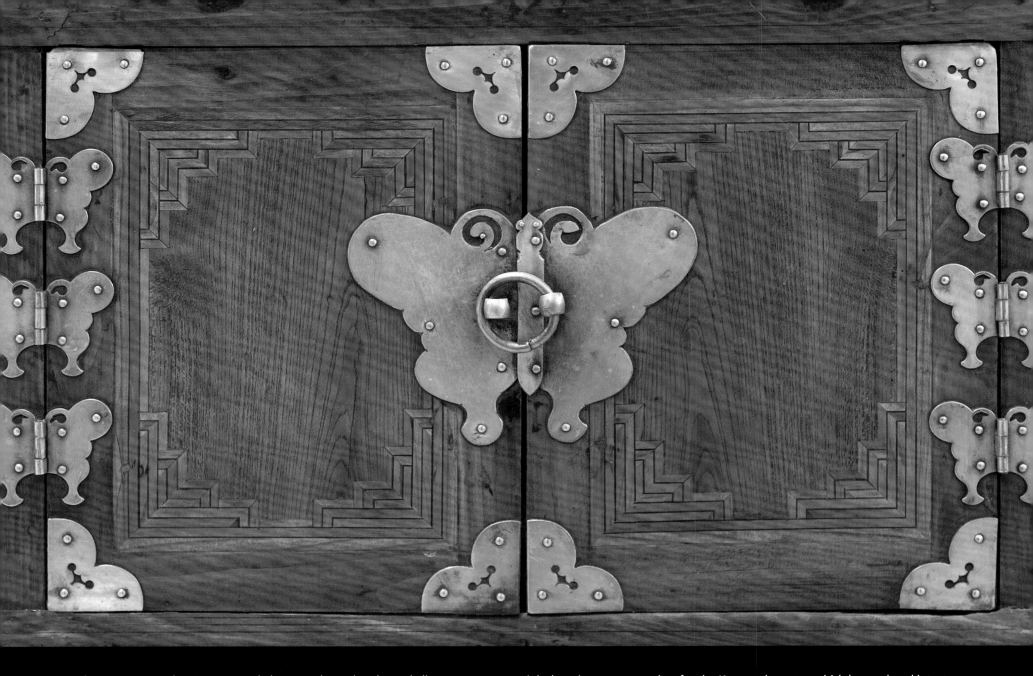

Since the Bronze Age, the Korean people have used metal and metal alloys to create household items, fittings, tools, weapons, religious items, and personal ornaments. As early as the Silla and Goryeo periods, these arts reached great heights of sophistication. One of the five basic elements in the Korean cosmology, metal is strong and enduring but can also be shaped to life's purposes. In this sense, metal might be taken as a metaphor for the Korean character, which has endured intact through centuries of hardship, bending to shoulder the burdens of invasion and periodic conquest but never breaking. Whether in the form of a beautiful fish lock on a Korean chest or the stately, sonorous sound of a temple bell, metal continues to support and express the Korean spirit.

Furniture Hardware Duseok 두석

Traditional Korean furniture is characterized by naturalness and simplicity. Primarily different types of wooden chests, the pieces are made from trees native to the Korean Peninsula. Usually rectangular, straight sided, and relatively small in size, the chests are decorated with metal hardware (*duseok*) that serves to strengthen, protect, and embellish. Hinges, handles, decorative plates, corner braces, and locks are made of yellow, white or red brass and wrought iron. With the exception of locks, *duseok* are flat and gracefully shaped, often with lovely curved lines. In the traditional Korean home, itself quite small, chests were placed side by side against the wall, hiding the back and sides from view. For that reason, they were decorated only on the front, while the backs and sides were left plain.

The brasses also contribute to the well-being of the family because they depict many different types of auspicious symbols. Plants, animals, geometric shapes, and Chinese characters convey wishes for longevity, happiness, wealth, health, fertility, and other longed-for outcomes. The juxtaposition of the simple lines of the chests and the elegance of the hardware creates unique and particularly lovely furniture that is rich in symbolic meaning.

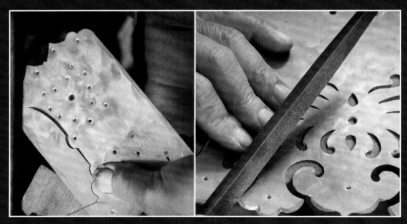

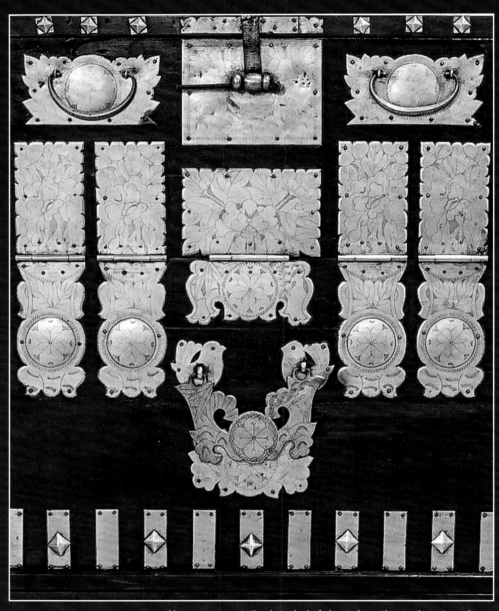

Heavy ornamentation is typical of chests from the northwest provinces.

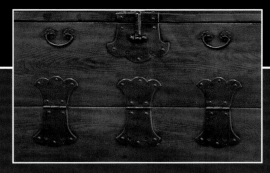

Thought to resemble a pair of socks, this hinge is aptly named the "paired socks hinge."

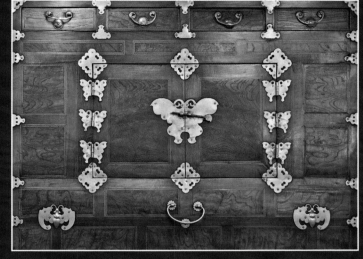

The delicate hardware on this ladies' headside chest is filled with meaning. The butterflies signify love and happiness, the bats good luck and longevity, and the angel wing corners on the doors ensure that the gods of the house will protect its owner.

Chests made for different purposes and in different parts of Korea have traditionally had different types of fittings. For example, headside chests made for the women's quarters (*anbang*) were embellished with bright brasses and delicate themes, such as butterflies, birds, and flowers. Furniture made for the scholar's quarters (*sarangbang*) often had iron fittings because of their dignified masculine appearance. While chests made in the central region of the country had very simple round or square brasses, those made in the northwest provinces were densely covered with elaborate *duseok*. The origin and function of chests could be easily determined based on their style, the type of wood used, and their metal fittings.

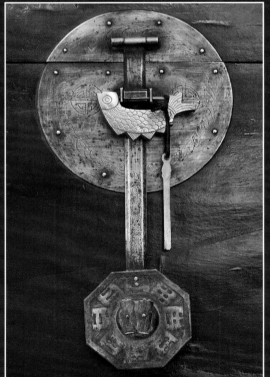

Korean chests were traditionally secured with metal locks to protect their contents. Later, locks took on a more decorative function. Often shaped like fish, turtles, bats, or dragons, locks bestowed additional blessings to the family through the furniture to which they were affixed. Fish, which have eyes that never close, were considered fine guardians, and they also represent fertility, given the large number of eggs they lay. Turtles symbolize protection, long life and prosperity. Bats drive away evil spirits, as do dragons. Dragons, originally the exclusive symbol for the king, later also came to represent the scholarly pursuits of noblemen in the Joseon Dynasty.

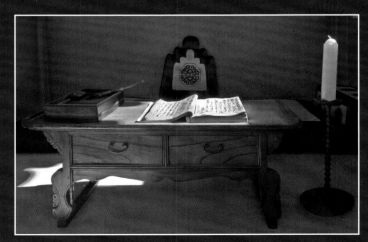

In contrast to the lively ornamentation on the ladies' headside chest, this scholar's desk appears spare and somber, befitting the thoughtful work that takes place in the *sarangbang*.

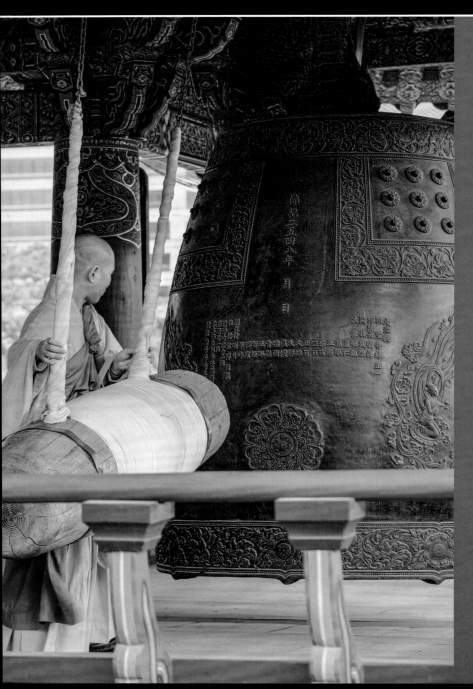

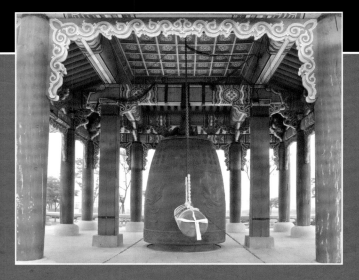

Throughout much of Korea's history, Buddhism has greatly influenced its art, an excellent example being Korean temple bells. Several hundred old bells remain in Korea and are admired as some of the finest in Asia. Unique in a number of respects, they are made of bronze rather than iron and have a distinctive straight-sided shape, which results in a particularly beautiful resonance. Perfected during the Unified Silla period (676–935) and made for 1000 years, bells were no longer being produced by traditional methods in the mid-Joseon era. Eventually, that knowledge was lost.

In the 1980s, however, after decades of research and effort, a Korean artisan devoted to making bells discovered that the key was the beeswax casting method that had been used in ancient times. Beeswax was mixed with beef fat, molded into the shape of the bell to be made and carved with the decorative motifs that the bell was to contain. This mold was then carefully covered with layers of clay. It is believed that the excellent clay found in the area near Gyeongju, where many of the old bells were made, was a factor in their fine quality. After the clay had dried, the wax was carefully melted away, and molten metal was poured into the mold.

The most famous of these ancient bells is the Devine Bell of King Seongdeok, commonly called the Emille Bell (*Emille* is the ancient Silla word for "mother") or the Bell of Bongdeoksa Temple, where it was first hung. This bell weighs an amazing 18.9 tons and had to be cast several times because the first versions made no sound when struck. Finally, 34 years after the project began, the bell that is now National Treasure No. 29 was successfully cast in 771 AD. One of the largest bells in the world, it has a magnificent sound—which some say resembles the cry of a child calling for its mother—that reverberates for an exceptionally long period of time.

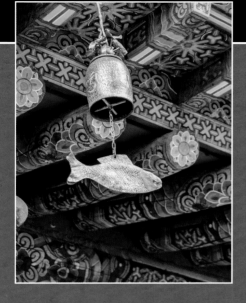

The Buddhist tradition produced another type of bell that is still very common in Korea, the windbell or *punggyeong*. A tiny version of the temple bell, these charming bronze bells are typically hung from the eaves of Buddhist temples. The metal piece that hangs below the bell and catches the wind is made of copper and shaped like a fish. Always moving, the fish symbolizes Buddhists' continuous quest to achieve Nirvana.

An unusual bell that is also found in Korea is the tiger bell. Varying in size from 1 to 3 inches, these very appealing bells are cast with the face of a smiling tiger on either side. Found throughout Asia, tiger bells probably originated with early shamanist groups. They have also been used as amulets and dance bells and tied to animals. In times past, parents also tied small tiger bells to their baby's ankle to drive away evil spirits.

Usually flatter than they are wide, tiger bells have a square loop at the top, the Chinese character "王" meaning "king" or "royal" above the tiger's nose, and other curving decorative lines covering the remainder of the surface.

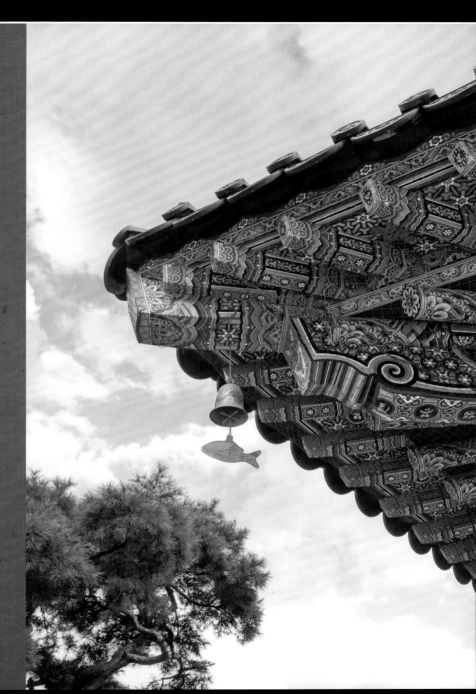

Royal Gold *Geumje Gwansik* 금제관식

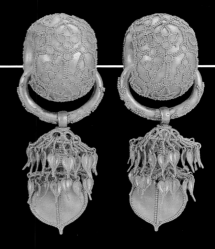

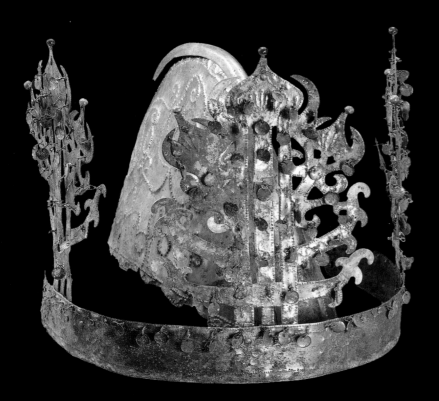

Although Koreans have worked with metal since the Bronze Age, it wasn't until the Three Kingdoms Period that gold was used. Both the Baekje and Silla kingdoms are known for their mastery of goldsmithing, and some of the most beautiful Korean artifacts have been recovered from tombs dating from those eras. Among the stunning pieces made for royalty and the aristocratic elite are elaborate pins and earrings, gilt-bronze shoes, gold girdles and belts, swords with gold hilts, saddle fittings, and, perhaps the most famous and striking of all, gold crowns.

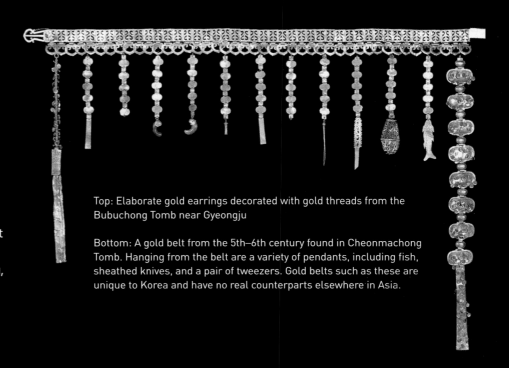

Gold was plentiful in the southeastern part of the Korean Peninsula. Indeed, the capital city of Silla was called Geumseong ("City of Gold"). Crowns have been excavated from royal burial chambers that were exceptionally well fortified, happily protecting their precious contents from robbers throughout the centuries. The best known of these tombs are Geumgwanchong ("Gold Crown Tomb") and Cheonmachong ("Heavenly Horse Tomb") near Gyeongju, but all have yielded elaborate crowns of pure gold (thought to have been made for kings) and giltbronze and gold-plated bronze (undoubtedly for lesser royal figures). A number of these have been designated as National Treasures.

Top: Elaborate gold earrings decorated with gold threads from the Bubuchong Tomb near Gyeongju

Bottom: A gold belt from the 5th–6th century found in Cheonmachong Tomb. Hanging from the belt are a variety of pendants, including fish, sheathed knives, and a pair of tweezers. Gold belts such as these are unique to Korea and have no real counterparts elsewhere in Asia.

These unassuming grassy mounds near Gyeongju are typical of the royal tombs of the Silla Kingdom. Their construction—a wooden chamber, either below or above ground, covered with thick layers of large rock and then earth—served to protect the golden artifacts buried deep inside for centuries.

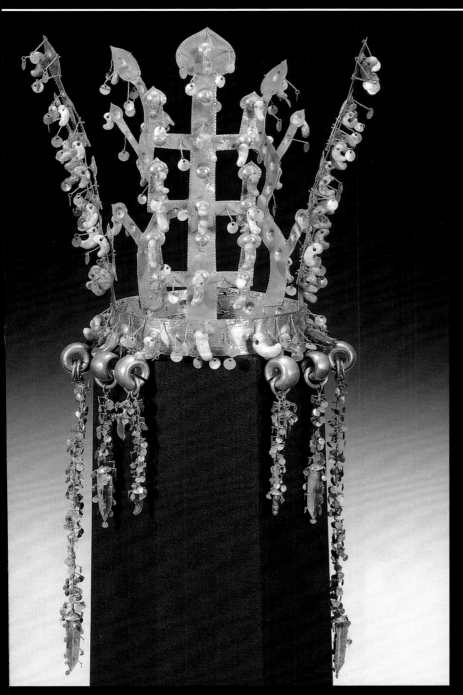

The crowns were composed of two parts—an inner cap of rigid gold mesh that may have been covered with silk, and the actual outer crown. In addition, chains made of gold with pieces of jade were attached to the outer band of the crown. The main part of the crown typically had several treelike protrusions, each with three or four branches, commonly thought to represent the Siberian shamanist idea of the world tree, although others interpret them to be mountains or birds. Each crown also typically had two antler-like prongs that also suggest a strong link to Korean shamanism and reindeer. At the same time, some have compared the level of goldwork seen on the crowns with work done by Greek or Etruscan artisans and have suggested that the Silk Road may actually have stretched all the way to Korea. Interestingly, however, there are no Chinese influences in these crowns.

The most famous crown of all, National Treasure No. 191, shown at left, is 27.5 cm high, with gold chains that range from 13 to 30.3 cm in length. Seventy-seven pieces of jade, both green and blue, are attached to the trees, antlers, outer band, and gold chains of the crown. Small gold "mirrors" are liberally attached as well. It is easy to imagine that the crown, when worn by the king in bright sunlight, would present a vivid image of the "sun on earth," a traditional and highly symbolic role for Silla royalty.

An elaborate gold ornament that was attached to the silk burial cap of King Muryeong of Baekje (501–523 AD)

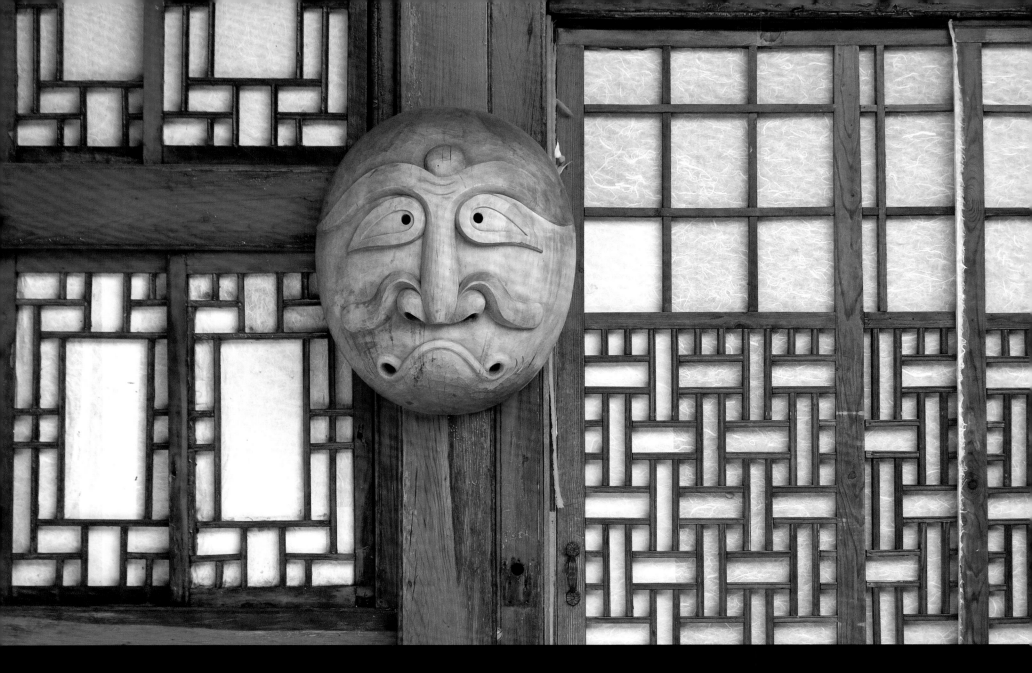

Inhabiting a land of rock and forest for many millenia, the Korean people have a deep reverence for nature and natural forms. The indigenous Korean religion of shamanism posited that the goal of a fully human life is to live in harmony with nature. Wood is considered to be a warm, beautiful, strong, and malleable material that is a gift from nature and, appropriately, returns to nature. In addition to playing

an essential role in heating and cooking, it has been used throughout Korean history to construct buildings, to cover doors and windows, to make furniture and countless other items for the home and the farm, to create objects used for safeguarding, celebrating, and entertaining, and finally, to fashion the conveyances and guides that help ease the soul to the afterlife at the time of death.

Wood

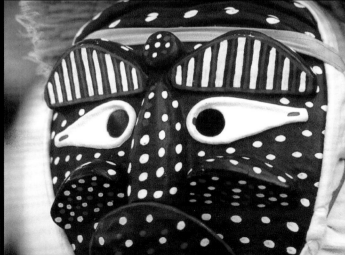
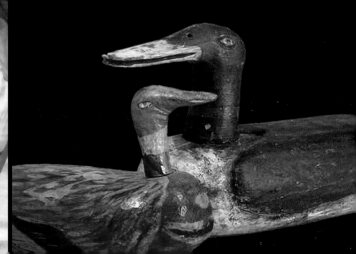

Masks *Tal* 탈

The Korean mask dance (*talchum*) or mask play (*tallori*) originated in the Three Kingdoms Period and developed through the Goryeo and Joseon Dynasties into the form seen today. It was unique because, unlike dance traditions in many other cultures, it was not performed by professional actors or dancers. Rather, members of the community spontaneously took the roles of the dancers and enacted a performance that was never the same twice.

Based on even earlier shamanistic rites in which masks were donned in an attempt to drive out evil spirits, illness or bad luck, the *talchum* became a way in which the common people expressed their criticism of the aristocracy and the clergy and poked fun at themselves. By creating spoofs—the stupid nobleman and his clever servant, the drunk Buddhist monk who chases women, the eternal love triangle of husband/wife/concubine—and mocking the village gossip or meddling grandmother, *tallori* was able to provide comic relief from the stresses of everyday existence.

Traditionally, all mask dancers were men, even for female roles. Combining comic dialogue, dancing, singing, and pantomime, the plays were commonly performed at night around a campfire and were accompanied by *nongak,* or farmers' music. Several different acts of no set length were performed, and often the audience joined in with the performers, making for a rowdy party! When the play was over, the masks were burned and new ones made for the next performance.

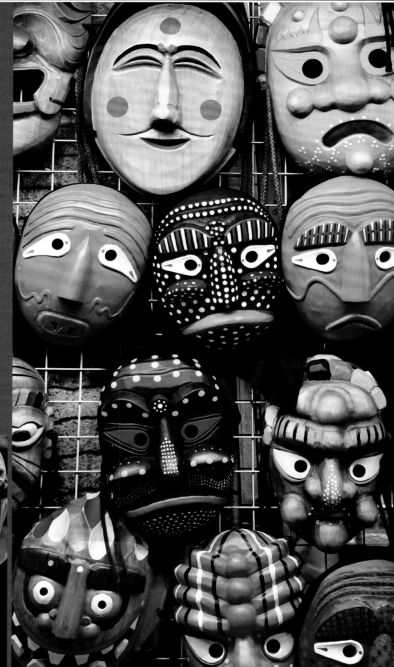

The masks that are used in the plays vary according to the region in which they are made. Those from the central part of the country tend to be made of wood, while masks from the west coast are often made of paper. Sometimes gourds are used. Some masks are quite realistic, while others are clearly caricatures of the person being portrayed. Most have a black cloth attached to the back of the mask that helps hold it in place and gives the illusion of hair. Generally, a white mask indicates a young person, red denotes a middle-aged person, and black tells the audience that the character is elderly.

Probably the most famous masks are those that have been made in Andong's Hahoe Village since the middle of the 12th century AD. Each carved from a single piece of wood, they have hinged chins that can be moved by the actors as they perform to simulate a wide range of emotions.

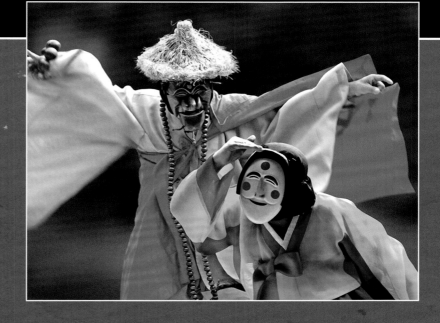

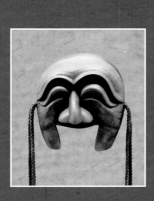

According to legend, a Hahoe village resident, Bachelor Heo, was instructed by the gods to make twelve masks, but he was to have no contact with other people until he finished. He locked himself in his house and proceeded to follow orders. As he was working on the chin of the very last one, a young village girl, who was in love with him, peeked in through his window. As a result, Heo was punished by the gods and died, and the last mask was never finished. To this day, this mask—the *imae* or "fool"—is portrayed without its lower jaw.

The people of Hahoe believed their masks had magical powers that would protect their village, so unlike in other regions, their masks were not burned at the end of the dance or play but carefully stored in a local shrine. You can imagine their dismay when three of the original masks disappeared. Two are believed to be in a neighboring village, and the third has been found in a museum in Japan, probably stolen by Japanese invaders over 400 years ago. The remaining nine masks have been designated as National Treasure No.121.

Some of the many masks that appear in the Korean mask dance

 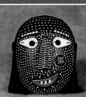 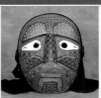 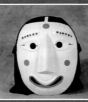 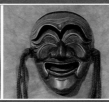 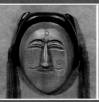 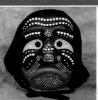 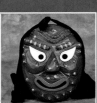

| *Choegwari* Drunken monk | *Gaksi* Bride | *Miya* Old woman | *Malttugi* Servant | *Waejangnyeo* Barmaid | *Yangban* Aristocrat | *Bune* Flirtatious young woman | *Nojang* Old man | *Jung* Monk |

Anyone who has heard Korean drumming can never forget it. The artistry of the drummers together with the physical beauty of the drums touch the soul. Used in most genres of Korean traditional music, drums have been a part of Korean culture since the Three Kingdoms Period. An integral part of folk or farmer music (*nongak*) throughout the centuries, drumming shapes the rhythmic structure of the music, guiding the dancers and captivating the onlookers. Drums are also a major part of ceremonial and military processional music, serving to punctuate melodic phrases in the music and also to indicate starting and stopping times to the rest of the orchestra. Drums are used in *pansori* as well, in which a narrative story is sung and told by a master performer to the accompaniment of a single drum.

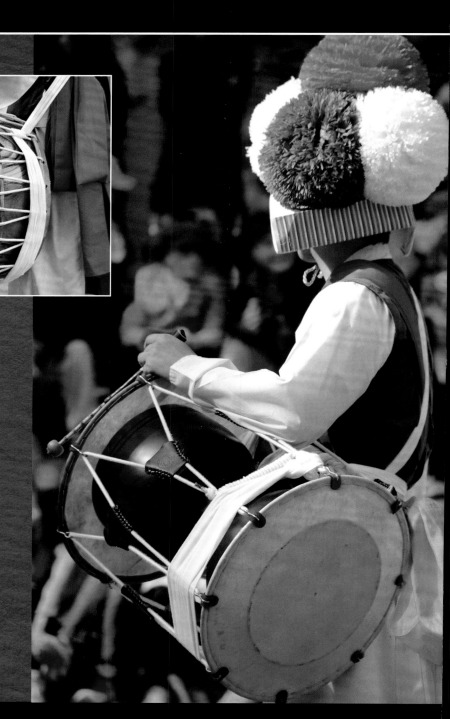

Korean drums come in two basic shapes. The most common, the *janggu,* is shaped like an hourglass and is usually played by striking the left end with the hand and the right end with a bamboo stick. Made in various sizes, the drum is shaped from a single piece of paulownia wood that is hollowed out into the shape of two bowls (connected by a thin hollow neck that acts as a resonating chamber), covered with leather mounted on metal hoops. The two heads are slightly different in size, and the skins covering them differ in thickness, which produces sounds of varying pitch. They are tightly laced together with a cord that is used to adjust their tension. The drum, which may be painted red or left a natural color, is played from a seated or standing position and carried by the drummer in outdoor performances of farmer music.

A variety of drums are used in the traditional Korean farmers' dance, including the small *sogo*.

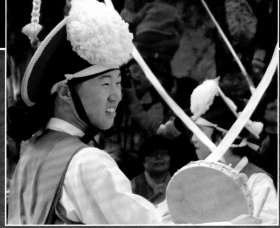

The barrel drum, or *buk*, comes in approximately 20 different sizes and proportions, ranging from the *jingo*, which is about 160 cm in diameter and mounted on a stand, to the *sogo,* which is about 20 cm in diameter and held by its wooden handle. Barrel drums are usually made of pine with drum heads of cowhide.

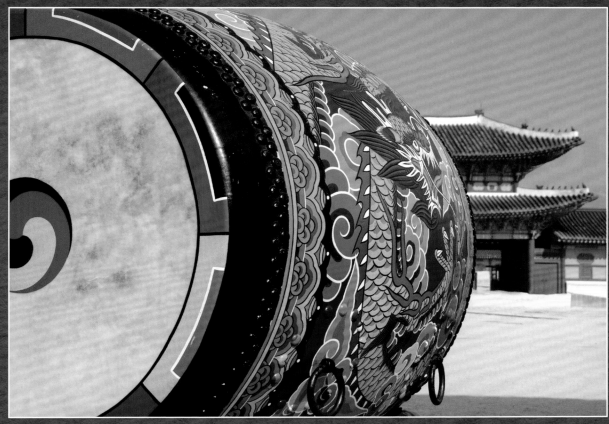

A spectacular *yonggo* stands in front of the entrance to Gyeongbokgung Palace.

It is common to see the Korean *taegeuk* design painted in the center of the drum heads. Dramatic, colorful designs are also often painted on the barrel, as well as the stand holding some types of drums. Of the barrel drums, the *yonggo,* or dragon drum, is one of the most beautiful and versatile. Sometimes referred to as a "spirit-invoking drum," the *yonggo* is painted with a glorious dragon in vivid colors. Of medium size (approximately 35–40 cm wide and 20–25 cm deep), it is carried by means of a shoulder sash and is used in military processional music (*gochwi*). The *soribuk* drum used to accompany the singer in a performance of *pansori* looks similar to *yonggo*, but has no dragon painting on it. The drummer, seated with the drum upright in front of him, strikes the head of the drum with his left hand and the barrel of the drum with a stick held in his right.

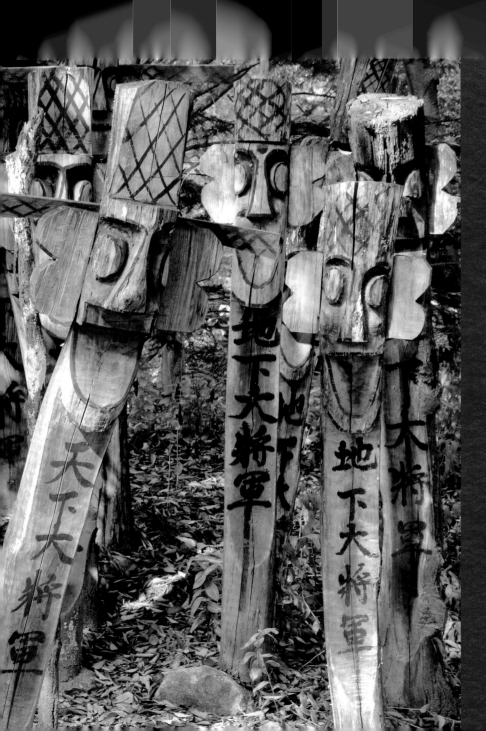

In the past, every village in Korea had a pair of totem poles known as *jangseung*, one male and one female, at its entrance. Dating from at least the 8th century, totem poles were believed to protect the village from evil spirits and to ensure peace and prosperity for all.

Reflecting Korea's animistic tradition, regular ceremonies were held to honor the spirits residing in the poles by offering food and drinks. Other rites were held to pray for a bountiful harvest and, on occasion, to pray that illness in nearby areas would not spread to the village. Totem poles were also used as mileposts along roads and to demarcate the limits of village property. There was usually a pile of stones around the base of the pole, placed there by praying villagers or travelers.

The male pole was carved with the inscription "The greatest general under the heavens," meaning guardian of heaven, this life, the here-and-now. The female pole was inscribed, "The greatest general under earth," meaning protector of the earth or the netherworld. Together, the poles symbolized one universe or *yin/yang*.

The installation or repair of a totem pole was a special occasion that could take place only in lunar leap months occuring every three years. The village chose an individual who was considered lucky to lead the ritual, someone who had seen neither a dead body nor the blood of an animal for a specified period of time. The area where the pole was to be erected was cleaned, food was prepared, and a tree was cut down. It had to be carved, painted, and erected in one day, after which the village held a celebratory feast.

Carved from tree trunks in most parts of Korea but made of stone in the southern regions, the poles had purposefully ugly, comical, or weird faces, the better for scaring away evil spirits. Bulging eyes, a round potato-shaped nose, a wide-open mouth, protruding teeth, big ears, and hats were standard.

Stone poles called *hareubang* are found on Jejudo Island off Korea's southern coast. Carved from the volcanic rock that covers the island, they have a slight smile instead of a huge open mouth, with both hands resting on the belly. If the right hand is above the left it indicates a scholar, while a left hand above the right signifies a military figure. Large stone *hareubang* once stood outside the gates of the Jeju Town Fortress. Today small replicas are sold as souvenirs, as they have become an important part of the island's culture.

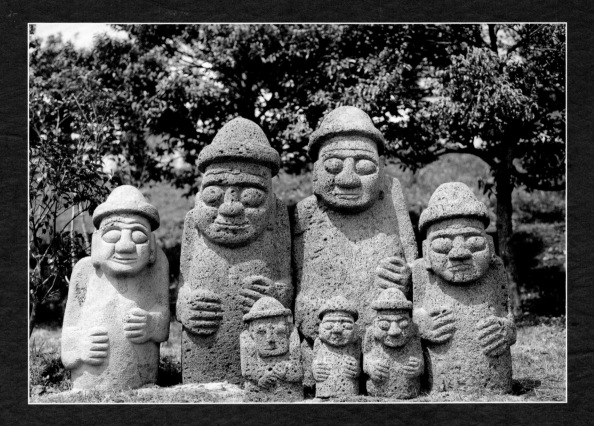

During the past 50 years, as large numbers of Koreans have left their villages to live in urban areas, totem poles have become less important. There is currently only one master *jangseung* carver in Korea. Lee Ga-rak, who lives in the city of Chuncheon, has been making the traditional poles for 20 years. Hoping to preserve and extend the appreciation of this uniquely Korean folk craft, Lee teaches students how to carve, produces souvenir items based on the poles, and has a larger goal of installing pairs of *jangseung* in 100 countries around the world. To date, he has donated at least 20 poles that have been placed in France, Luxembourg, and Italy.

Stone *jangseung* such as these are typical of those found in southern coastal villages in the province of Jeolla-do.

Spirit Poles *Sotdae* 솟대

A *sotdae* is a tall wooden pole, or sometimes a stone post, that has a carved figure of a bird sitting at its top. Traditionally placed at the entrance to a village, the *sotdae* was a guardian spirit and object of worship, protecting the village and its inhabitants from illness and harm and ensuring a good harvest. The number of birds on a *sotdae* varied from one to three. They were placed facing south if the wish was for good weather for farming, to the north to bring rain, and away from the village to repel evil spirts.

The bird could be a crow, a goose, a magpie, or even an ibis, but the great majority of time it was a duck. In early Korean agricultural society, ducks were thought of as protectors. Because they could travel through the air, on land, and, most importantly, both on and under the water, ancient Koreans believed that ducks could control the rain, survive floods, and protect a village from fire.

Because ducks are migratory birds that come and go with regularity, it was also believed that they carried the souls of the dead to the afterlife and served as messengers between the human and spirit worlds. Villages prayed to the *sotdae* to protect them from harm and disease, to bring peace to the village, and to ask for an abundant harvest.

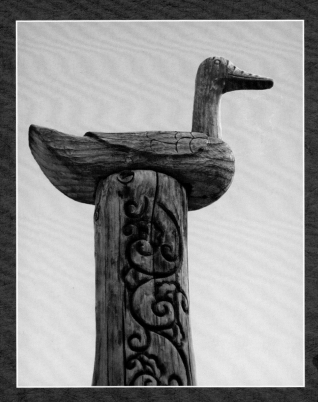

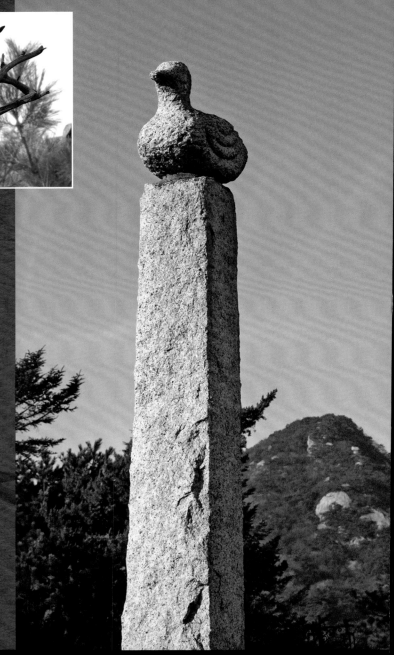

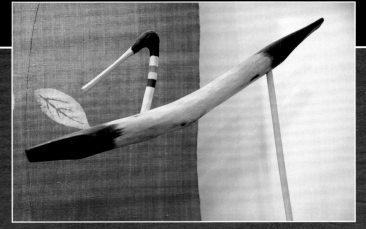

Families would also use *sotdae* to give thanks for a happy event or to celebrate a special achievement such as a graduation. In these instances, the *sotdae* was erected in the yard, where it might be topped with a dragon instead of a bird and painted in bright colors. This way the entire village would know that the family had something worth celebrating.

The *sotdae* tradition continues in Korea today. At Imjingak: Pyeonghoa-Nuri Park, near the border with North Korea, hundreds of brightly-colored *sotdae* stand tall in a field, carrying wishes for peace up to the heavens.

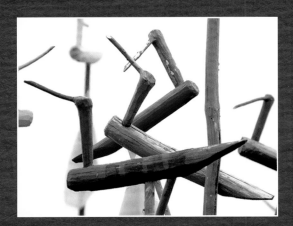

Stamps and Molds Tteoksal 떡살 & Dasikpan 다식판

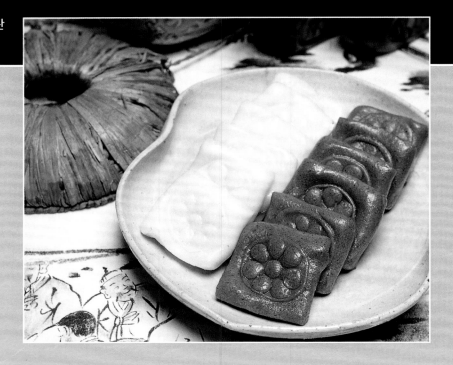

Rice cakes (*tteok*) have been made and enjoyed in Korea since the the Three Kingdoms Period, centuries before boiled rice as is eaten today was introduced. *Tteok* were an indispensable food on special occasions, which included the changing of the seasons, holidays, special events such as a first or sixtieth birthday, or the first day of the first lunar month, when the spirits of ancestors were traditionally invited to enjoy the special treat. As the poet Lee Sang said, "Out wafts that wholesome aroma of fresh-steamed pumpkin rice cake, and in drifts grandfather."

Traditionally, the type of rice cake varied with the occasion. The layered rice cake, made from non-glutinous rice flavored with either young mugwort leaves or the budding leaves of the zelkova tree, symbolized spring. For Chuseok, the Harvest Festival, folded rice cakes steamed over pine needles and filled with sweet bean paste were common. Although modern ingredients may have taken the place of some traditional ones, *tteok* are as common today as they have ever been.

Tteok are decorated, colored, or stamped with auspicious designs. The wood or porcelain stamps made for this purpose (*tteoksal*) are charming, and their designs are meaningful, sending a personal message for the occasion. For that reason, *tteoksal* were traditionally never made from trees that had been struck by lightning. At a wedding, pomegranate and grape designs signify fertility and longevity, butterflies send a wish for happiness, and bats symbolize good fortune. When honoring ancestors, rice cakes

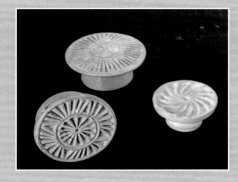

might have patterns of lotus flowers, symbolizing immortality. Animals, plants, and geographic features found in the woods and mountains are more likely to appear on *tteoksal* in inland areas, while images associated with the sea are more typical in coastal areas.

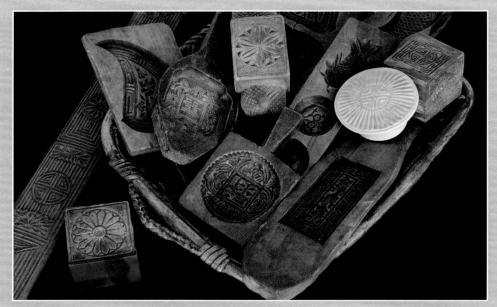

Hand-carved from pine, oak, persimmon, birch, ginkgo, or jujube, *tteoksal* and *dasikpan* are treasured by families, who hand them down from generation to generation.

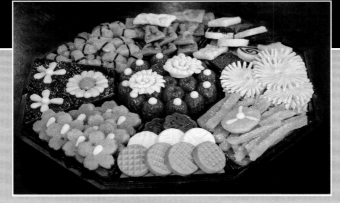

Another type of treat with a long history is *dasik*, small cookies made from ground sesame seeds, rice, and honey. They became particularly popular during the Goryeo Dynasty when Buddhism discouraged the eating of meat, resulting in an increase in the consumption of grains. In fact, they became so popular that twice during the 12th century their production was banned by the king for fear their popularity would result in a shortage of their ingredients. This carried into the Joseon Dynasty, when the penalty for commoners eating the sweets at times other than weddings or ancestral rites was 80 lashings with a bamboo rod!

The cookies are made in molds called *dasikpan*. The dough, in traditional Korean colors, is placed in a two-part mold that creates individual round cookies impressed with auspicious designs indicating wishes for longevity, good fortune and happiness.

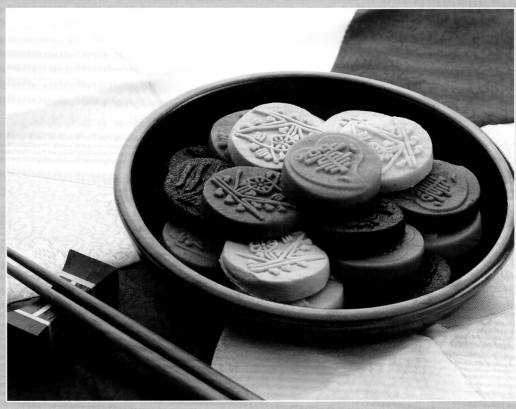

The word *dasik* means "tea food" because they are especially good when served with tea. These rich cookies have been said to be too beautiful to eat in just a single bite.

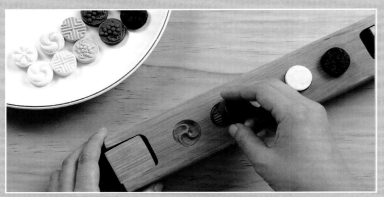

In the 1970s, with the advent of machine-made *tteok* and *dasik,* the use of traditional *tteoksal,* and *dasikpan* decreased, and they found their way onto the walls of Korean homes as decorative objects. However, today's tea drinkers are rediscovering the custom of making *dasik* in traditional molds, thus bringing those *dasikpan* down off the walls and back into service as they were intended.

Wedding Geese *Gireogi* 기러기

The Korean people, farmers in close touch with nature for most of their long history, knew that wild geese (and ducks) mate for life, a characteristic that lent itself readily to Korean symbolism. Geese represent fidelity, loyalty, and trustworthiness, and they came to be used in Korean wedding ceremonies many centuries ago.

The goose plays a very special role in the traditional ceremony. Although it is believed that live geese and ducks were originally used, carved wooden replicas became popular early on, for obvious reasons. Choosing the person to carve the goose was a matter of serious consideration. It was believed that this person must be a close, honorable friend who would accept no payment for the work. He must also possess the "five fortunes"—wealth, perfect health, a good wife, many sons, and an extended family free of divorce—because he would pass his fortune on to the bride and groom through the goose that he made for them. Skill at carving was less important than these other virtues, which may explain why the quality of the carving varied widely, from exquisite to fairly crude.

The goose is made in two parts—the body and the head/neck, which fits into the body and can be swiveled when in place. Carved of pine or paulownia wood, the bird is often painted in bright colors. Originally, the bill of the goose was decorated with red or blue threads, strung through tiny holes carved in the beak. In pairs of wedding ducks seen in markets today, however, the bill of the female is tied closed with thread, symbolizing the Confucian belief that wives should obey their husbands. The wedding goose is wrapped in a beautiful *bojagi* called a *gireogibo*, usually embroidered with symbols of wedded happiness.

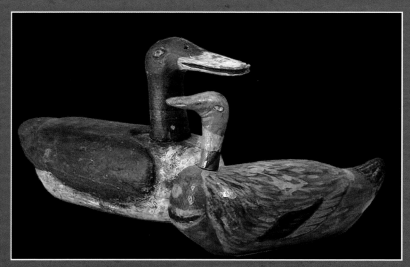

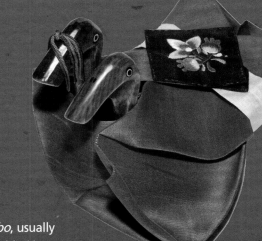

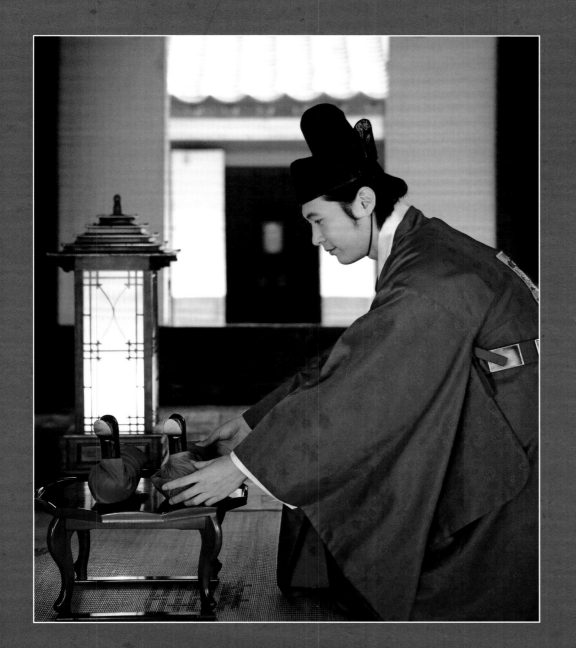

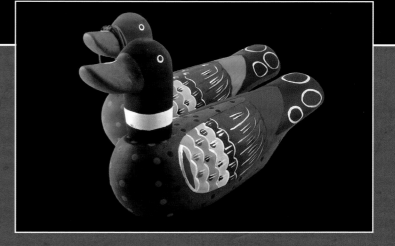

The day before the wedding ceremony, the groom, with a group of attendants that included the "blue lantern carrier," the "gift carrier," and the "wild goose carrier," went to the bride's home to greet her parents. He presented the goose to the family as a token of his lifelong loyalty to their daughter, placing it on a special table with its head pointed to the left. The groom's mother carried it to the bed chamber that would be used the next day. If the goose sat solidly upright when placed there, it was believed that the first child born to the couple would be a son. Much merriment followed the presentation of the goose, surely a traditional variant of today's bachelor's party. In the wedding ceremony the next day, the goose was carried by the groom and placed on the ceremonial table, where it remained throughout the proceedings.

Although many Korean couples now exchange vows in a Western-style marriage ceremony, traditional ceremonies do still occur and may be growing in popularity. Pairs of wedding geese are commonly given as wedding gifts, carrying on a meaningful, time-honored, and symbolically rich tradition.

Funerary Figures *Kkokdu* 꼭두

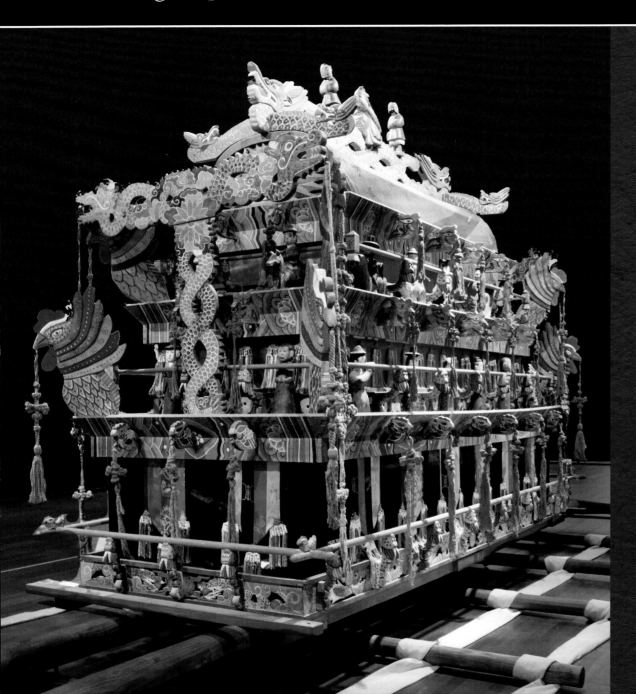

In traditional Korean village life, family members who died were buried in the family burial plot, which was often located in the countryside, some distance from the village. The body had to be carried from the home to the burial site, and the journey between the two places was considered to be a time of danger for the deceased, who was no longer "here" but not yet "there." To ward off evil spirits on this journey, small figures known as *kkokdu* were attached to the funeral bier that carried the coffin. Carved for the occasion out of wood (because they were usually burned after the burial), the figures were of several types, colorfully painted, and relatively crude in execution. Four different types of human figures were included, each one 9 to12 inches high, playing four different roles.

Guide had the important job of leading the deceased on the journey of death. Guides were usually men of importance (noblemen, government officials, scholars, or monks) with solemn expressions. The Guide was usually shown riding an animal—a mythical beast, a blue dragon, a horse, a bird, or even a turtle. Occasionally, perhaps for the funeral of a child, the Guide was depicted as a child himself, often seated snugly on the back of a bird in flight.

Guard protected the deceased during the journey. With menacing expressions and often carrying weapons, Guards were usually powerful male figures (military officers, warriors or police officers) mounted on various types of animals.

Caregiver served the deceased during the journey. Most often women, Caregivers were occasionally depicted with smiling faces, although most were solemn. Sometimes they carried objects with them to better serve the deceased, such as jars, cups, and flowers.

Entertainer had the role of lightening the mood of the somber occasion. Jugglers, acrobats, musicians, or dancers, Entertainers were lively and positive, frequently smiling as they capered about. Surely, the journey was easier for the deceased because of the humor and sense of perspective on the natural cycle of life and death that Entertainers provided.

In addition to these human figures, dragons and phoenix, symbolizing the transcendent power of the king, served to further protect the deceased on their journey. Dragon faces were placed on the front and back of the bier to ward off evil spirits, aided by two more on top, one yellow and one blue, with their tails braided together. A phoenix sat on each of the four corners, symbolizing the flight from this world to immortality.

Kkokdu represent a little-known but significant and very appealing type of Korean folk art. Common during the Joseon Dynasty and into the Japanese occupation, they tell us much about village life and beliefs in rural Korea.

Guide

Guard

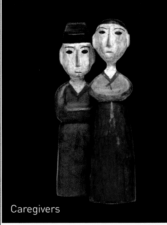

Caregivers

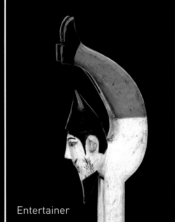

Entertainer

Dragon

Phoenix

Temple Doors *Kkotsalmun* 꽃살문

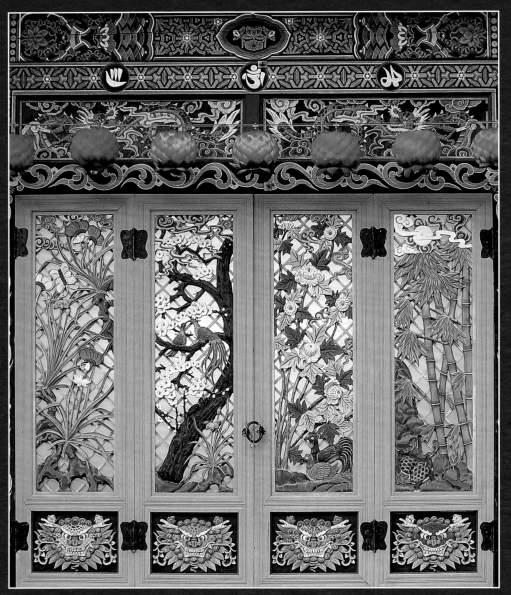

Baekcheonsa Temple

Buddhism was brought to Korea in the second half of the fourth century by monks from China. It flourished and spread, becoming the official religion of Korea for 1000 years until it was suppressed at the end of the Goryeo Dynasty.

The ultimate goal of practicing Buddhists is to reach a state of Nirvana in which suffering is overcome. Desire and ignorance are surmounted through a life of moderation, moral conduct, and meditative practice. A Buddhist temple represents that "pure land" of Nirvana, filled with flowers, butterflies, singing birds, fragrant scents, and sparkling water. It is a place where people come to rest, refresh themselves and pray.

Welcoming visitors, temple gates and doors are lavishly decorated with bright colors and, most typically, with beautiful floral designs. Made of wood, the gates are lattice (*bitsalmun*), like those of other traditional Korean buildings, but they are unique in that they frequently combine diagonal and vertical lines (*soseul bitsalmun*).

Buddhism represents the religion of approximately one-third of the population of Korea today.

Many doors have elaborately carved openwork designs attached to solid pieces of wood that are combined with the lattice. The Ten Symbols of Longevity, animals, and even human figures may be used in these designs. The entire door often has an inner layer of traditional handmade paper, which softens but does not block the light entering the temple. Often painted with the five traditional colors in the *dancheong* style, temple doors are examples of Korean art at its highest and have been preserved and protected for centuries in temples throughout the country.

Flowers symbolize truth in Buddhist thought, and carved peony and lotus blossoms are often incorporated at the intersections in the lattice of the doors (*soseoulbit kkotsalmun*).

Bongeunsa Temple

Chests & Wardrobes *Jang*

Wooden chests were the most common type of furniture found in Korean households of all classes during the Joseon Dynasty. Perfectly adapted to the typically small living quarters, where family members spent most of the time sitting or sleeping on the floor, *jang* were also relatively small and were arranged along the walls of the room. Primarily used for storing clothing, they ranged from one to three (sometimes even four or five) levels tall. Two doors in the center of each level opened outward. *Jang* were typically constructed of pine or elm, with the doors and panels on the front (facing the living area) beautifully veneered with persimmon, elm burl, or fruitwood. Typically the panels were surrounded by a raised edge and/or a black paulownia wood inlaid key design. Locks and hardware in the shape of auspicious symbols adorned these chests, creating serene works of art that have been considered one of Korea's finest handicrafts.

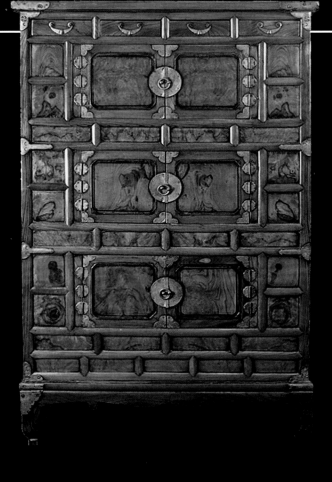

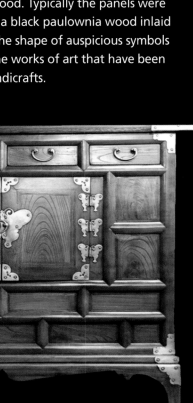

What comes to mind when many people think of a Korean chest is the headside chest, or *meoritjang*. Used beside the head of the bed in a lady's room, or *anbang*, it typically held night clothes and socks. The drawers were used for storing hairpins, jewelry and other ornaments, and sometimes silk chopstick cases. During the day, the mattress and bedding would be folded and stacked on top. However, in the men's quarters, or *sarangbang*, *meoritjang* were used for the storage of books, important papers, keys, and writing instruments. Depending on where it was to be used, a *meoritjang* could be rather plain and somber-looking (for men) or more delicate and decorative (for women).

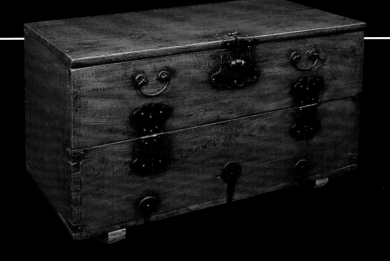

Blanket Chest *Bandaji*

The word *bandaji* means "half-opening," referring to the fact that the entire upper half of the front is a door that opens downward. One of the most common pieces of furniture in Korean homes, they were used in many parts of the living quarters. Commoners typically used *bandaji* instead of *jang* for storing clothes, while in upper-class homes they held household goods and documents. *Bandaji* were made of thick, wide wood panels and were sturdy enough to stack mattresses, quilts, jars, and other household items on top.

Bandaji were produced throughout the Korean Peninsula, and the design, hardware, and decoration varied depending on the region. Those in the north were the most heavily ornamented; they became simpler and less refined the further south they were made. Those made for commoners were constructed of pine, while the upper class chose elm and persimmon woods. However, because the back was typically pushed up against a wall and the sides often touched another chest, it was not unusual for a cheaper wood to be used for the back and sides.

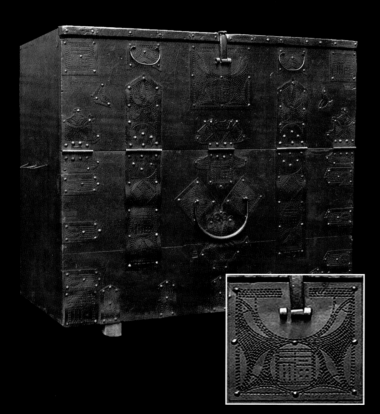

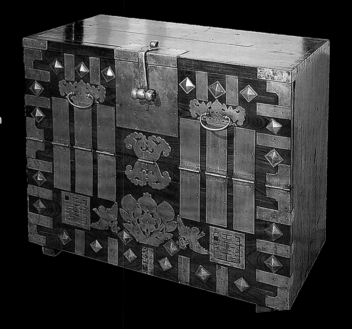

Bakcheon *bandaji* are particularly distinctive. Often 80 percent of the chest front was covered with either iron or brass metalwork, primarily to hide the undistinguished wood, which was usually pine. When cast iron metalwork was used, it was pierced in geometric designs. The fine, lacelike openwork on the chest on the left from Bakcheon, North Korea, is called *sungsungi*. Chest-makers in other provinces sometimes copied this style of openwork, but the perforations were never as tiny or as delicate as those found on Bakcheon *sungsungi*.

Mirrored Vanity *Gyeongdae*

The cosmetic box, or *gyeongdae*, was designed to be used while sitting on the floor and was small and portable so that it could be moved to wherever the light was good, such as in front of a window. The top folded down when not in use, and two drawers were used for storing makeup, combs, and hair ornaments. Often decorated with ornate hardware or inlay, a *gyeongdae* was one of the most essential items that a new bride took with her when she moved to her husband's home.

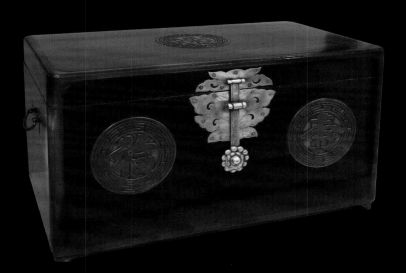

Wedding Box *Ham*

The custom of the *ham*, or wedding box, is a very old one in Korea. According to tradition, the groom's family packed a *ham* with gifts such as jewelry, fabric, clothing, and money and sent it to the bride's family before the wedding as a thank-you for allowing their daughter to marry the groom. It was delivered by several of the groom's friends, who were rewarded for their efforts with drinks and dinner served by the bride's family. Made from woods such as ginkgo, paulownia, lime, or pine, the *ham* was often unlined so the scent of the wood would permeate what was stored inside. Toward the end of the Joseon Dynasty, the exterior often had a lacquer finish with the Chinese characters for "happiness," "long life," and "good luck" molded in relief on the top and front.

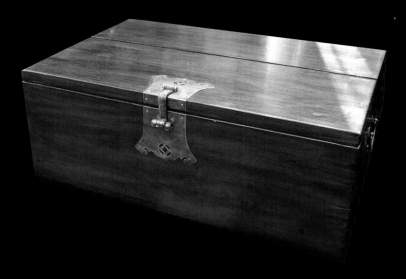

Coin Chest *Dongwe*

During the Joseon Dynasty, coins were the only form of currency. These coins were of very small denominations, so it took a sizable number of them to be of any value. A sturdy money box in which to keep the coins was necessary, which meant that coin chests were usually the heaviest and most well-built pieces of furniture in the home. They opened from the top and were constructed of elm or other hardwoods with heavy hardware and large locks so that they were, understandably, difficult to break into.

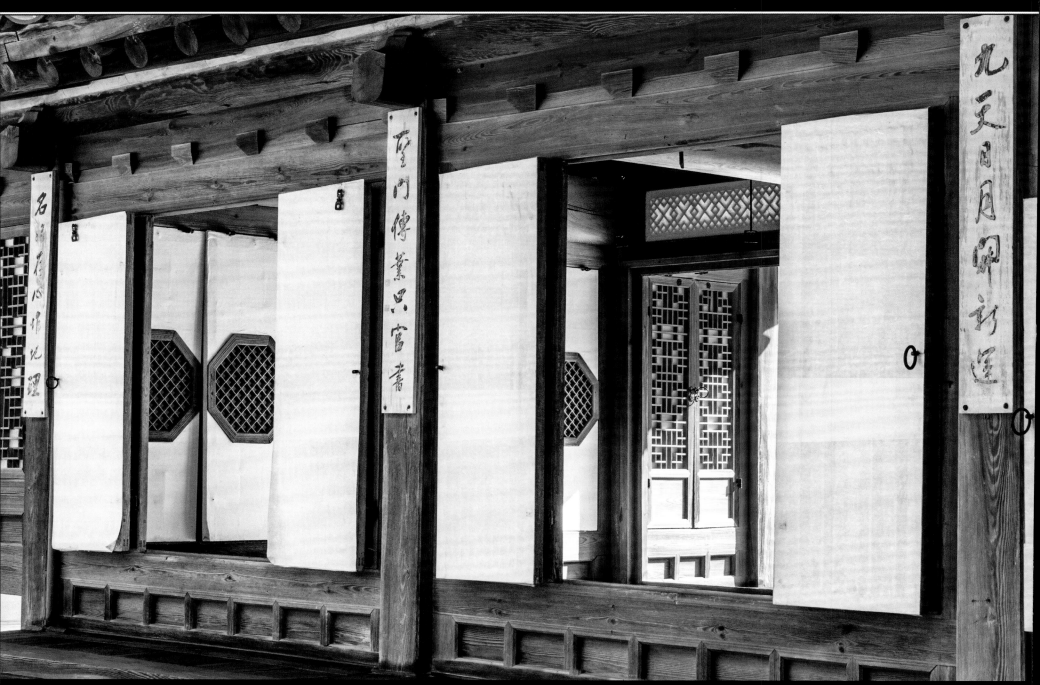

While the *hanji* paper used to cover windows and doors was remarkably strong, it was still necessary to apply fresh paper every year in preparation for winter, using a special paste made of wheat flour.

Korean houses, traditionally small, modest, and environmentally friendly, were not intended to be judged from the outside. Rather, the heart of the house was the interior, where the family lived together. Windows and doors (*changho*) provided some of the only architectural ornamentation for these homes, and served to connect the interior life of the house to the environment surrounding it. They allowed diffuse light and air to enter, creating lively designs, adding visual warmth, and enhancing the quality of life within.

Traditionally, doors were made by master carvers and windows by lesser carpenters. Built from wood, they had frames covered with open lattice designs and then covered on the

inside surface with *hanji*. Leaves and flowers were sometimes inserted between layers of paper for a decorative effect. *Changho* have been described as "plump, yet concise, possessing a sense of simplicity." Interestingly, Korean doors and windows did not fit snugly into the openings in the walls of the house. They commonly had cracks that had to be covered with specially cut pieces of paper.

Before the Goryeo Dynasty, the lattice designs consisted of simple vertical lines. In Goryeo times, designs became more elaborate and refined. With the advent of the Joseon Dynasty and its Confucian ideology, there was a return to simpler patterns, although the more elegant Goryeo designs were still retained. Each design had its own name, some of which incorporated symbols of everlasting life, wealth, or great blessing. This symbolism further enhanced the personal, lively spirit of the house. These doors and windows are still seen in Korea today, especially on traditional homes that have been preserved or restored.

Although strongly influenced by the Chinese, Korean painting evolved over the centuries to be unique in most respects. Less rigidly constrained than Chinese artistic traditions, Korean painting thoroughly blends elements of shamanist, Buddhist, Daoist, and Confucian belief to faithfully reflect the Korean character. Varieties of folk painting were enjoyed by all classes, from the king to commoners, and could

be found in the palace, the *yangban* home, and the farmhouse. Boldly composed, dynamically executed, and brightly colored, folk paintings were also filled with the deep and persistent Korean longing for longevity, good fortune, and protection from evil. Functioning as talismans as well as decorations, they filled and enlivened palaces, temples, and homes with affirmations of the Korean mindset, heart, and soul.

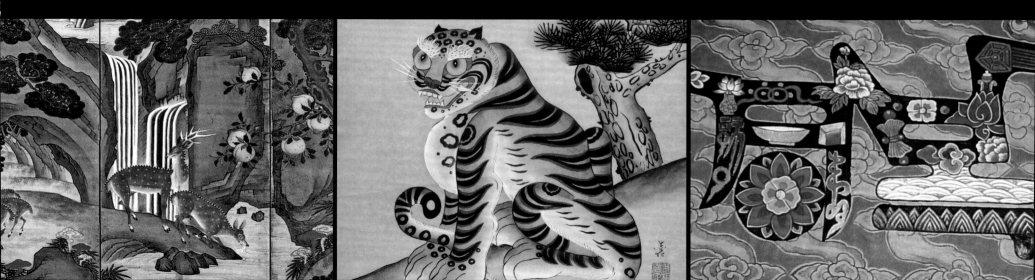

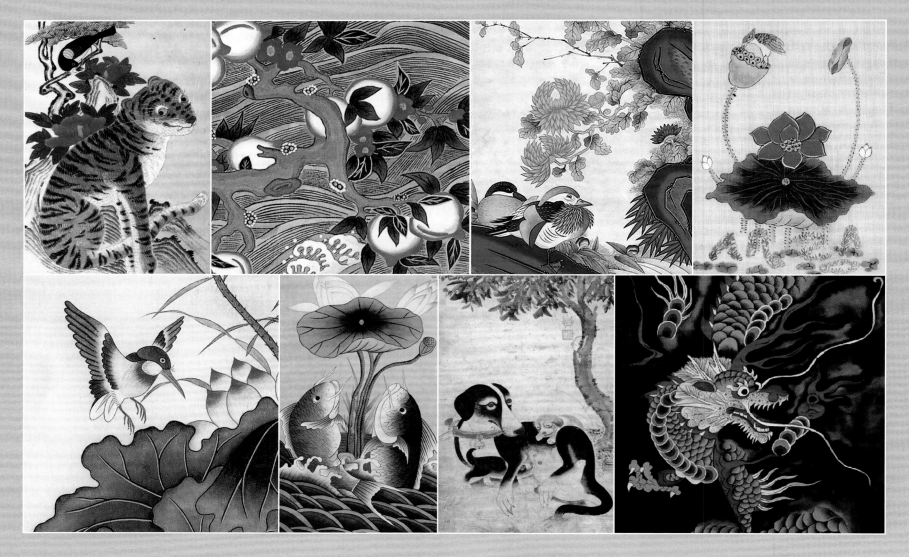

Minhwa, literally translated as "painting of the people," is a style developed by the common people in Korea during the Joseon Dynasty. Prior to that, art in Korea was created by scholars and court artists and was prohibitively expensive for everyday people. *Minhwa* gave commoners the opportunity to create their own art. This art, in turn, was used to decorate their homes, bringing the power of the symbols it always contained into their daily lives.

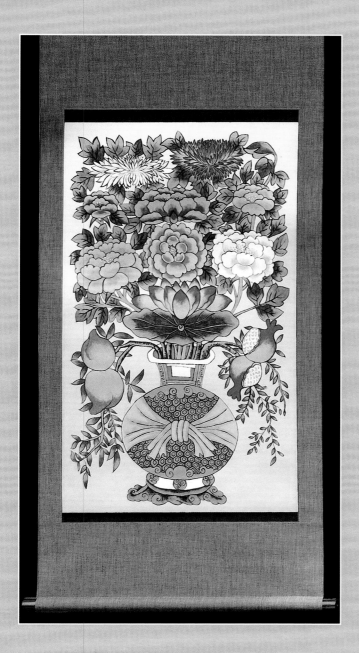

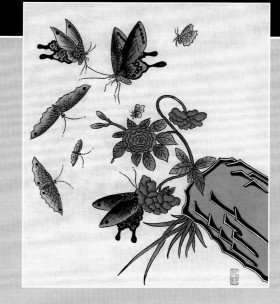

Korean folk art has several defining characteristics. It is largely created by unknown and untrained artists who do not sign their work. It is made for people to use in their homes and daily lives, and it serves practical and religious purposes. *Sehwa* (New Year painting) was traditionally believed to possess the power to bring happiness and repel evil spirits, and the importance of this role in *minhwa* at all levels of Korean society cannot be overstated.

In *minhwa*, bright colors predominate. Familiar themes tend to be repeated, but individual works are spontaneous and original. The works portray humor, satire, and a positive view of life. Some of the animal figures have human-like faces, allowing the artists to express their emotions in their paintings. In short, *minhwa* reflects and serves the hearts and minds of the Korean people.

Traditionally, *minhwa* was displayed both inside and outside of the home on walls, gates, doors, and windows. Folding screens and scrolls made with folk paintings were ubiquitous. Folk paintings were also applied to clothing, linens, pottery, and furniture. They were embedded in brickwork and carved in stone. These cheerful, spontaneous pieces of art were a part of every seasonal celebration and rite of passage. For example, symbols of longevity were displayed on the *hanbok* used for a baby's first birthday. The same themes appeared in the homes of every class of people, regardless of status. Although the quality of the materials and craftsmanship varied among the classes, any Korean of any class would know the meaning of any piece of folk art. This universal appeal and shared meaning were defining characteristics of folk paintings, more true in Korea than in other Asian cultures.

Until 100 years ago, Korean folk art and the artisans who produced it were considered unworthy of serious consideration by art historians. However, in the 1970s, Jo Ja-yong, a Korean engineer and architect, devoted much of his time and energy to collecting, exhibiting, and writing about Korean folk art. Because of his efforts, *minhwa* has garnered the appreciation it deserves, and many Korean museums today house collections of folk art.

Paintings of Ten Longevity Symbols Sipjangsaengdo 십장생도

The ten symbols of a long life—rocks, water, clouds, the sun, pine trees, deer, cranes, tortoise, mountains, and the mushroom of immortality—were among the most popular and commonly portrayed symbols in the Joseon era. Appearing on countless personal and household items, they permeated the everyday life of Koreans. When they were all depicted together as a group, the composition was called Sipjangsaengdo.

Living a difficult agrarian existence in a relatively harsh climate and seldom reaching the age of sixty, Koreans deeply desired a long life free from illness. Longevity symbols were expressions of this yearning, having almost magical characteristics and meaning. Originating in Daoism, which was introduced into Korea in the 7th century AD, the symbols reflected the Daoist emphasis on the search for spiritual enlightenment and immortality through meditation in the mountains and the use of magic potions. Daoist immortals were figures who had achieved this state.

According to legend, these figures rode to and from the sacred Islands of the Immortals in the Eastern Sea on the backs of cranes. Deer were their friends and companions in that magic land. Both types of animals were considered to have magical powers, live for 2000 years, and then become immortal themselves. The mushroom of immortality (*yeongji*) was believed to grow on the mountains and confer immortality on those who consumed it. The Daoist tortoise, believed to live for 1000 years, was portrayed as the messenger of the Dragon King, who lived at the bottom of the sea. Pine trees and bamboo embody qualities such as strength and endurance that confer longevity, while the sun, rocks, water, and clouds are long-lasting elements of the cosmos.

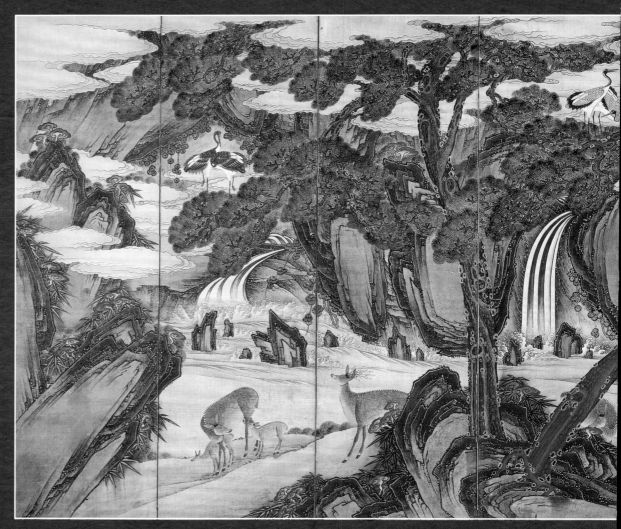

The Ten Symbols of Longevity are presented in a multitude of different ways in Sipjangsaeng works. Always, however, the elements are grouped in harmonious arrangements that convey an idealized and very beautiful, magical land where nothing grows older.

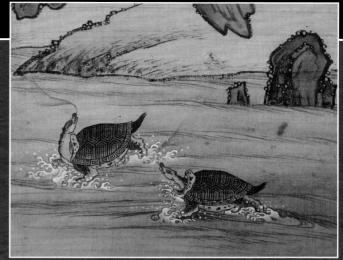

Sipjangsaeng paintings sometimes include whimsy or humor, such as these tortoises playing in the water.

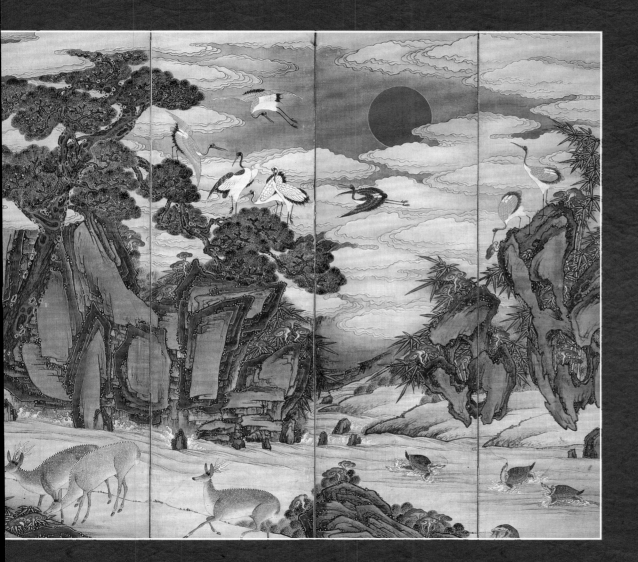

As with all *minhwa* (folk painting), the colors tend to be bright and deeply saturated, with reds, blues, and greens predominating. Interestingly, unlike Chinese depictions of longevity themes—which usually include portrayals of the immortals—Korean paintings exclude the immortals and focus on the landscape features, animals, and plants, painting a picture of immortality in which humans have returned to nature.

Joseon kings presented Sipjangsaengdo to worthy officials on the Lunar New Year. A longevity screen was also placed behind the queen's throne, and the sun, moon, and five peaks screens made for the king were a version of Sipjangsaengdo. They were used in important celebrations such as a sixtieth birthday or a renewal of wedding vows. With their rich symbolism that touched the hearts and minds of all Koreans, Sipjangsaengdo are surely one of the finest legacies of the *minhwa* tradition. Korean artists and craftsmen have carried this very long and meaningful

Paintings of Sun, Moon, and Five Peaks Irworobongdo 일월오봉도

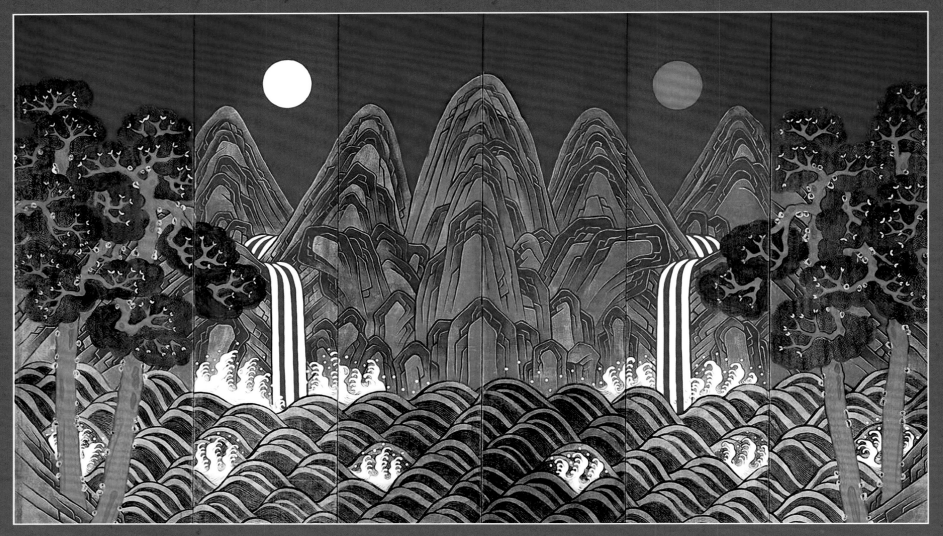

One of the most striking and beautiful of Korean folk paintings is called Irworobongdo. Highly symbolic, this painting, which was usually made in the form of a screen that was five to eight feet high and had up to eight panels, stood behind the throne in each of the king's palaces in the Joseon Dynasty.

A version of it was also carried with the king when he traveled. Picturing the sun, the moon, five mountains, pine trees, and ocean waves, the painting was boldly composed with bright and dramatic primary colors.

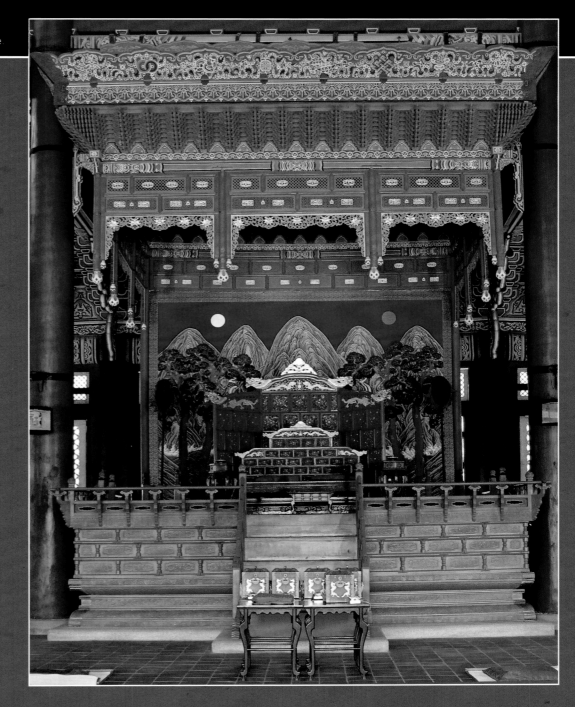

A screen depicting the sun, moon, and five peaks stands behind a throne at Gyeongbokgung Palace.

It was forbidden for anyone outside of the royal family to own this particular painting because the symbolism that it contained represented the king and his all-encompassing power. The sun and the moon stood for the king. Based on Daoist belief, *yin* (moon) and *yang* (sun) interact to shape and order the universe. Mountains, pine trees, and waves all stand for longevity and immortality. An aspect of animistic thinking in Korea, mountains were believed to have spirits. Mountains are also believed to be the home of Daoist immortals, residing there in eternity. Evergreen and tenacious trees that are able to withstand wind, weather, and the ravages of time, pine trees are another symbol of immortality. Water, essential to life, is symbolic of longevity throughout Asian cultures. By equating the royal family with *yin/yang* and immortality, Irworobongdo represented the Korean conception of the king as the enduring force in cosmic affairs.

Although the painting was restricted to royal use, scholars often classify Irworobongdo as a type of *minhwa* (folk painting) because its meaning, as expressed in the symbolism it contained and as revealed by its use as a talisman, was rooted in the same body of folk belief that gave rise to the many other forms of *minhwa*. After the fall of the Joseon Dynasty in 1910, the rigid rules that had dictated appropriate behavior for the various classes in Korea began to relax, and other groups of people began to be able to use the painting. Today, anyone can own and display Irworobongdo, which can easily be found in shops and markets. It is also possible to see the screens in their original context and splendor by visiting the throne rooms of Gyeongbokgung Palace and Changdeokgung Palace in Seoul, where they have been preserved. While it may be difficult for modern visitors to fully grasp the mystical qualities that these screens held for those who saw them in the past, it is very easy to appreciate the powerful aesthetic appeal they still hold for viewers today.

Character Paintings *Munjado* 문자도

Chinese characters were the preferred means of writing for the Korean upper classes, even after the invention of the Korean phonetic alphabet (Hangeul) by King Sejong in 1443 AD. Intended to promote literacy for all Koreans, Hangeul became the written language for women and the lower classes. However, Chinese characters continued to be used by the court and the scholarly elite. *Yangban* included Chinese characters in their paintings, which were found exclusively in upper-class homes until the 19th century, when the Confucian class structure began to crumble. At that time, character paintings were adopted by the larger population, and a very interesting and uniquely Korean form of *minhwa* developed. Ideographs, characters that communicated the Confucian philosophy of Joseon, were combined with Daoist symbols to create colorful, inventive, highly appealing images that both conveyed moral lessons and served symbolic functions.

Called *munjado*, these paintings most commonly depicted and embellished the Chinese characters that represent the eight principles of Confucian morality, the basis for harmonious living in the Joseon Dynasty. Those principles were filial piety, brotherly love, loyalty to king and state, trust, propriety, loyalty to friends and colleagues, integrity, and humility.

Folk artists decorated the characters with symbolic plants and animals that complemented their Confucian messages. Most commonly, the symbols were arrayed around the characters or became an integral part of them. Because the number of virtuous characters matched the number of panels typically found in a Korean screen, *munjado* frequently appeared on screens.

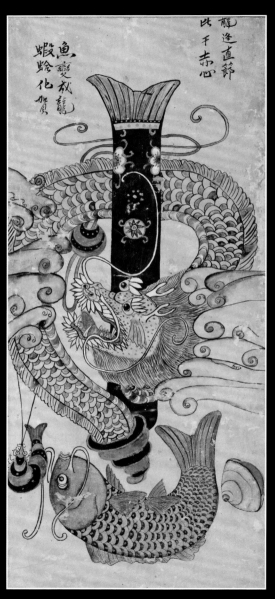 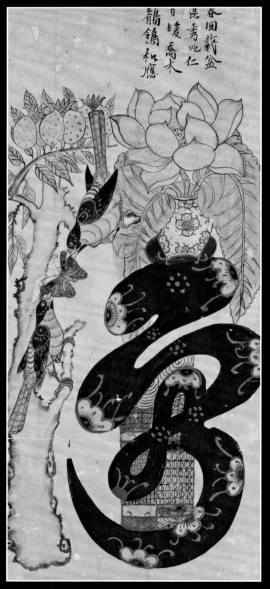

19th-century *munjado* paintings—*Loyalty to King and State* (left) and *Brotherly Love* (right)

Gyeongbokgung, a contemporary interpretation of *munjado* by artist Oh Young-sun

Filial piety or honoring one's parents (孝, *hyo*), was often shown as a combination of carp, bamboo, and tangerines. Brotherly love (悌, *je*) included pictures of two birds sharing an insect or three generals in the Three Kingdom Period swearing an oath of brotherhood. Loyalty to king and state (忠, *chung*), incorporated a number of different symbols indicating faithfulness, such as dragon, carp, bamboo, and turtle. Trust (信, *sin*) usually depicted two birds, often a white goose and a bluebird, carrying letters in their beaks. Propriety (禮, *ye*) was usually represented by an image of Confucius himself or a turtle with a book on his back, containing instructions for how family members were to treat each other. Loyalty to friends and colleagues (義, *eui*) most often included the same three Korean generals that stood for brotherly love, this time pledging their oath to each other in a peach garden before heading off to battle. Integrity (廉, *yeom*) typically included a *bonghwang*, an auspicious creature that never harms living things, or a crab, which is believed to have the wisdom to know when to act or refrain from acting. Finally, humility (恥, *chi*), the capacity to be humble and to evaluate and take responsibility for one's actions, is most commonly represented by two brothers who exiled themselves to the mountains rather than live comfortably under a ruthless king.

Integrity is an example of a kind of *munjado* that is painted with a detailed scene on the surface of the character illustrating how that virtue was enacted in everyday life.

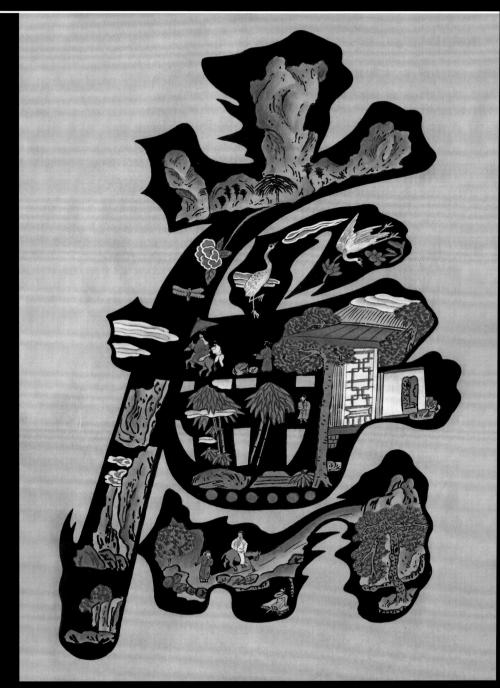

Scholar's Study Paintings *Chaekgado* 책가도

Paintings of objects typically found in a scholar's study (*sarangbang*) were popular in the Joseon Dynasty and were typically found on screens. Uniquely Korean, *chaekgado* or *chaekgeori* portray books artfully arranged with other scholarly tools and luxury items, embodying the aspirations of learned men of that era for knowledge and wisdom. Each panel showed a different composition of scholar's utensils, often pictured in or around a bookcase.

The four friends of the scholar—calligraphy brush, inkstick, inkstone, and paper—were prominently displayed along with an array of other items that might be in the study. Eyeglasses, seals, and scrolls were common, as were musical instruments that learned gentlemen were expected to play. Items associated with leisure, such as pipes, fans, bottles of wine, and game boards, were also included. Teapots and cups were pictured, as were vases. Flowers, fruit, plants, and small animals, such as beautiful fish swimming in a bowl, were also common and reflected the deep reverence for nature that all Koreans felt.

During the Joseon Dynasty, books were precious and were usually kept in closed chests. Picturing them sitting on open shelves was a way for the scholar to display his learning to others and to fill his quarters with constant reminders of his most treasured possessions. Because the books painted on *chaekgado* were usually shown stacked, the paintings have sometimes been referred to as "bookpile screens."

Sets of *chaekgado* paintings were commissioned by individual families to be made into folding screens and were typically produced by professional painters. Interestingly, these artists often hid their signatures among the many objects in the composition. Three general types of composition were used: a single flower arrangement, the depiction of an entire room and its contents, and the portrayal of a bookcase with its contents. Unlike other folk paintings, *chaekgado* were drawn quite realistically using three-dimensional effects. However, odd perspectives were another characteristic, with more distant objects often painted larger than those in the foreground. Intricately detailed, these screens were a visual feast, inviting the viewer to study them closely to discover and appreciate the charming details.

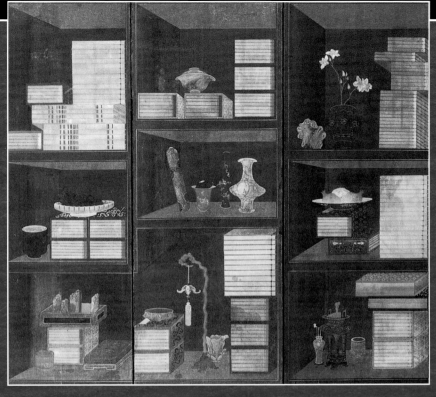

The colors in *chaekgado* paintings were often subdued, befitting a scholar's *sarangbang*.

Although *chaekgado* were originally found primarily in well-to-do *yangban* homes, they were owned by commoners as well. The difference was not in their content but in the quality of the materials and the level of artistry involved in creating the paintings. While *yangban* screens were often painted on silk with expensive, imported pigments, those painted by and for commoners were done on paper or hemp with less expensive, diluted pigments. Portraying the Confucian values of learning and accomplishment that were so highly valued in the Joseon period, they appealed to people of all classes, even though farmers, artisans, and most merchants had little chance of becoming highly educated themselves. Even in rural villages, these screens were often placed where children would see them as a way of inspiring them to improve their lives. In keeping with their embodiment of traditional Confucian values, *chaekgado* were believed to promote harmony in any home in which they were placed.

Folding Screens Byeongpung 병풍

Probably the most common way of displaying Korean folk art, from the royal palace to the humblest farmhouse, was and still is the folding screen (*byeongpung*). It has been said that the life of a Korean began and ended behind a screen, as it provided privacy during childbirth and respect at the time of death. Screens were also used to decorate the home with colorful, appealing images. They served important utilitarian purposes as well, shielding family members from drafts during the long, cold Korean winters (the word *byeongpung* means windbreak) and dividing the space in the home, which typically had few individual rooms, according to family activity and need. Finally, a very important function of the screen was to bring auspicious symbolism into the home, thereby expressing the most heartfelt hopes and aspirations of the family.

Screens were, and still are, usually made with individual though related pictures on each panel. They may also portray a single painting that continues across the width of the screen. Usually the images on screens are painted, although the material used varies from expensive silk and elegant paper to hemp. Occasionally very fine *byeongpung* are embroidered rather than painted. Requiring much time and extraordinary skill, these rare masterpieces were made for the very privileged upper classes.

Because they were not attached to the walls of the house and consisted of between four and ten folding panels that could be adjusted depending on the circumstances, *byeongpung* were endlessly adaptable.

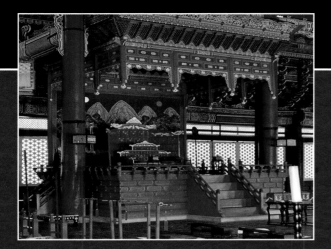

The Irworobongdo screen in the throne room at Gyeongbokgung Palace symbolized the king sitting beneath it as "first under heaven."

Surprisingly, with one exception, the same subject matter appeared on screens at all levels of society. The Irworobongdo (sun, moon, and five peaks screen) however, was restricted to royal use and was placed behind the throne of the king in each of his palaces. Beyond that, though, screens with motifs that appeared in the home of a commoner would almost certainly also be found in the home of a *yangban* scholar or in the royal palace. The quality of the screens would differ, but the message and the meaning would be the same.

A wide variety of folk motifs have been used for screens over the centuries. Nature is a dominant theme—plants, flowers, fruits, vegetables, birds, insects, fish, mountains, trees, rocks, and water, to name but a few. The symbolism used dictated how and where the screen would be used. A screen depicting flowers and birds (marital harmony), peonies (wealth) or fish (fertility) was appropriately placed in the quarters of a newlywed couple. A screen with seeds and fruits, symbolizing the prosperity, fortune or wealth of her children, might grace a mother's quarters. Symbols of learning (books and the four friends of the scholar) would fill a screen found in the scholar's study. Longevity symbols were commonly seen on screens placed behind the family member being honored at a sixtieth birthday celebration. And at the time of death, a *byeongpung* was positioned so that the serene white back of the screen faced the deceased. Thus, the folding screen did, indeed, frame the lives of Koreans, celebrating each stage with beauty and with wishes for the best of fortune along the way.

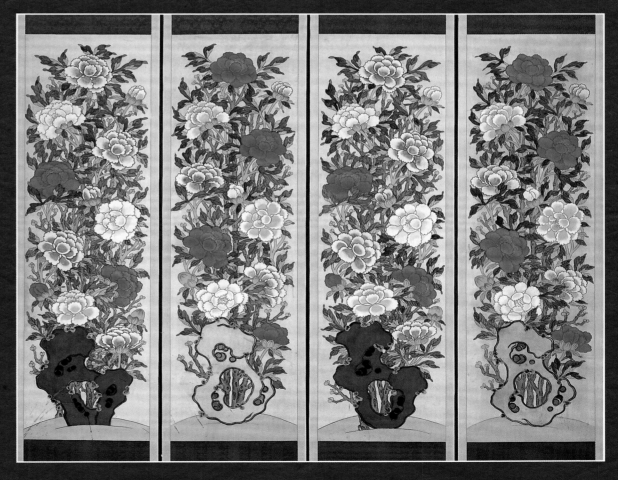

Tilling the Field, Kim Hong-do, 1796. One of 25 paintings (including *Jumak* on the opposite page) from an album of *pungsokhwa* entitled *Danwon Pungsokdocheop*, taken from Kim's pen name, Danwon. Each painting in the album, which is held by the National Museum of Korea and has been designated as Treasure No. 527, provides a glimpse into the daily life of the common people during the Joseon period.

It has been said that the type of painting that depicts the lives and everyday activities of the Korean people (*pungsokhwa*), is the most Korean of all Korean art forms.

In the Joseon Dynasty, there was a strict hierarchy of classes with the *yangban* elite at the top, followed by the farmers, artisans, merchants, and shamans and priests. Among commoners, farmers were accorded the highest status because the welfare of the largely agrarian Korean state depended on the productivity of its farms. An interesting form of genre painting, *gyeongjikdo* depicted the activities of farmers and related workers. Mandated by King Sejong, these paintings were specifically intended to be a visual reminder to the king and other administrators that they must always appreciate and support the hard work of the common people whose labor formed the foundation of society. It is reported that a Joseon scholar advised the king that keeping such a painting close by would remind him to "distribute food and clothing during times of need, reduce the burden of taxation, and manage the people with mercy." Thereafter, *gyeongjikdo* screens stood next to the Irworobongdo screens in each of the throne rooms of the king, as well as in the working quarters of other state officials.

Another type of genre painting flourished for 200 years from the early eighteenth to the early twentieth century. It grew out of cultural forces that began to embrace the notion of a uniquely Korean identity. These realistic paintings depicted the settings and daily activities of all classes (for example, life inside the royal court or the scholar's study), thereby constituting an invaluable historical record of Korean life at many levels.

Perhaps the most popular and appealing of the *pungsokhwa* were the paintings of commoners. Whereas the economic contributions of farmers and other workers had long been appreciated, their everyday lives had been ignored in most artistic traditions until that time.

A group of painters who sympathized with commoners and observed their lives closely produced a large body of work that depicted many aspects of village life: the work of women, the schooling and play of children, trade and other forms of work, leisure time activities, special ceremonies such as weddings and funerals, holiday celebrations, and shaman rites. Increasingly detailed and realistic as the painting style developed, these paintings focused on the human figures, thereby according them great respect.

Major museums in Korea have extensive collections of genre paintings, and they constitute a priceless window into the past. Their fresh vitality and widespread appeal have not diminished with the passage of time, and they are treasured and widely reproduced, providing a way to connect today's Koreans with those of years gone by.

Jumak (*The Inn*), Kim Hong-do, 18th c.

Literati Paintings *Muninhwa* 문인화

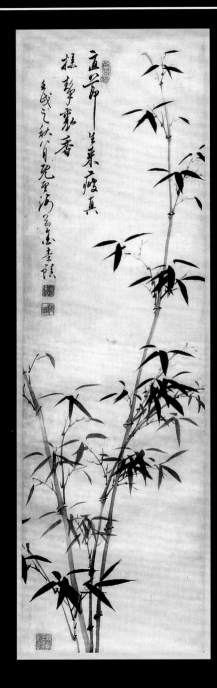

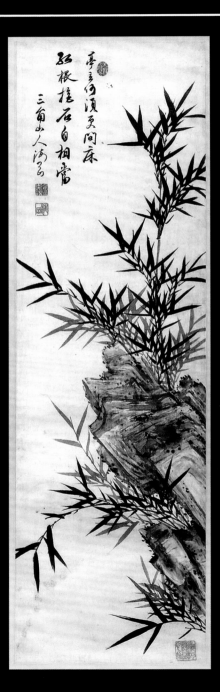

In the Confucian tradition of the Joseon Dynasty, gentleman scholars strove to model their lives after the ideals of scholarship, artistic achievement and refinement. Expected to master painting, calligraphy and poetry, they often combined these skills in producing beautiful literati paintings (*muninhwa*). The subject matter in the paintings was usually nature, very often the Four Gentlemen Plants (bamboo, orchid, plum blossom, and chrysanthemum), to which the scholar added, in beautiful calligraphy, a poem that he had written. The creation of a painting combined the scholar's understanding of literature, philosophy and art and was undertaken only after deep thought.

Muninhwa, in contrast to folk paintings, which were produced by anonymous artists and characterized by the bold use of color, were usually monochromatic and often signed by the scholar artist. The paintings displayed great skill in traditional brush painting, with subtle gradations in line and shading. The paintings were often executed as scrolls that could be hung in the scholar's study or presented as gifts.

Literati painting by Kim Gyu-jin (1868–1933)

The brush is held vertically over the paper by the tip of its handle so that gradations in line and shading are produced by subtle pressure of the bristles on the paper.

The tools and materials used to produce these paintings—brush, ink, inkstone, and paper—were called "the four friends of the scholar's studio," reflecting the respect they garnered as necessary companions of the literati class. Second only in social status to royalty, it was the scholars' refinement that set them apart from other classes, and thus their tools, which oftentimes were symbols of that status, had to be of the finest quality.

Brush size varied according to use, with bristles of differing length and flexibility. The bristles were traditionally made from bird feathers or animal hair including sheep fleece, racoon hair, hair from the tails of squirrels and weasels or the backs of cats, and sometimes even the whiskers of mice.

Korean ink was traditionally made from pine soot (or scorched sesame) or camellia (or soybean) oils. These were mixed with a glue, a fragrance and carbon black. In order to produce ink of the highest quality, the ingredients had to be combined at just the right temperature and on days when the humidity was correct. The ink was then shaped into ink sticks and very carefully dried, again under the right conditions of temperature and humidity. Most ink sticks were black or black with a bluish or reddish tint, but sometimes they were colored. The lighter the weight of the ink stick the better, as this indicated that a superior type of glue had been used. Although petroleum-based products are often substituted today, the best ink sticks are still those that are made in the traditional way.

The inkstone was the third important friend of the scholar. Usually made from stone but also sometimes from ceramic, the quality of the stone was important. The flat sloping surface had to have just the right degree of abrasiveness to allow the artist to grind the end of the ink stick into very fine particles that were then thoroughly dissolved using the water in the inkstone's well. An old Korean saying held that superior ink should be "as clear and pure as a child's eyes." Inkstones were shaped and carved to reflect the tastes of the owner, and many are themselves beautiful works of art.

Finally, the paper that a scholar used for his paintings was critical. Korean traditional *hanji* paper, being softer and more absorbent than Western paper, was superior for this purpose.

Muninhwa is a valuable legacy of the lifestyle and aspirations of the educated upper classes during the Joseon Dynasty, one that continues to deeply influence Korean aesthetics and character to this day.

Documentary Paintings *Girokhwa* 기록화

A portion of the 64-foot-long scroll entitled, *Royal Procession to the City of Hwaseong*, commissioned by King Jeongjo in 1795 to commemorate his visit to his father's tomb. He was accompanied by more than 6100 people and 1400 horses.

An important but relatively little-known type of Korean painting from the Joseon Dynasty, documentary paintings are the equivalent of modern photographs of important events. Executed by the professional painters in the government bureau of painting, the paintings were commissioned by the king, his high officials, or sometimes by *yangban* elite to document significant events.

Surviving paintings provide invaluable information about court rites presided over by the king, royal processions, ceremonial installations of government officials, court banquets, religious ceremonies, battle scenes, and martial arts performances. Often these paintings were mounted on large ten-panel screens with a poem or other inscription that described the event.

If a documentary painting includes the king's throne, it is almost always empty, as it was considered improper to portray the royal family.

Girokhwa are fascinating to examine closely. They typically use multiple points of view simultaneously—including bird's eye, side, three-quarter, and reverse perspective—in order to portray all aspects of the events being pictured. They are also painted in minute, exquisite detail. Often the people in the paintings are no bigger than a human fingernail, yet all are painted as individuals with varying facial expressions and even behavioral differences. In one painting of a royal procession that includes thousands of soldiers, one horseman can be seen to be falling asleep as he rides, while another turns to chat with the soldier behind him. Historically very accurate, they depict the costumes of the time, the duties of the individual participants, the scope of the ceremonies, and the way in which events were choreographed.

One of the most popular categories of documentary paintings depicts the turtle ships (*geobukseon*) that, under the command of Admiral Yi Sun-sin, played a crucial role in repelling the Japanese invasions of Korea (1592–1598). The original painting of *geobukseon* was mounted on a magnificent twelve-panel screen that stands today in a memorial shrine dedicated to the Admiral. In it, an armada of turtle ships joins the main vessel, which itself carries a painting on its bow of the four symbols that guard against evil coming from all four directions—the dragon, tiger, phoenix, and tortoise. The ships carry sailors and even women, who provided food to the troops. The painting appears to depict a triumphant victory procession, although that may not have occurred in reality, since Admiral Yi himself died during the final battle. The original painting, and many other versions of it, celebrate the deep pride that the Korean people feel for the technical genius and heroic accomplishments of Admiral Yi, who is considered to be one of Korea's greatest national heroes.

Paintings of *geobukseon* were displayed at court, but also in the homes of *yangban* and even commoners. Such was the pride of the Korean people in the turtle ships and their feats.

Architectural Painting *Dancheong* 단청

Dancheong is the name used for a style of embellishing temples and palaces with elaborate, brightly colored, painted designs. The five symbolic colors related to the Five Elements—red (fire), blue (wood), yellow (earth), black (water), and white (metal)—are used, together with green and some neutral tints.

This elaborate, time-consuming form of decoration had several purposes. Most obviously, it conveyed beauty and dignity. Since it was used primarily on royal palaces and temples, it set them apart and conveyed their authority. In addition, the paint was a strong insecticide and preservative that both protected the wooden buildings and covered imperfections in materials and workmanship.

Technically, applying *dancheong* was a refined skill, traditionally reserved for highly trained monks and craftsmen. Each color was painted by a different artist. It was the job of a master craftsman, who was chosen to plan and supervise a new *dancheong* production, to assess the building and develop the design.

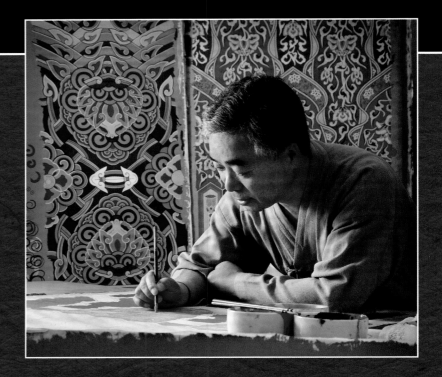

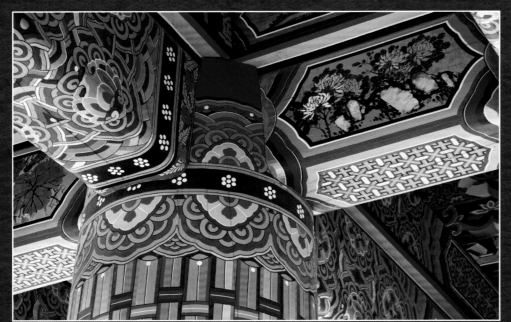

This design was transferred to sheets, and the outlines of the design were pricked with pins. The sheet was then held against the wood and patted with a bag of chalk dust, which transferred the design to the wood. Prior to this, however, the wood was primed with a coating made from a green mineral powder, crushed seashells and a wheat starch binder. The paints were made from finely ground mineral particles (some of which were very rare and costly) mixed with glue and water. The

paints were heated in order to apply them, and they had to be stored underwater when not being used. Finally, camellia oil was painted over the entire finished design to protect it from the weather.

There was a definite sequence to the colors and how they were applied, following a code derived from Buddhist symbolism. The designs incorporated symbols of protection and good luck and represented heaven, earth and resurrection. Patterns that were commonly used were those typically seen in Korean art—the lotus, pomegranate, peony, chrysanthemum, clouds, phoenix, dragon, tortoise, and crane. But flying horses, lions and even giraffes could be depicted as well. Exterior painting was always placed above the lintel of the building, while on the interior it could extend to the floor.

Over the centuries, versions of *dancheong* appeared in Japan and China (the word *dancheong* was originally derived from the Chinese characters for red and blue). Today, however, the art form is only actively practiced in Korea. It is easy to find lovely examples of *dancheong* throughout the country, as traditional palaces and temples are repainted when existing designs fade. The modern synthetic paints that are now used, however, are less vivid in color and less durable than the very complex traditional paints. Nevertheless, these pieces of architectural art bring centuries of Korean philosophy, thought, and culture into the present for everyone to enjoy.

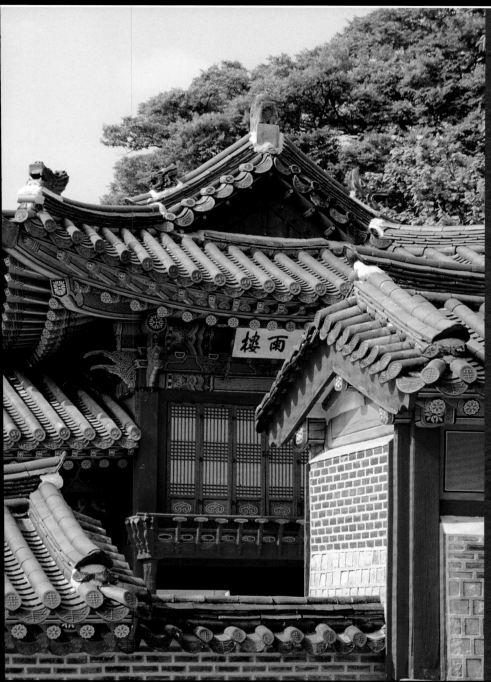

Changdeokgung Palace

Hanbok installation by Suh Young-Hee

The long cultural legacy of Korean traditional handicrafts has entered upon very exciting times. Handicraft techniques that had been handed down from generation to generation over thousands of years were threatened with near extinction during the first half of the 20th century when Korea was ravaged by occupation and war. Fifty years after the end of the Korean War, however, the South Korean people have

that does not harbor the past will be greatly diminished, they have put much energy and wisdom into recovering and preserving the nation's handicraft traditions. Today those traditions live on, available for those who want to continue to create beautiful, traditional artifacts as well as for contemporary artisans to use as a springboard for modern interpretations sure to enrich generations for years to come.

Handicrafts in Korea Today

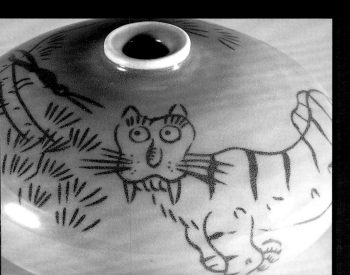

A Culture in Crisis

The first half of the twentieth century was a very difficult time for Korea, with the Japanese occupation, World War II, and the Korean War all exacting a devastating economic and social toll. Korea's culture was attacked as well, as the Japanese systematically tried to erase the sense of identity that had developed on the Korean Peninsula over thousands of years, mandating that people take Japanese names and learn to speak Japanese. Arts and crafts were modified to suit the tastes of the Japanese market, and many Korean masterpieces were taken to Japan. The Korean War, in addition to dividing a nation with a 5000-year history into two parts that are still technically at war to this day, also resulted in physical and economic ruin. At the end of the war in 1953, many historic buildings and the magnificent art in them had been destroyed. Craft industries were devastated, and the Korean people were simply struggling to survive.

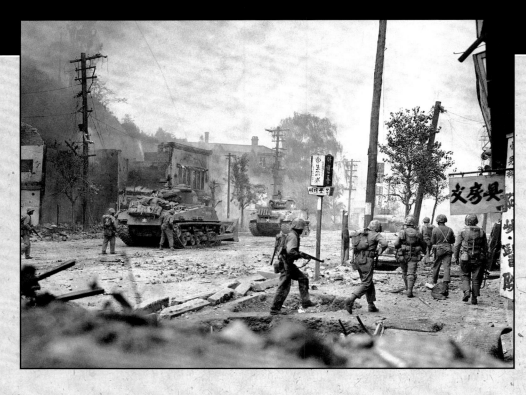

However, the Korean people quickly began to address cultural issues in the aftermath of the war, including the revival and protection of traditional arts and handicrafts. In July, 1960 the first of a series of articles about traditional Korean artisans was published in the national daily *Hankook Ilbo*. The author Ye Yong-hae travelled around the war-torn country locating and interviewing accomplished traditional artisans. Those who had not given up practicing their craft were desperately poor and discouraged. Ye's articles were published as the book, *Living Human Treasures* (*Inganmunhwajae*), coining the phrase that has been used ever since to honor these important artisans.

Influenced by this book and other calls for action, the Korean government enacted the Cultural Heritage Protection Law in 1962, a mere nine years after the end of the Korean War. Four categories of preservation were originally designated (that number has increased to seven today): Important Tangible Cultural Heritages, Important Intangible Cultural Heritages, Folklore Heritages, and Monuments. Traditional handicrafts are considered to be Important Intangible Cultural Heritages, and the designated expert artisans who make them are called holders (*boyuja*). In a similar but distinct process, holders are also named at the province and city level.

Living National Treasures

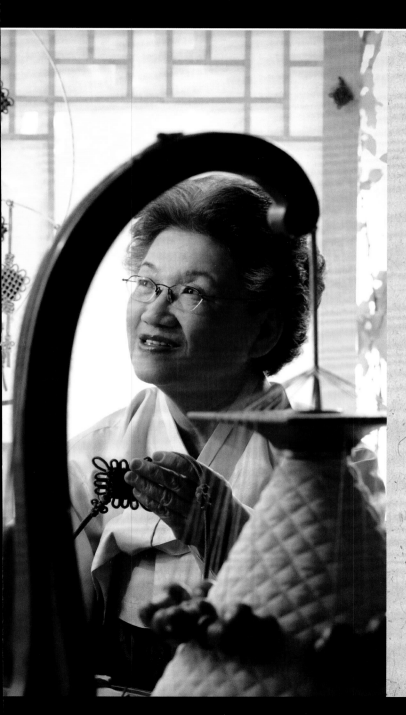

Holders of the Important Intangible Cultural Heritages are expected to transmit their expertise to the next generation, and they must demonstrate and display their skills to the public on a regular basis. They identify trainees who then go through an arduous, multistep training process that promotes only the most talented to the role of apprentice. Holders and their apprentices are paid a monthly stipend and receive health insurance. They also receive special protection in times of war or other emergencies. If holders fail to carry out their obligations, fines are imposed and their designation is sometimes withdrawn. When a holder dies, his or her designation is cancelled, and if there are no other holders or suitable successors, the handicraft is no longer supported. Although the preservation program has been extremely successful, a persistent problem has been finding enough young artisans willing to devote the years of training needed to master what many consider to be outdated practices that are not relevant to the modern world. To counter the risk that holders may die without a successor, their skills are being systematically documented on film so they are not lost forever.

In addition to preserving its own cultural legacy, Korea has been instrumental in promoting preservation on the international stage, proposing to UNESCO in 1993 that it institute a worldwide Living Human Treasures program. This was accomplished in 2003 with the adoption of the UNESCO Convention for the Safeguarding of Intangible Cultural Heritage. Since that time, a number of Korean Intangible Cultural Heritages and holders have also received UNESCO designation, thus increasing awareness of Korean traditional culture, including handicrafts, around the world. Korean holders today proudly note their UNESCO designation on their business cards.

The UNESCO program targets a broader range of cultural entities than Korea has typically protected, including cultural practices that do not require special training by individual artisans. Korea decided to similarly widen its own preservation program, especially after China named several Korean practices—the traditional wedding ceremony, the sixtieth birthday celebration, the games of swinging and seesaw, and the Arirang folk song—as intangible aspects of Chinese culture based on the fact that they were practiced in ethnic Korean communities in China.

Kim Hee-jin, holder of Important Intangible Cultural Heritage No. 22—decorative knot making—has practiced her craft for over 40 years. In 2004, she donated her entire body of work to the National Museum of Korea and shifted her efforts almost exclusively to teaching.

Five Generations of Superior Craftmanship

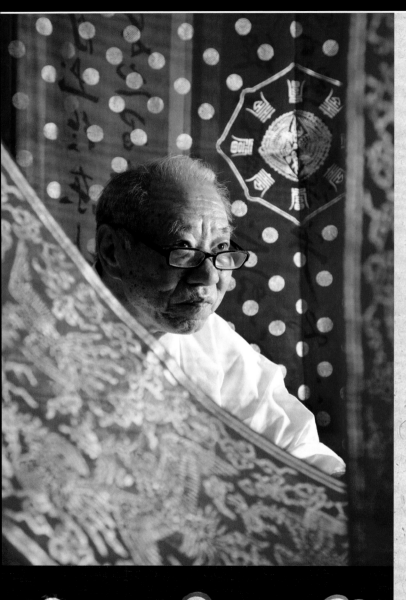

Kim Doek-hwan, holder of Important Intangible Cultural Heritage No. 119, is the fourth generation of his family to practice the art of *geumbak,* or gold leaf decoration. As is required of all holders, he has an apprentice who is learning the art form from him—his son, Kim Gi-ho—meaning that the only remaining master of gilding in Korea will pass it on to the fifth generation of his family. Since the mid-1800's, when Doek-hwan's great-grandfather was a gold leaf artisan in the court of King Cheoljong, the tradition has been passed down from father to son. The family takes great pride in their craft as well as a sense of obligation to preserve it.

Can this exquisite craft remain relevant in modern times? During the Joseon Dynasty, gold leaf was used only to decorate clothing worn by the royal family on special occasions. Today, although it appears on *hanbok* worn by all groups of people, the designs are increasingly applied by modern methods such as iron-on transfers. The very complicated and time-consuming techniques and the high cost involved in applying gold leaf in the traditional way make it difficult to practice the craft today. And this, in turn, poses the question that is important for many crafts in contemporary Korea: Is there a role for traditional *geumbak* in the 21st century?

Both Master Kim and his son are exploring ways to modernize the craft, developing alternatives to the traditional glues made from fish bladder, and experimenting with artificial gold. Gi-ho is developing a range of gilded items other than clothing, including business card and cell phone cases, framed compositions, bookmarks, ties, and plates, which are sold at the family's workshop, *Geumbagyeon* ("Feast of Gold Leaf"). Both men feel encouraged by the government's decision to renew *geumbak* as an Important Intangible Cultural Heritage in 2006, and are committed to finding ways to carry this unique and cherished family tradition into the future.

Today Kim Doek-hwan (left) is Korea's only surviving gold leaf master. Fortunately his son, Kim Gi-ho (right), will ensure that the art form continues. Gi-ho works with centuries-old designs in the traditional manner, but as shown on the left, he is also adapting those designs to give them contemporary appeal.

Traditional Themes Coming of Age

In English, the word "tradition" comes from Latin and means something that is handed over, delivered, or entrusted. Traditional customs and practices do not simply endure in a static state. Instead, they are actively transferred from one generation to the next. And, since handicrafts are made to meet the needs of people, they must adapt as people's needs change. It has been written that when Koreans adopted Western styles and cut off their long hair, ten traditional crafts immediately became obsolete.

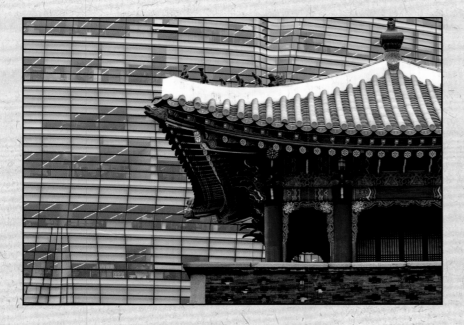

Korea is a land where the past and the present already visibly coexist. To walk down a street in Seoul is to see, at any turn, evidence of both the 21st century and centuries past. Turn one way and you see an ancient royal palace; turn the other and a steel skyscraper looms. Koreans value this juxtaposition of the old and new. So, while traditional handicrafts and techniques are being meticulously preserved, they are also constantly interfacing with modern society and the contemporary art scene.

Contemporary artists in Korea often reach back to traditional themes in their work, not necessarily using traditional techniques per se, but rather incorporating the icons and meanings of the art and craft traditions of the culture into their work. Thus, handicraft traditions influence modern creativity, and contemporary artisans and artists influence the form in which traditional handicrafts are passed on to the future. In addition, some Living National Treasures are simultaneously preserving old techniques in their pure form while exploring ways to "push the envelope" and adapt traditional forms to modern sensibilities and tastes.

Top: A very contemporary interpretation of traditional Korean *sotdae* by artist Won Sung-ran
Bottom: Referring to himself as a "drawing architect," Gilzook Boy has always been fascinated with the process of reinterpreting traditional architecture, injecting his own humor and whimsy in the process.

Reaching to the Past to Create the Future

The contemporary art scene in Korea is vibrant and innovative. Frequently, new work involves strikingly original reinterpretations of traditional materials and themes, helping to carry the past into the future.

Fiber

Chunghie Lee is a textile artist who has incorporated many traditional themes into her work. In one series of pieces, she has explored the legacy of the anonymous women of the Joseon Dynasty who created stunning hand-pieced wrapping cloths (*bojagi*), considered to be one of Korea's great artistic accomplishments. Deeply moved by the constraints on women's lives in a strict Confucian society and the creativity they marshaled despite their lack of education and extreme social isolation, Lee decided to honor their artistry in her work. She printed very old photographs of women in the late Joseon era on fabric, which she then made into striking—sometimes haunting—works of art. Lee has also incorporated the patchwork theme into her fabric creations and encouraged her students and other international artists to do the same, thereby playing a leading role in introducing this quintessentially Korean art form to the world.

No-Name Women, 2001, Chunghie Lee

Whisper-Romance IV, Jiyoung Chung

Paper

Lee's daughter, painter and paper artist, Jiyoung Chung, works with traditional Korean paper using an ancient technique called *joomchi*. In this process, *hanji* paper is dampened and then squeezed and rubbed between the hands for long periods to soften and break down the fibers, resulting in a much stronger fused version of the paper. This inexpensive material was widely used in Korea in the past, sometimes as a substitute for fabric in making clothes. Today, Chung creates modern hangings, lanterns, clothing, and mixed media pieces with the *joomchi* that she laboriously creates. An internationally known artist, she takes pride in her role as a cultural ambassador, for "showing the beauty of Korean tradition and handing it down to the next generation" (*American Craft*, June/July 2012).

Sculpture

Sculptor Choi Jinho has spent over twenty years exploring the origins of Korean stone carving and creating a body of work that infuses traditional themes and values into modern pieces of art. The mythical Korean *haetae* has been a favorite subject of Choi's, and he has moved from more traditional interpretations of them to contemporary variations. In addition to stone, Choi explores a diverse range of materials, including plaster, iron, and traditional *hanji* paper, always striving to create pieces that harmonize with the natural surroundings in which they are placed, a value that has characterized Korean life and art for centuries.

Pottery

Traditionally, Korean celadon *(cheongja)* was never painted but was decorated with incised patterns inlaid with colored clay slip, a technique perfected by Korean potters in the Goryeo Dynasty and considered to be one of Korea's finest artistic achievements. Today, however, young artists like Baek Ra-hee are reinterpreting *cheongja* by using folk painting to decorate pieces. In addition to developing new methods of coordinating the colors in the painting to the traditional green glazes, Baek has expanded the range of pottery forms beyond those that were traditionally used to include utilitarian rice bowls, teacups, and incense holders. The result is the creation of lovely handicrafts made for the modern home that carry two traditional themes—celadon and folk painting—into the present with renewed energy.

Digital Art

Art in Korea is being profoundly affected by digital techniques. As one example, graphic designer Yongil Lee reinterprets traditional genre paintings from the Joseon Dynasty, capturing their essence but with a modern twist.

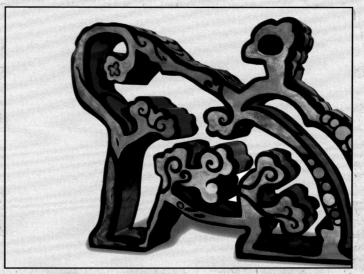

Haetae sculpture by Choi Jinho

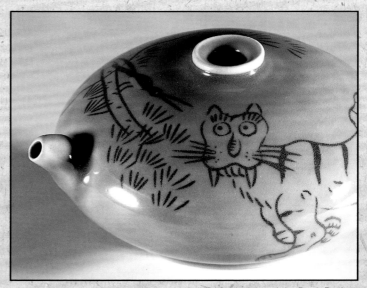

Painted *cheongja* by Baek Ra-hee

Yongil Lee revisits a classic genre painting by Sin Yun-bok.

Pushing the Envelope

Increasingly, master craftsmen and craftswomen are exploring ways to assure the survival of the traditions they have mastered. Perhaps more than anyone, they understand the role that these crafts have played in Korean history, but they are also aware that there is less demand for them today than there was in the past. While many artisans do not believe that traditional techniques and forms should be altered in any way, others argue persuasively that changes are appropriate and necessary so that the traditions don't become so obsolete that they completely disappear.

Metal Inlay

Hong Jung-sil (Important Intangible Cultural Heritage No. 78) studied metalcraft as a student but was unaware of metal inlay until she happened to see an example of it in an antique store in the 1970s. Captivated by the beauty of the piece, she was told that inlay was no longer practiced in Korea. Luckily, however, she found Lee Hak-eung, the last surviving metal inlay craftsman of the Joseon royal palace. Although he had not worked for 10 years, he agreed to teach her. Mastering the time-consuming and intricate traditional techniques, today Hong creates stunning pieces of art, some of them combining traditional and contemporary themes. Concerned that the craft will truly disappear unless it is adapted to modern culture, she has created a handicraft research institute to study ways to preserve the beautiful tradition that she stumbled upon one lucky day.

Lacquer Painting

A technique that originated in Korea before the Three Kingdoms Period, lacquer painting was later largely replaced by mother-of-pearl lacquerware during the Joseon Dynasty, and it essentially disappeared from Korea. In 1979, Kim Hwan-kyung (Intangible Cultural Heritage of the Seoul Metropolitan Government No.1) saw painted lacquerware on a visit to Japan, where the art form has always been favored over mother-of-pearl techniques, and decided to try to revive the indigenous Korean art form at home. After 30 years of research he has reinvented and mastered the difficult techniques involved and produces beautiful pieces of art. Kim works on wooden surfaces, but he also experiments with painting on materials like fabric and paper as well as painting lacquer onto bisque-fired ceramic pieces before firing them a second time. He regularly collaborates with other artists in expanding his repertoire. A firm believer in the importance of combining contemporary and ancient techniques (despite the fact that this attitude delayed his acceptance as a legitimate artist in traditional circles), Kim says that modernizing traditions increases their appeal, creates wider audiences for them, and helps assure their acceptance and survival.

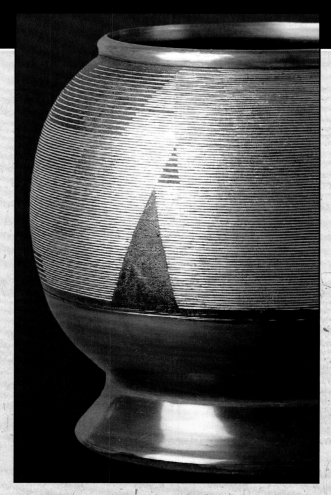

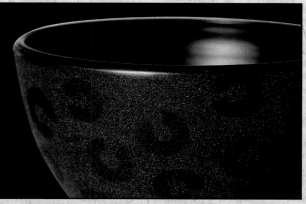

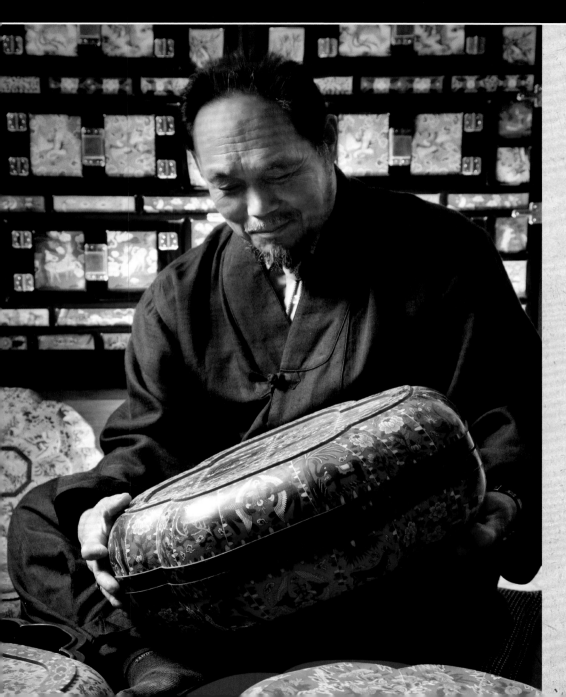

It's an exciting time for anyone who loves traditional Korean handicrafts. Today they are readily available in museums, the studios of Living National Treasures, galleries, and markets. Fifty years of extreme hardship followed by fifty years of difficult rebuilding resulted in a modern nation whose people understand that, without the past, the present and the future are both diminished. Many aspects of traditional culture have been painstakingly recovered and preserved, including numerous handicrafts that might have been lost forever without those efforts. Modern artists and craftsmen continually call upon those traditional themes to inspire their creativity, producing exciting and innovative contemporary art that will help assure that Korea's cultural legacy lives on. Thus, happily, the spirit of the past is palpably present in Korea today. An array of 100 thimbles in a box, popular with collectors, still symbolically signifies blessed longevity, just as lovingly hand-embroidered thimbles did when presented to her new family by a young Joseon bride.

Lee Jae-man, holder of Important Intangible Cultural Heritage No.109 (ox horn inlaying). Devoted to his craft, Lee has been practicing for over 40 years in spite of the limited use of one of his hands. His skill and dedication to his art truly qualify him, and the many others like him, to wear the title of "Living National Treasure."

Acknowledgments

This book was in the making for years as we delved into Korean arts and crafts, learned about them, collected them, and taught others about them. Throughout that time, hundreds of people supported our interests and our activities: our husbands and our children, extended family members, other adoptive families, friends in the Korean-American community and elsewhere, adoption professionals, neighbors, and colleagues. We cannot possibly name all of you, but you know who you are. Thank you very much for believing in what we have been trying to do!

Special thanks, however, must go to a number of people who helped us throughout this past year as we labored to photograph, write, and design this book. First, we offer our deep appreciation to our publisher, Hank Kim, who vaguely remembered some American mothers of Korean-born children visiting his bookstore 10 years ago, lugging bags of handicrafts, and took a chance on us when he received our manuscript out of the blue. Hank's energy, creativity, and dedication to his mission of providing insights into Korean culture for English-speaking audiences are an inspiration, and we are delighted to be members of the Seoul Selection stable. Jin Lee, our publications manager, patiently and graciously guided us through the process of negotiating a contract, tolerating and forgiving our persnickety ways. Our editor, Eugene Kim, has worked skillfully to integrate the many components of this project, while still allowing us to tell our story in our own way. We are deeply indebted to Chunghie Lee, whose vibrant textile art honors and perpetuates the traditional work of generations of nameless Korean *bojagi* craftswomen, for graciously consenting to write the Foreword to this book. Hana Lane, experienced book editor and friend, gave us generous, learned assistance as we struggled to understand book proposals, contracts, and the publishing world in general. Debbie Barron, our third sister, read chapter after chapter, always offering enthusiastic praise and spot-on suggestions for making the manuscript clearer and better. Bill Kent was our pragmatic voice of reason, gently pointing out when our eagerness and never-ending ideas threatened to divert our attention from the task at hand (but who, we like to believe, secretly enjoyed our capers!). Youngmin Lee could always be counted on for invaluable support and help every time we turned to her. Grace Song and Minyoung Kim have long shared and supported our commitment to bringing Korean culture to Korean-born adoptees and served as important liaisons to the Korean-American community. MaryJo Glover was our cheerleader extraordinaire, convincing us that, surely, we were incapable of failure. She and Kate Baschuk wisely encouraged us to think beyond our initial target audience, convincing us that there is a world of people out there who will find what we have to say both interesting and valuable. Dr. Jin Sook Kim and the staff at Eastern Social Welfare Society gave us a warm and welcoming place to come home to at the end of some very long days during our many trips to Seoul. Hyun-jin and Hee-jin Chung and Yooji No were our cheerful, ever-willing information gatherers, guides, and personal shoppers. And last, but most certainly not least, Bo-young Chung and Miran Lim were our hospitable and very patient host and hostess in Seoul, feeding us breakfast, lunch, and dinner, accommodating our always too-busy schedule, providing periodic legal advice, making sure we did *not* rent or drive a car, and personally escorting us hither and yon in our quest to see more, do more, and learn more. Thank you to each of these very special people. Without you, this book would not have happened.

References

Books

5000 Years of Korean Art: An Exhibition Organized by The National Museum of Korea. San Francisco, CA: Asian Art Museum, 1979.

Adams, Edward B. *Korean Folk Art & Craft.* Seoul: Seoul International Publishing House, 1987

Akaboshi, Goro, and Heiichiro Nakamaru. *Five Centuries of Korean Ceramics: Pottery and Porcelain of the Yi Dynasty.* New York: Weatherhill, 1975.

Beauty of Traditional Korean Wedding Culture. Seoul: Korean Craft Promotion Foundation, 2002.

Brother Anthony and Kyeong-hee Hong. *The Korean Way of Tea: An Introductory Guide.* Seoul: Seoul Selection, 2007.

Cho, Dong-il. *Korean Mask Dance.* Seoul: Ewha Womans University Press, 2005. Spirit of Korean Cultural Roots, Vol. 10.

Choi, Wan Gee. *The Traditional Ships of Korea.* Seoul: Ewha Womans University Press, 2006. Spirit of Korean Cultural Roots, Vol. 15.

Chun, Jin-Hee et al. Hanoak: *Traditional Korean Homes.* Elizabeth, NJ: Hollym International, 2010.

Chun, Shin-Yong. "Korean Society." *Korean Culture Series, Vol. 6.* Seoul: Si-sa-yong-o-sa, 1982.

Chung, Jiyoung. *Joomchi and Beyond.* Providence, RI: Beyond & Above, 2011.

Crane, Katherleen J. *Tiger, Burning Bright: More Myths than Truths about Korean Tigers.* Elizabeth, NJ: Hollym International, 1993.

Cultural Properties Administration, comp. *Korean Intangible Cultural Properties: Folk Dramas, Games, and Rites.* Elizabeth, NJ: Hollym International, 2001.

Cultural Properties Administration, comp. *Korean Intangible Cultural Properties: Traditional Handicrafts.* Seoul: Hollym International, 2001.

Hammer, Elizabeth. *The Arts of Korea: A Resource for Educators.* New York: Metropolitan Museum of Art, 2001.

Han, Suzanne Crowder. *Notes on Things Korean.* Elizabeth, NJ: Hollym International, 2012.

Jackson, Ben, and Robert Koehler. *Korean Architecture: Breathing with Nature.* Seoul: Seoul Selection, 2012.

Jeon, Kyung-wook. *Traditional Performing Arts of Korea.* Seoul: The Korea Foundation, 2013.

Jo, June J, ed. *Cultural Life in Korea: Scenes from Everyday Life.* Seoul: Kyomunsa, 2003.

Kang, Kyung-sook. *Korean Ceramics.* Seoul: The Korea Foundation, 2008.

Kim, Dong-uk. *Palaces of Korea.* Elizabeth, NJ: Hollym International, 2006. Korean Culture Series, Vol. 3.

Kim, Duk-Whang. *A History of Religions in Korea.* Seoul: Daeji Moonhwa-sa, 1988.

Kim, Hee-jin. *Maedeup: The Art of Traditional Korean Knots.* Elizabeth, NJ: Hollym International, 2007. Korean Culture Series, Vol.6.

Kim, Hongnam. *Korean Arts of the Eighteenth Century: Splendor & Simplicity.* New York: Weatherhill, 1993.

Kim, Jae-yeol. *White Porcelain and Punch'ŏng Ware.* Seoul: Yekyong, 2002. *Handbook of Korean Art, Vol. 3.*

Kim, Man-hee. *Korean Life: Portrayed in Genre Pictures.* Seoul: Hyeonamsa Publishing, 2002.

Koehler, Robert. *Joseon's Royal Heritage: 500 Years of Splendor.* Seoul: Seoul Selection, 2011.

Koehler, Robert. *Korean Ceramics: The Beauty of Forms.* Seoul: Seoul Selection, 2012.

Koehler, Robert. *Religion in Korea: Harmony and Coexistence.* Seoul: Seoul Selection, 2012.

Koehler, Robert. *Traditional Painting: Window on the Korean Mind.* Seoul: Seoul Selection, 2010.

Koo, John H., and Andrew C. Nahm, eds. *An Introduction to Korean Culture.* Elizabeth, NJ: Hollym International, 2008.

Korean Funerary Figures: Companions for the Journey to the Other World. Seoul: The Ock Rang Cultural Foundation, 2010.

Korean Culture and Information Service. *Guide to Korean Culture.* Elizabeth, NJ: Hollym International, 2010.

Korean Overseas Information Service. *Korean Heritage: Vols. 1 & 2.* Elizabeth, NJ: Hollym International, 1995.

Lachman, Charles. *The Ten Symbols of Longevity*. Seattle, WA: University of Washington, 2006.

Lee, Chunghie. *Bojagi & Beyond.* RI: Beyond & Above, 2010.

Lee, Han-sang, ed. *Gold Crowns of Silla: Treasures from a Brilliant Age.* Seoul: The Korea Foundation, 2011.

Lee, Kyong-hee, ed. *Masterpieces of Korean Art.* Seoul: The Korea Foundation, 2010.

Lee, Kyong-hee. *Masters of Traditional Korean Handicrafts.* Seoul: The Korea Foundation, 2009.

Lee, Kyong-hee, ed. *Modern Korean Artists.* Seoul: The Korea Foundation, 2009.

Lee, Kyung-ja. *Norigae: Splendor of the Korean Costume*. Seoul, Korea: Ewha Womans University Press, 2005. Spirit of Korean Cultural Roots, Vol. 2.

Lee, Soyoung, and Seung-chang Jeon. *Korean Buncheong Ceramics from Leeum, Samsung Museum of Art.* New York: Metropolitan Museum of Art, 2011.

Moes, Robert. *Auspicious Spirits: Korean Folk Paintings and Related Objects.* Washington, D.C.: International Exhibitions Foundation, 1983.

Oh, Ju-seok. *Special Lecture on Korean Paintings.* Elizabeth, NJ: Hollym International, 2011.

Oh, Ju-seok. *The Art of Kim Hong-do: A Great Court Painter of 18th-century Korea.* Chicago, IL: Art Media Resources, 2005.

Pak, Youngsook, and Roderick Whitfield. *Earthenware and Celadon*. Seoul: Yekyong, 2002. Handbook of Korean Art, Vol. 2.

Park, Youngdae. *Essential Korean Art: From Prehistory to the Joseon Period.* Seoul: Hyeonamsa, 2004.

Prothero, Stephen R. *God Is Not One: The Eight Rival Religions That Run the World.* New York: HarperOne, 2011.

Shin, Hyong Sik. *A Brief History of Korea*. Seoul: Ewha Womans University Press, 2005. The Spirit of Korean Cultural Roots, Vol. 1.

Stickler, John. *Land of Morning Calm: Korean Culture Then and Now.* Fremont, CA: Shen's Books, 2003.

Suh, Jae-sik. *Korean Patterns.* Elizabeth, NJ: Hollym International, 2007.

The Association of Korean History Teachers. *A Korean History for International Readers.* Seoul: Humanist, 2010.

The Korea Success Story: From Aid Recipient to G20 Chair. Seoul: Seoul Selection, 2010.

The Museum of Korean Embroidery. *Wrappings of Happiness: A Traditional Korean Art Form.* Hawaii: Honolulu Academy of Arts, 2003.

The National Institute of the Korean Language. *An Illustrated Guide to Korean Culture: 233 Traditional Key Words.* Seoul: Hakgojae Publishing, 2002.

Traditional Lifestyles. Seoul: The Korea Foundation, 1997. Korean Cultural Heritage, Vol. 4.

Vos, Ken. *Symbolism & Simplicity: Korean Art from the Collection of Won-Kyung Cho.* Leiden: Hotei Publishing, 2002.

Yang, Sunny. *Hanbok: The Art of Korean Clothing.* Elizabeth, NJ: Hollym International, 1998.

Yim, Seock Jae. *Floral Lattices, Columns and Pavilions.* Seoul: Ewha Womans University Press, 2005. Spirit of Korean Cultural Roots, Vol. 7.

Yim, Seock Jae. *Roofs and Lines.* Seoul: Ewha Womans University Press, 2005. Spirit of Korean Cultural Roots, Vol. 3.

Yim, Seock Jae. *Stone, Walls and Paths.* Seoul, Korea: Ewha Womans University Press, 2005. Spirit of Korean Cultural Roots, Vol. 5.

Yim, Seock Jae. *The Traditional Space*. Seoul, Korea: Ewha Womans University Press, 2005. Spirit of Korean Cultural Roots, Vol. 6.

Yim, Seock Jae. *Window and Doors.* Seoul, Korea: Ewha Womans University Press, 2005. Spirit of Korean Cultural Roots, Vol. 4.

Yoon, Yeol-su. *Minhwa: Tales of Korean Folk Paintings*. Seoul: Design House, 2005.

Magazines

Koreana	Published by The Korea Foundation, www.koreana.or.kr
Morning Calm	Published by Korean Air, www.morningcalm.koreanair.com
SEOUL	Published by Seoul Selection, www.magazine.seoulselection.com

Online Booksellers

HanBooks	www.hanbooks.com
Hollym International Corp.	www.hollym.com
Seoul Selection Bookshop USA.	www.seoulselection.com/usa

Other U.S. Resources

Organizations

Kang Collection Korean Art – 9 East 82nd St., New York, NY 10028. (212) 734-1490 www.kangcollection.com

Korean Art Society – www.koreanartsociety.org

Korean Cultural Centers

- 5505 Wilshire Blvd., Los Angeles, CA 90036. (323) 936-7141 www.kccla.org
- 38 West 32nd St., #300, New York, NY 10001. (646)429-9476 www.koreancc.org
- 2370 Massachusetts Ave., NW, Washington, DC 20008. (202) 587-6168 www.koreaculturedc.org

The Korea Society – 950 Third Ave., 8th Floor, New York, NY 10022. (212) 759-7525 www.koreasociety.org

Museums

American Museum of Natural History – Central Park West at 79th St., New York, NY 10024-5192. (212) 769-5100 www.amnh.org

Arthur M. Sackler Gallery at the Smithsonian Institution – 1050 Independence Ave., SW, Washington, DC 20013. (202) 633-4880 www.asia.si.edu

Asian Art Museum of San Francisco – 200 Larkin St., San Francisco, CA 94102. (415) 581-4700 www.asianart.org

Cleveland Museum of Art – 11150 East Blvd., Cleveland, OH 44106. (216) 421-7350 www.clevelandart.org

Freer Gallery of Art at the Smithsonian Institution – Jefferson Drive at 12th St., SW, Washington, DC 20013. (202) 633-4880 www.asia.si.edu

Jordan Schnitzer Museum of Art – University of Oregon, 1430 Johnson Lane, Eugene, OR 97403. (541) 346-3027 www.jsma.uoregon.edu

Los Angeles County Museum of Art – 5905 Wilshire Blvd., Los Angeles, CA 90036. (323) 857-6000 www.lacma.org

Metropolitan Museum of Art – 1000 Fifth Ave., New York, NY 10028. (212) 535-7710 www.metmuseum.org

Minneapolis Institute of Arts – 2400 Third Avenue South, Minneapolis, MN 55404. (612) 870-3000 www.artsmia.org

Museum of Fine Arts, Boston – 465 Huntington Ave., Boston, MA 02115. (617) 267-9300 www.mfa.org

Newark Museum – 49 Washington St., Newark, NJ 07102. (973) 596-6550 www.newarkmuseum.org

National Museum of Natural History at the Smithsonian Institution – 10th St., and Constitution Ave., NW, Washington, DC 20013. (202) 633-1000 www.mnh.si.edu

Pacific Asia Museum – 46 North Los Robles Ave., Pasadena, CA 91101. (626) 449-2742 www.pacificasiamuseum.org

Peabody Essex Museum – East India Square, 161 Essex, St., Salem, MA 01970. (978) 745-9500 www.pem.org

Philadelphia Museum of Art – 2600 Benjamin Franklin Parkway, Philadelphia, PA 19130. (215) 763-8100 www.philamuseum.org

University of Michigan Museum of Art – 525 South State St., Ann Arbor, MI 48109. (734) 764-0395 www.umma.umich.edu

Other Resources in Korea

Organizations

Cultural Heritage Administration – 1600-0064 www.cha.go.kr

Korea Cultural Heritage Foundation – 406, Bongeunsa-ro, Gangnam-gu, Seoul. (02) 556-6300 www.chf.or.kr (Korean)

Korea Craft and Design Foundation – 53, Yulgok-ro, Jongno-gu, Seoul. (02) 398-7900 www.kcdf.kr/eng

Museums

Donglim Knot Museum – 11-7, Gahoe-dong, Jongno-gu, Seoul. (02) 3673-2778 www.shimyoungmi.com (Korean)

Gahoe Museum – 17, Bukchon-ro 12-gil, Jongno-gu, Seoul. (02) 741-0466 www.gahoemuseum.org (Korean)

Gyeongju National Museum – 186, Iljeong-ro, Gyeongju-si, Gyeongsangbuk-do. (054) 740-7500 gyeongju.museum.go.kr

Han Sang Soo Embroidery Museum – 29-1, Bukchon-ro 12-gil, Jongno-gu, Seoul. (02) 744-1545 www.hansangsoo.com (Korean)

Jeju Folklore and Natural History Museum – 40, Samseong-ro, Jeju-si, Jeju-do.
(064) 710-7707 museum.jeju.go.kr/eng

Kokdu Museum– 1-5, Dongsung Art Center, Dongsung-dong, Jongno-gu, Seoul.
(02) 766-3315 www.kokdumuseum.com

Korea Furniture Museum – 330-577, Seongbuk-dong, Seongbuk-gu, Seoul.
(02) 745-0181 www.kofum.com

Leeum, Samsung Museum of Art – 747-18, Hannam 2-dong, Yongsan-gu, Seoul.
(02) 2014-6900 leeum.samsungfoundation.org

Museum of Korean Embroidery – 34, Nonhyeon-ro 132-gil, Gangnam-gu, Seoul.
(02) 5155-1114 www.bojagii.com (Korean)

National Folk Museum of Korea – 37, Samcheong-ro, Jongno-gu, Seoul.
(02) 3704-3114 www.nfm.go.kr

National Museum of Korea – 137, Seobinggo-ro, Yongsan-gu, Seoul.
(02) 2077-9047 www.museum.go.kr

National Palace Museum of Korea – 161, Sajik-ro, Jongno-gu, Seoul.
(02) 3701-7500 www.gogung.go.kr

Onyang Folk Museum – 123, Chungmu-ro, Asan-si, Chungcheongnam-do.
(041) 542-6001 www.onyangmuseum.or.kr

Index

Credits

Editor Kim Eugene
Assistant Editor Shin Yesol
Copy Editor Daisy Larios
Proofreader Felix Lim

Designer Debbi Kent
Assistant Designers Yu Hye-Ju, Son Hong-Kyeong

Publisher Kim Hyung-geun

Additional Photo Credits

* All photos by Debbi Kent with the exception of those noted below.

Ahn Hong-beom 82 (left)

Ainsley McGregor 116 (top)

Antique Alive 38 (right), 53 (left), 92 (top)

Bahk Huhn 154(right)

Bukowskis, Stockholm 136

Chojun Textile and Quilt Museum 71 (second at the bottom)

Cultural Heritage Administration of Korea 152 (left)

David Hasenick 100 (left), 120, 121 (left bottom, right)

Derek Winchester 106 (left, middle)

Doyenong (www.doye.co.kr) 33 (left), 51 (right bottom)

Ganainsa Art Center (Artist Lee Hyun-ja) 35 (top), 38 (left bottom), 39 (left),
 130 (top: second, third; bottom: first)

Gahoe Museum 130 (top: first), 147 (right)

Gongju National Museum 103 (right bottom)

Greentea Design 98 (right)

Gyeongju National Museum 102 (right bottom)

Harubang Antiques 116 (left), 139 (lef)

Ho-am Art Museum 35 (left bottom), 40 (left, right bottom), 149 (right), 142

Image Today 6, 71 (third at the bottom), 76 (left), 77 (right), 85 (right bottom), 92 (bottom),
 114 (top), 115 (right)

Jeonju University Museum 125 (top)

Jonathan V. Acierto 145 (left)

Jordan Schnitzer Museum of Art 35 (right bottom), 38 (top), 40 (right top), 43 (bottom), 132, 133

Jung Joong-hi 21 (right bottom)

Kang Collection 138, 144 (left, right bottom)

Kim Won-jung 90

Kokdu Museum 119 (right)

Korea Cultural Heritage Foundation 98 (left), 148 (top), 153, 154 (left), 159 (left)

Korea Intangile Heritage Promotion Center 66 (right top)

Korea Kite Fliers Association 85 (right top)

Korean Culture and Information Service 107 (top)

Korean Tourism Organization 19, 20 (left), 66 (right bottom), 67 (left top), 76 (right middle),
 84, 85 (left), 86 (left), 107 (left top)108 (left), 111 (right), 115 (bottom), 117 (left)

Korean-Arts 107 (bottom)

Lee Jae-man 94 (right)

Lee Youngmin 63 (bottom), 70 (right bottom), 73 (left top)

Leeum, Samsung Museum of Art 34 (top), 52 (right bottom), 64 (left), 139 (right)

Mark Johnson 83 (left bottom, right)

MBC 70 (right top)

Mulpa Space Gallery 130 (top: fourth), 137 (left), 155 (top)

National Museum of Korea 16, 20 (right), 26 (left bottom), 31 (left), 53 (right), 102 (left, right top),
 103 (left), 130 (bottom: third), 143 (left), 145 (right), 146, 147 (left)

National Palace Museum of Korea 18 (right), 36 (right), 47, 76 (right top), 128, 141 (right)

Oh Jong-eun 91, 158

Rekishi no Tabi 82 (right bottom)

Robert Turley (www.koreanartandantiques.com) 123 (right), 124 (left top and bottom)

Seo Heun-kang 17 (top), 41 (bottom), 94 (right), 95

Park Woo Jin 150

Tansu Design 124 (right bottom)

The Korean Institute of Minhwa Research 39 (top, right bottom), 40 (right bottom),
 130 (bottom: second, fourth)

The National Folk Museum of Korea 62 (right bottom), 67 (right), 74, 75

The Seoul Shinmun 63 (top)

The Traditional Paper Artists Association 80 (top), 81 (left top and bottom)

Wikimedia Commons 26 (left top), 50 (right bottom)

Yonhap Photo 26 (right), 28 (right), 30 (left bottom)

YoungDoo Moon 86 (rignt top and bottom), 87 (right bottom)